IKAT TEXTILES OF INDIA

IKAT TEXTILES OF INDIA

CHELNA DESAI

Chronicle Books • San Francisco

First published in the United States 1988
by Chronicle Books

Copyright © 1987 by Chelna Desai.

Printed in Japan

First published by Graphic-Sha
Publishing Co., Ltd., Tokyo, Japan

Library of Congress Cataloging-in-Publication
Data

Desai, Chelna.
 Ikat textiles of India / Chelna Desai.
 p. cm.
 ISBN 0-87701-548-1
 1. Ikat−India−Catalogs. I. Title.
NK8976.A1D47 1988
746.1′4′0945−dc19 88-12671
 CIP

Distributed in Canada by Raincoast Books, 112 East
3rd Avenue, Vancouver, B.C. V5T 1C8

10 9 8 7 6 5 4 3 2 1

Chronicle Books
275 Fifth Street
San Francisco, California
94103

�֎ �֎�֎�֎✖✖✖✖✖ ✖ ✖✖✖✖✖✖✖✖

Contents

HISTORY OF IKAT TEXTILES OF INDIA

India is a land of many wonders. Her civilization, spanning five millenea, from times lost in the mists of antiquity and mythology to the mechanized modern age, has produced an endless array of masterpieces, wrought in every art form known to man. But even in a land where superlatives become common place, her magnificent ikat textiles command a very special status. Revered by generations of kings, treasured in the finest museums of the world, their beauty lies enmeshed in their rich visual texture and precision bound technique. This immensely skilled craft has developed in three diverse regions of the country at different periods of time. Distinct in both geographical location and cultural traditions, each zone synthesised its own awareness, experience and sensitivity to colour, form and fabric. Today, scattered in a few towns and villages in the three states of Gujarat, Orissa and Andhra Pradesh, looms still resound to the vibrant rythmns of tradition and modernity.

The term 'ikat' stems from the Malay-Indonesian expression 'mangikat', meaning to bind, knot or wind around. In principle, ikat or resist dyeing, involves the sequence of tying (or wrapping) and dyeing sections of bundled yarn to a predetermined colour scheme prior to weaving. Thus, the dye penetrates into the exposed sections, while the tied sections remain undyed. The patterns formed by this process on the yarn are then woven into fabric. The three basic forms being single ikat, where either warp or weft threads are tied and dyed prior to weaving; combined ikat where warp and weft ikat may coexist in different parts of a fabric occasionally overlapping and double ikat which is by far the most complex form. Here both warp and weft threads are tied and dyed with such precision, that when woven, threads from both axis mesh exactly at certain points to form a complete motif or pattern.

While numerous legends and oral traditions indicate the existence of the single ikat technique in India in prehistoric times, the 6th century frescoes of the Ajanta Caves provide the first visual records of it. Many of the world's ancient cultures practised the single ikat craft but the more complex double ikat exists only in India, where it is known as 'patolu' (plural 'patola'), in Bali, where it is called 'geringsing' and in Japan, where it is named 'kasuri'.

The Patola of Gujarat

From the 12th century ownards, references in praise of patola appear in the writings of many eminent poets and authors of Gujarati literature. Characterized by their bold, grid based patterns, juxtaposed with intricate geometrical, floral and figurative motifs, they are woven in the exacting and time consuming double ikat techniqe. The history of these famous textiles is as enchanting as the fabric itself.

Patola patterns were discovered in the 16th and 17th century frescoes in the south Indian temples and palaces of Padhmanabhpuram and Tiruchinapalli. As early as the 13th century[1], patola and other fabrics grouped under the same name, were exported to the Malayan Archipelago and then to China and Japan in the 1500's. Later, they were among the most valuable articles that the Dutch French and Portuguese traders of the 17th century bartered in exchange for spices. So highly esteemed were they in the spice islands that to this day they are treasured and guarded as priceless heirlooms. Their importance can also be gauged by the innumerable rituals and customs for which they were indispensible. It is said that the Sultan of Surarkarta enacted a law forbidding any, but the royal family from wearing certain patola designs.

During the Dutch colonial era in Java, patola, known locally as 'Tjinde', were worn as silk trousers by Javanese district regents. So great was their significance, that they were utilized at every important transitional phase of life - from naming ceremonies, initiation rites, wedding rituals to covering for the dead. Even today, they are in use for weddings and ceremonial dances. Apart from being fashioned as wedding garments for bridegrooms of noble families, each princely family in Java had an altar or ceremonial bed upholstered with patolu called 'Krolong Patanen', which symbolised the house of Devi Shri or Mother Goddess. Royal weddings were conducted only before such an altar. The sacred canon 'Njahi Satomi', rare musical instruments and other revered objects were wrapped only with patola. Certain magical properties were also accredited to these silken textiles. It is plausible that over time, these fabrics gained a magical sacred and awesome presence on account of their relative scarcity, obscure sources of manufacture and complex patterns and technique. Besides their social, ceremonial and mystical functions patola were also used for medicinal purposes. Water, into which the end of a patolu had been dipped was drunk as a potion against certain diseases. In Bali, the mentally ill were treated with the inhalation of smoke derived from burning patolu threads.

Patola export reached its zenith under the enterprising European traders of the 17th century. During the 18th and 19th centuries, export to Indonesia continued but to a lesser extent. It was largely as a result of the introduction of printed textiles during the industrial revolution and

local patolu imitations, that patola export declined. A ban on imports from India during the second world war finally sealed off all avenues of this once flourishing trade.

In India, especially Gujarat, patola have been worn in the form of saris by ladies of the aristocracy and women of high social standing. Preferably woven from the finest Japanese, Chinese or Thai silk, patola symbolized wealth, refinement and culture. Worn during marriages or festivals, they were important in the customs of certain Gujarati communities. In addition, they were used as coverings for royal elephants and horses or hangings in temples and the adornment of deities. They also formed shrouds for the dead prior to cremation. Although their ceremonial significance has almost vanished today, patola still symbolize status and material prosperity, (a patolu from Patan can cost upto Rs. 20,000 today). Above all, patola represent a rich tradition mastery and sophistication of technique and fabrics of exceptional beauty.

Today it is only in the city of Patan, the ancient capital of Gujarat that this age old craft survives. It is believed these fabulous silks were once woven in the cities of Ahmedabad, Surat, Cambay, Bharuch, Baroda and Patan in Gujarat, as well as Jalna in Maharashtra and Burhanpur in Madhya Pradesh. A curious legend exists about King Kumarpala of the 12th century who shifted his capital from Bimbora to Patan, bringing in his retinue 700 patolu weavers. Patolu fabric, considered pure and auspicious, was worn by the king every morning for his visit to the temple. Since the time taken to complete one patolu from pre-loom to post-loom stages took six months, 700 weavers were employed to ensure his supply of a new patolu for each day of the year! This explanation was proferred by Shri Chotalal Salvi, master weaver from Patan, who belongs to one of the only two families from the ancestral patola weavers' clan who still practise this painstaking, priceless art. The survival of these two families is increasingly threatened by less expensive imitations woven in Pochampalli, Rajkot and machine printed imitations which are even cheaper.

Apart from double ikat patola from Patan, in recent years single ikat centres have sprung up in villages around Billimora, where weavers from Andhra Pradesh are believed to have migrated. Patan and Surat are two of the largest producers of single ikat mashru textiles. While the proliferation of single ikat workshops are encouraging signs for both design and trade, their very popularity threatens the continued manufacture of the more expensive and time intensive double ikat fabric.

Ikat Mashru Textiles

Possibly developed after the muslim conquest of northern India, ikat mashru textiles, by virtue of their silk warp and cotton weft, have been classified in the group of mixed fabrics. These shimmering 'semi-precious' textiles are woven in Patan, Mandvi and Surat in Gujarat, and Ajamgarh in Uttar Pradesh. Mashru meaning 'permitted', were worn by orthodox muslim men who were forbidden to wear pure silk by their prophet, for certain unknown reasons. Even today there are a few orthodox muslims who abide by this tradition. According to John Irwing, during the 17th century, the English supplied quantities of cheap, mixed fabric called 'tapaseils' to West Africa. These fabrics were stripped and may have been single ikat.

To simulate a silken effect, mashru fabrics are woven in satin weave whereby, when worn, the cotton weft is inside and the silk faces outward. The most striking feature of these textiles is their bright, colourful, stripped bands between which ikat areas alternate. Nowadays it has become rare to find ikat-mashru fabrics as opposed to plain mashru fabrics. Used by Gujaratis and other non-muslim communities as lining for coats, petticoats, pillowcases, umbrellas, borders etc., they are also very popular among tribal sects and are exported in bulk to several Arab countries. At present there are about 400 looms in Patan. According to the Indian census, 35,000 metres of mashru is produced in Patan annually of which 70% is used in Madhya Pradesh and Rajasthan and 30% in Gujarat.

The Bandhas of Orissa

Whereas northern India has historically been the scene of repeated invasions and hence susceptible to external influence, Orissa, enjoyed greater immunity, being isolated from the rest of India by ranges of hills on the west and the Bay of Bengal to the east. Consequently the 'bandha' textiles of this region have a distinct native identity. In contrast to the imposing, mosaic like appearance of the patolu from Gujarat, traditional single ikat bandhas from Orissa have a soft curvilinear quality. The charm of these cotton and silk ikat textiles lies in the 'feathered' flame-like, hazy effect of the forms, as opposed to the sharp, grid based patterns of the patolu where 'flaming' is deliberately kept to the minimum. Also, the effect achieved by the addition of extra weft threads woven beside the ikat areas, gives the bandhas an uniquely rich texture.

Patronized for generations by the local population of all social strata, the bandha industry of Orissa is represented almost entirely by two weaver communities – the Mehers of

Sonepur and Bargarh and the Patras from Nuapatna and Cuttack regions – each group having developed their own characteristic styles. Presently there are approximately 40,000 looms scattered in and around the villages of Attabira, Bargarh, Barpalli, Sonepur in the west and Nuapatna in the east. Orissa also produces large quantities of ikats in tussar silk.

Certain ikat textiles woven in silk are used for religious purposes in the famous temples of Jaganath Puri. In Nuapatna[2], one of the oldest ikat weaving centres, there exists an intriguing tradition of weaving slokas or verses from the Gita Gobinda texts into the fabric known as 'pheta'. The earliest documented evidence was found by Sri Sadashiv Rath Sharma, a scholar and devotee, in the daily diary (Madala Panji) of King Ramchandradeva the II who ruled in Puri (circa: 1719 A.D.). The essence of the inscription is as follows, "Jayadeva, the great poet of the 12th century wished to offer the sacred 'Gita Gobinda' text to Lord Jaganath, Lord of the Universe. In order to ensure close proximity to his deity, he decided to procure fabrics with lyrics woven into them, with which to adorn the image. So impressed was King Ramachandradeva by this symbolic act that he immediately placed orders for these fabrics in Nuapatna." Each pheta contained one sloka or verse woven into it. Today the weavers from the Patra community in Nuapatna continue to weave these traditional Gita Gobinda fabrics.

Another interesting custom which throws some light on the antiquity of ikat weaving in Orissa is found[3] in a tradition practised by some Patra weavers of Nuapatna. Each family preserves a small piece of fabric woven by their forefathers to the seventh generation. When an elder dies, his successor adds his fabric to those of his ancestors. The fabrics, apparently endowed with some mystical significance, are kept in secret places and are not ordinarily available for inspection. According to Jaganath Kethial who chanced to see a set, each one of them was woven in the ikat technique.

Whereas traditionally Patra weavers from Nuapatna specialised in bandhas of pure and tussar silk and the Mehers of Bargarh wove mainly cotton ikats, today the bandhas of Orissa are poised on the crossroads of change. Rigid distinctions no longer exist as division of skills and specialization has entered ikat production in many villages. Some specialise in tying and dyeing while neighbouring villages buy the dyed yarn to be woven into saris. In the realm of design, traditional motifs, once confined to one or other weaver group, are now borrowed and redesigned by both communities. Weavers who once wove only saris for local usage, now produce yardage, scarves, linen, etc., for urban and export markets.

Ikat Textiles of Andhra Pradesh

Andhra Pradesh, characterised by its stark, boulder studded landscape, once the seat of the powerful Nizam, today symbolises the rapidly growing, fast changing texture of the Indian ikat industry. A region where this technique was unknown two or three generations ago, today there are at least 40 villages within a 70 km. radius of Hyderabad, including Pochampalli, Koyalagudam, Puttapakka, Elanki and Chautupal, where ikat textiles are woven. The mastery of this tedious, precision craft in so short a time span, is perhaps the most remarkable achievement of the hard working, Padmasali and Devang weavers or 'Pagdhu Bandhu' (ikat) weavers of Andhra Pradesh. Here ikat weaving has become a way of life – from child to grandparent, every family member is involved at one stage or another.

No written document is available to ascertain the origin or evolution of the ikat technique in this region. It is widely believed to have developed around the turn of this century. The oldest centre, Chirala, situated on the rail route between Vijaywada and Madras, was once known to produce the famous cotton 'Telia Rumals' or Chowkas, woven in pairs admeasuring 55 to 75 cms. square. Characterised by their bold, geometrical motifs in red, black and white, offset by wide single coloured borders, they were used in India by fisherfolk and cowherds as loin cloths, lungis or turbans. In the 1930's they were exported in large numbers to Burma, the Middle East and East Africa where they were known as Asia Rumals. So popular were they that soon printed imitations from Manchester and China flooded the market. However, there were two disadvantages to these beautiful cotton fabrics. The dyes used were not fast and tended to bleed on washing. The use of alazarine dye process required for the red colour, invariably left a strong oily smell in the textile, which is why these cloths earned the name 'telia'[4] meaning oily. It is likely that these factors influenced their decline. Although improved versions are produced today in small quantities, Chirala is no longer their main production centre.

In the 1900's it was fashionable for ladies from wealthy, aristocratic families of Hyderabad state to wear ikat dupattas as veils to cover the head and shoulders over which they gracefully flowed. Dark areas on these fabrics were embellished with intricate motifs embroidered with cotton, silk, silver gilt and gold thread. The juxtaposition

of ikat areas with embroidery enhanced their elegance and gave them a fascinating texture. Unfortunately these beautiful fabrics are no longer produced. Ikat mashru textiles were also believed to have been woven in Hyderabad during the Nizam's rule. During the 1950's the ikat technique spread to Pochampalli which has emerged as one of the leading production and marketing centres for double ikats woven in the patola tradition of Gujarat.

Similar to modern trends in Orissa, ikat production here has also undergone specialization with each village catering to definite market segments. Thus Pochampalli specialises in silk saris of both single and double ikat for the urban and semi-urban market. Chautupal makes only cotton saris. Siripuram, Elanki and Koyalaguddam produce cotton and silk yardage for export. Today Andhra Pradesh is the largest exporter of ikat fabrics from India.

Modern Markets

In India – especially among the urban affluent, ikat textiles have come to symbolize a spirit of rediscovery and revival – a sudden awareness of India's rich heritage, neglected during the British Raj and forgotten with the advent of the age of synthetics. The entry of 'designer' textiles and 'designer labels' into urban markets have greatly influenced the demand for these fabrics. The 70's and 80's witnessed an unprecedented mushrooming of export houses both in private and government sectors. Ironically, the ikat weavers of India, apart from keeping a rich heritage alive and having earned India foreign exchange, are at the mercy of the fast changing tides of fashion.

The last three decades have seen multiple levels of change in the ikat weaving industry. Upto the 1950's the decentralised nature of the industry isolated the weaver from information regarding technological advances, changes in raw materials and shifting consumer demands. The all India Handlooms Board was established in 1952, bringing together representatives of the handloom industry. Soon after in 1955, the All India Handloom Fabrics Marketing Co-operative Society was formed to streamline operations between production units, research organizations and marketing agencies. Simultaneously the formation of Institutes of Handloom Technology and weavers Service Centres, aimed to bridge gaps in technology and to extend services in the areas of research, training and design. In 1958 the Handicrafts and Handloom Exports Corporation was established with a view to extending the marketing of handlooms abroad. This infrastructure gave a new lease of life to the waning handloom industry of the 50's. The gradual diversification of product range from mainly saris to yardage, linen, upholstery and drapery, mats and dhurries and other products opened up new markets. Today ikat textiles are exported from both private and government sectors to Japan, U.S.A., almost all European countries, Africa, the Middle East and Australia.

While reforms have changed the face of the weaving industry, the same factors have created a transformation in the role of the weaver, and spurred significant changes in the traditional design vocabulary. In earlier times weavers were as much artists as craftsmen. No boundaries existed between skill and creativity. Weavers created their own textiles, working within the intuitive bounds of their classic, rural or tribal traditions. Colours, forms and functions of each garment or fabric held a deep significance in the social, cultural and religious lives of both weaver and wearer. Today, fast changing lifestyles and the opening up of urban and international markets – alien to the weaver, have made it mandatory for urban and international design houses to step into the creative aspect of textile design. Thus reducing many a weaver's job to pure craftsmanship. Amongst weavers who still create their own patterns a new set of colours, design possibilities and uses have invaded their consciousness with startling rapidity. Increased access through mobility and the media have made an average weaver alive to diverse cross cultural influences, often resulting in hybrid design solutions. This is a significant evolutionary period in the history of the Indian ikat industry.

Sensing the need for direction several designers are working in close collaboration with weavers in both aspects of revival and experimentation. Many, many of these new creations are unique – exemplary of India's inborn spirit and ability to imbibe diverse views, synthesise and create jewels of exquisite beauty.

References

Pg 4 ; 1 : Historical information pertaining to the patola of Gujarat is mainly based on the book by Alfred Bühler entitled 'The Patola of Gujarat'

Pg 6 ; 2 : Information on the pheta tradition of Nuapatna is based on the work of Professor B.C. Mohanty and Mr. Kalyan Krishna in their work 'Ikat Fabrics from Orissa and Andhra Pradesh.

Pg 6 ; 3: Information related to the custom of cloth preservation, is based on the work of Professor B.C. Mohanty and Kalyan Krishna in their work 'Ikat Fabrics of Orissa and Andhra Pradesh.

Pg 6 ; 4 : On the other hand, the popularity of the Telia Rumals in Arab countries, is attributed to the 'oil' content in the rumal, which when worn as a head cloth, is believed to keep the head cool and relatively free from dust.

IKAT TECHNIQUE

Ikat or yarn resist dyeing, involves the sequence of tying (wrapping) and dyeing sections of bundled yarn to a pre-determined colour scheme or pattern, prior to weaving. Thus the dye penetrates into the exposed sections, while the tied sections remain undyed. The patterns achieved by this process on the yarn are then woven into fabric. The characteristic blurred or fuzzy-edged appearance of ikat textiles, is caused primarily by the dye, which has a tendency to 'bleed' into tied areas, due to capillary action along the yarn.

Within the 3 ikat categories, single ikat involves tying and dyeing of *either* warp or weft threads. In combined ikat, *both* warp and weft ikat coexist in different parts of the fabric, with both thread systems occasionally overlapping. In double ikat, both warp and weft threads are tied and dyed in such a manner, that when woven, threads from both axes mesh exactly at predetermined points to form a motif or pattern. Ikat patterns have also been formed by pulling sections of the dyed warp in such a way, so as to form new design configurations. The most common 'pulled' forms are chevrons or arrowheads and diagonals.

Although the basic technique employed in all 3 ikat regions of India is the same, variations in tools and related methods do exist. While pit looms are used in Orissa and Andhra Pradesh, the patola weaver's of Gujarat use single harness looms with no rigid framework. While yarn for upto 32 saris is patterned together in Andhra Pradesh, only 3 saris at a time are patterned together in Patan. In Andhra, semi-circular frames are used in the preparation of warp and weft, while pegs mounted on the wall and rectangular frames are used in Gujarat.

Overall changes in all three regions, such as the shift from vegetable dyes to chemical dyes, the introduction of new wrapping material such as plastic and rubber, the use of bicycle wheels and mechanized twisting machines, the replacement of throw shuttles with fly shuttles in some regions, are changes which have taken place over the years.

Although the focus of this book is on design, a brief overview of the ikat process has been included, to give some idea of the complexity of ikat production. A typical production process for a patolu from Patan, Gujarat is described below.

Yarn Preparation: Skeins of yarn are wound individually on hand reels and then plied together in groups of 8 threads. Followed by the process of de-gumming and bleaching, the yarn is left to dry and then wound. Later it is wound once again on a twisting machine.

Preparation of Yarn for resisting: The warp is assembled with the help of 17 pegs mounted on the wall. Usually the length warped is 19 metres, equivalent to 3 saris; each sari contains 2500 warp threads. After the required length is assembled, the warp is removed from the pegs and spread on a rectangular frame, sectioned and marked by grouping the ends to be dyed in the same sequence. Further sub-groups and sections are marked out and separated by leasing threads. The warp is then divided into 3 equal parts corresponding to 3 sari lengths. Thereafter further groupings upto 49 sections, corresponding to the patterned repeats are marked out and grouped. Finally the warp sheet is folded across and 6 layers to be patterned together are assembled. The weft is stretched, marked and grouped in a similar manner.

Wrapping and Dyeing: Both warp and weft yarns are stretched on tying frames and marked. Designs are normally worked out from memory or graph paper. Damp cotton yarn is used for the tying process. In all, wrappings are applied three times and removed three times. The dyeing sequence usually practised is as follow:- Red is first dyed, followed by yellow or orange, followed by green or blue. Black is obtained by over-dyeing red and blue with iron fillings. A needle with a wooden grip is used for untying. After dyeing, the yarn is thoroughly wrung and immersed in developing solution. Later it is washed in cold water and hung out to dry.

Preparation of dyed yarn for weaving: This is a very complex process. First warp sections which have been brought together for dyeing are separated. The warp is then unfolded and laid out on a long corridor and stretched. Weft threads are arranged in sequence, wound on bobbins and numbered.

Preparation of the loom for weaving: Patterned weft threads are fixed on the breast beam of the loom to position warp threads. Once the position is fixed, they are removed and used for weaving. The warp is then starched with rice water. Only 3 to 5 metres of the warp lies open, the rest is wound up.

Weaving: Two persons are involved in the process of weaving. Only 4 to 6 inches of fabric is woven in a day, as the coordination of threads of both axes is an extremely skilled and time consuming job. Patola are always woven in plain weave or tabby. Occasionally metallic, gold leaf threads are included in the border and pallav sections.

Pg 14 ★ Information related to the double ikat process of Patan, is based on the findings of Alfred Bühler, in his work 'The Patola of Gujarat and conversations with the patolu weaver's of Patan.

Ikat Regions of India

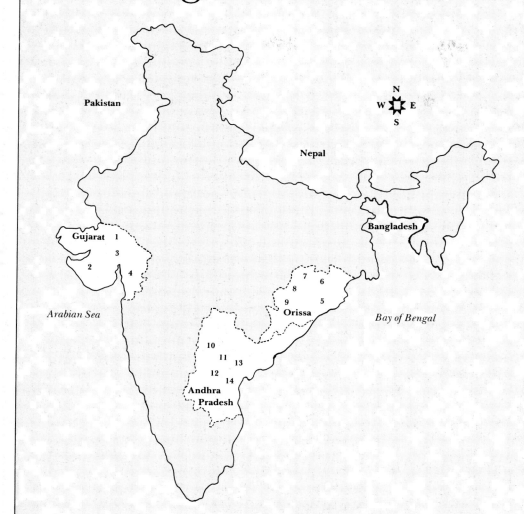

Pakistan

Nepal

Bangladesh

Gujarat

1

3

2

4

Arabian Sea

7

8

9

6

5

Orissa

Bay of Bengal

10

11

13

12

14

Andhra
Pradesh

N
W · E
S

MAJOR CENTRES

GUJARAT

1 Patan
2 Rajkot
3 Ahmedabad
4 Surat

ORISSA

5 Bhubaneshwar
6 Nuapatna
7 Sambalpur
8 Bargarh
9 Bolangir

ANDHRA PRADESH

10 Hyderabad
11 Puttapaka
12 Koyalaguddam
13 Pochampalli
14 Chirala

The production of ikat textiles in India is mainly concentrated in the regional states of Gujarat, Orissa and Andhra Pradesh. Each region has produced a rich variety of traditional and contemporary ikat patterns corresponding to the socio-cultural needs of each community and in recent years, to the requirements of urban and international markets. Most of the textiles presented in this volume are woven in this century.

Typical examples from each region have been reproduced below, to illustrate the distinct visual character of each ikat group.

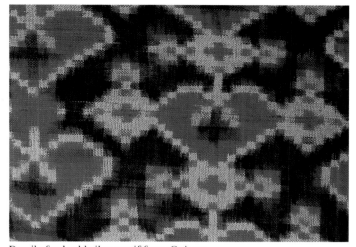

Detail of a double ikat motif from Gujarat

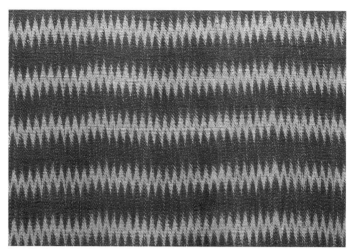

Detail of a single ikat mashru textile from Gujarat

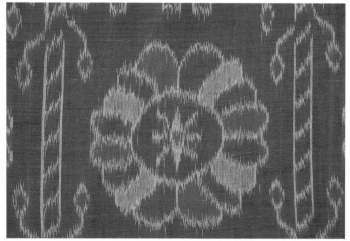

Detail of single ikat motif from Orissa

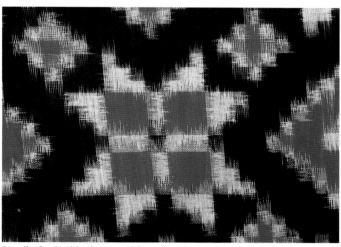

Detail of a double ikat motif from Andhra Pradesh

Ikat textiles are mainly produced in the form of saris, which may be termed as traditional garments worn by women in most parts of India. The sari is basically a rectangular length of cloth generally admeasuring 5 metres in length and 120 cms in breadth. It has three distinct design features, namely the centre field, border and end piece or (pallav). This deceptively simple, two dimensional length of cloth *comes alive* the moment it is draped around a woman's body, lending grace and dignity to the wearer. There are several methods and 'styles' in which a sari may be draped. Originally each 'style' corresponded to the needs of specific sects or communities. It is for this reason, that even today, sari dimensions and design proportions vary throughout India. Apart from saris, ikat textiles are also woven in the form of 'dupattas', odhnis or veils, lungis, turbans and yardage.

Overleaf : semi tye-dyed yarn

MAIN SECTIONS OF A SARI

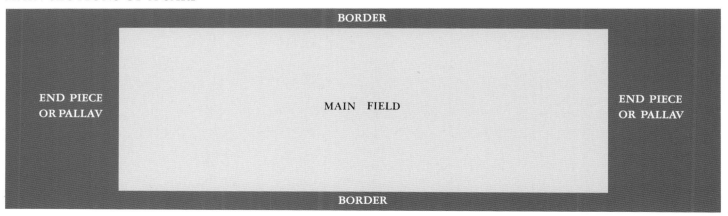

BORDER

END PIECE
OR PALLAV

MAIN FIELD

END PIECE
OR PALLAV

BORDER

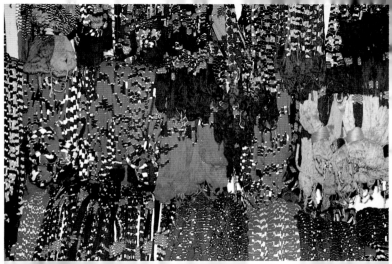

THE PATOLA OF GUJARAT

Dynamic geometrical grid patterns and intricate stylized motifs combine to form one of the most fabulous double ikat textiles of India. The precise placement of closely woven motifs in a rich array of colours, gives the patolu of Gujarat a striking mosaic like appearance. Moreover, it is in the fusion of form with technique, that the genius of the patolu lies.

The essentially stepped[1] or block-like quality of these textiles springs from the very nature of the double ikat technique. In this process, sets of identically marked threads are tied and dyed at regular intervals, which, when woven form networks of stepped motifs or patterns. The larger the set of identically patterned threads, the more pronounced the stepped or block-like pattern.

Precision is the most highly cherished goal of a patolu weaver.

Meticulous care is taken to minimize 'bleeding' or 'feathering' of edges when the two thread systems of warp and weft meet. Based on the degree of precision achieved, the technical quality and consequent value of a patolu is determined.

The entire vocabulary of patolu forms is derived from the square or rectangular unit. Ingenious combinations of these two elements in varied placements, sizes, colours and orientations have resulted in a rich repository of stylized ikat forms. Classified under geometric[2], floral[3] or figurative motifs[4], many of these forms are symbolic and represent deeper culture rooted concepts.

In earlier times, a set system of motifs and colours was assigned to each of the fifteen or so traditional patolu sari types. Each patolu type was used by a specific community or social group for a specific purpose.

It is only in recent years that these norms have been set aside and an explosion of colours and forms has emerged.

Apart from patola woven in Patan, single ikat patolu imitations are now woven in Rajkot. Although these textiles are not strictly 'patola' in that only single ikat is employed, many designs are replicas[5] of their original patolu counterparts. Hence the name Rajkot-patolu has come to stay. In recent years, new designs[6] have been developed, in keeping with the changing demands of growing consumer markets.

1 see page 39 plate 44 4 see page 38 plate 41
2 see page 45 plate 66 5 see page 50 plate 83
3 see page 22 plate 1 6 see page 53 plate 95

Right – Detail from a patolu sari

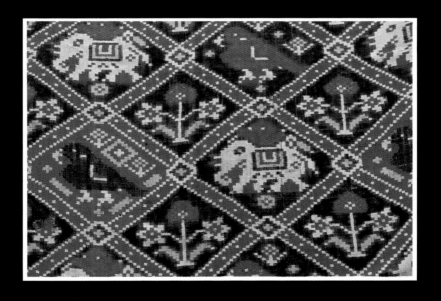

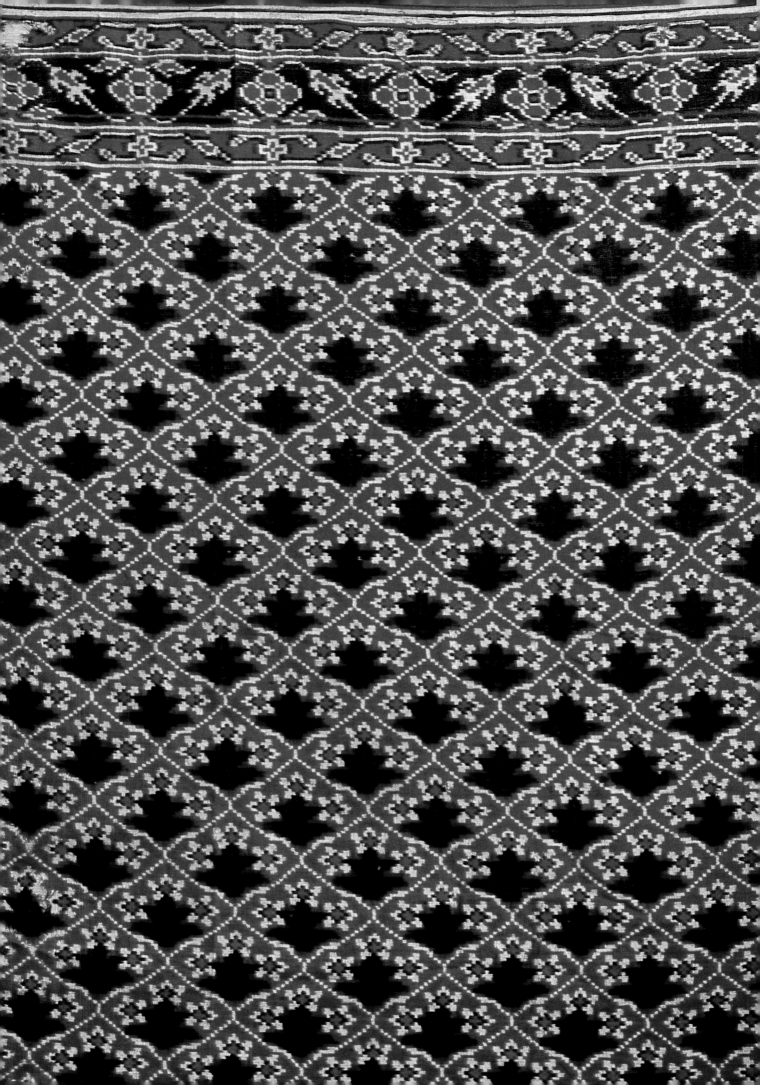

1

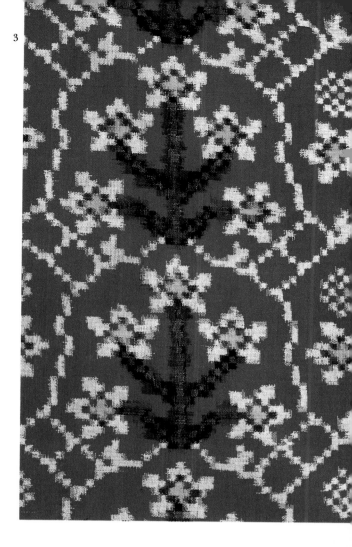

1
Tran Ful Bhat, silk
Patolu sari, Patan
Double ikat,
Collection of:
Sulochanaben Patolawalla

2
Tran Ful Bhat, silk
Patolu sari fragment
Double ikat,
Collection of:
Chotalal Salvi, Patan

3

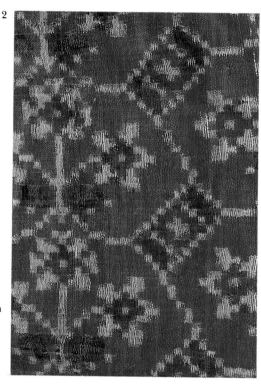

3
Panch Ful Bhat, silk
Detail of Patolu sari,
Double ikat,
Collection of:
Kanubhai Patolawlla, Patan

4
Pallav of Patolu, silk
Double ikat sari
Collection of:
Chotalal Salvi, Patan

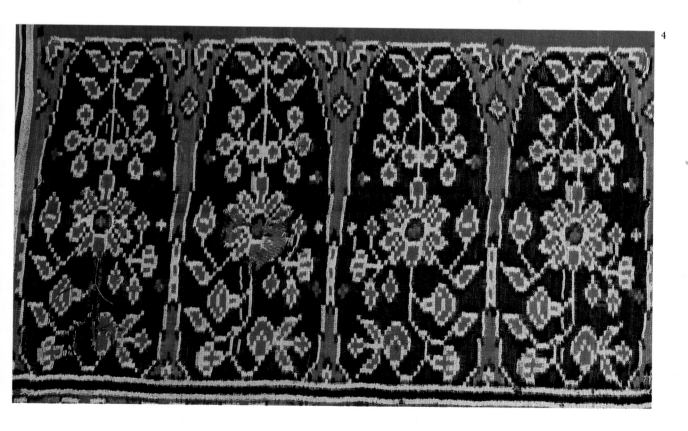

4

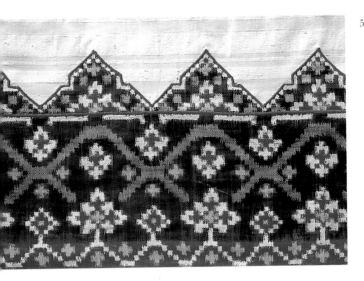

6

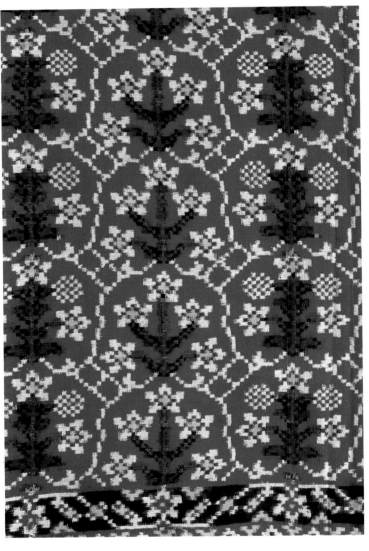

7

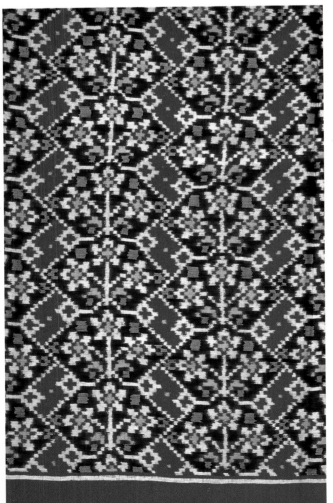

7.1

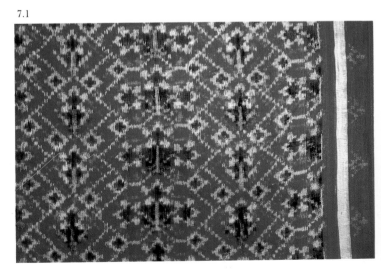

24

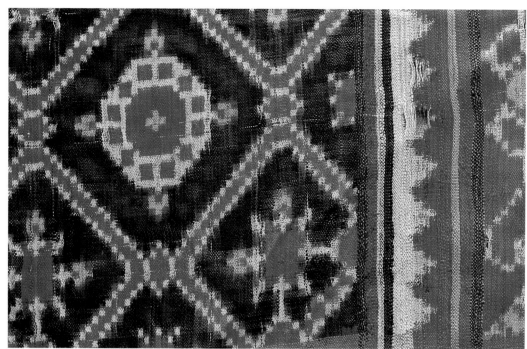

8

9

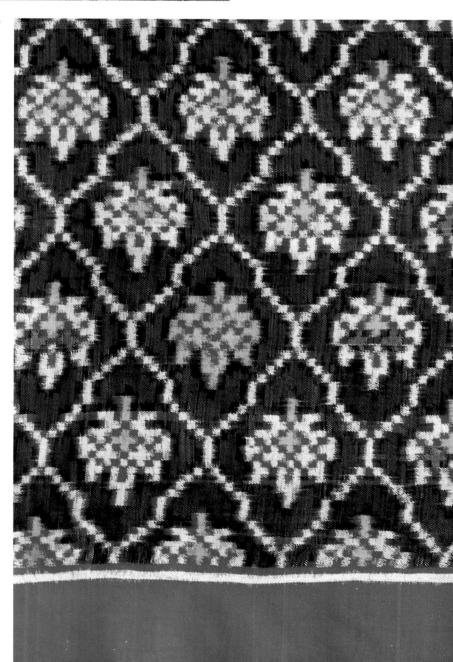

10

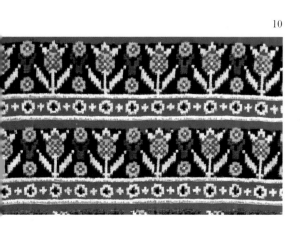

25

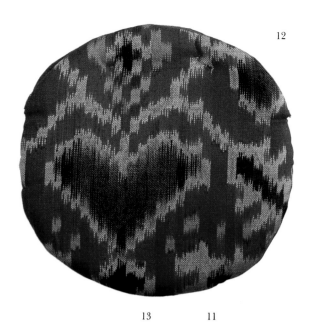

12

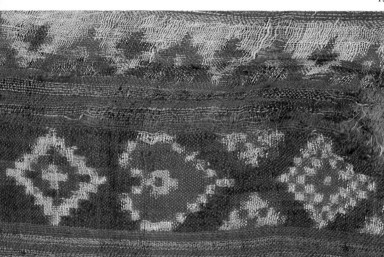

13

11

Border of Galo sari, detail,
Silk Patolu, double ikat
Collection of
Lataben Jhaveri, Bombay

12

Bangle case from
Patolu fragment,
Single ikat,
Collection of
Maya Desai, Bombay

13

Detail of Patolu, silk,
Double ikat sari
Collection of
Chotalal Salvi, Patan

14

Pan Bhat sari, detail,
Silk, Double ikat
Collection of
Chotalal Salvi, Patan

14

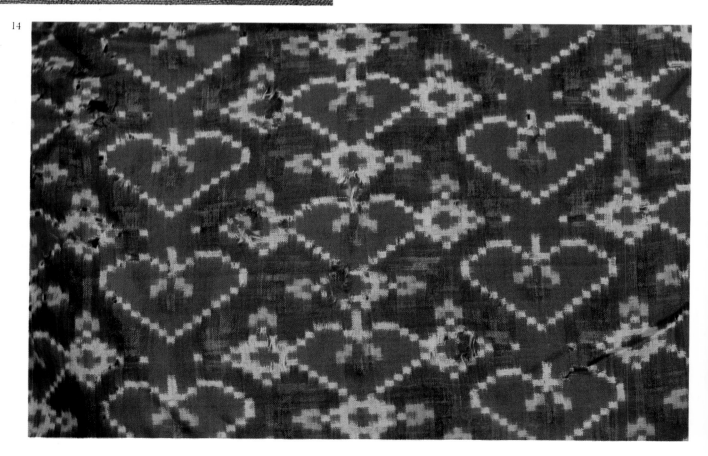

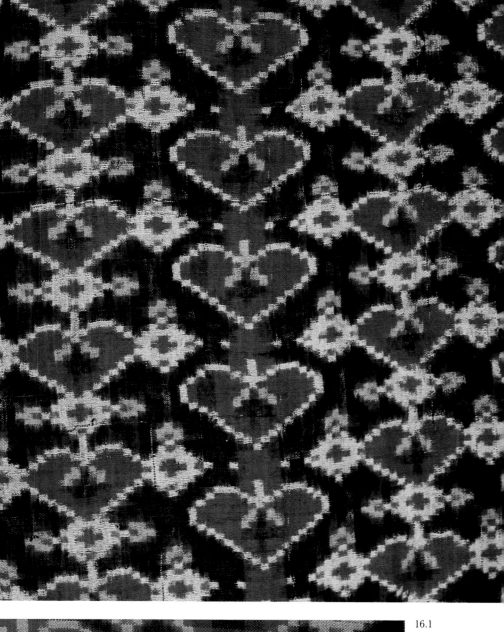

15
Letter Holder
stitched from
Patolu fragments
Double ikat, silk,
Collection of
Chotalal Salvi, Patan

16
Section of Pan Bhat sari,
Silk, double ikat
Collection of
Chotalal Salvi, Patan

16.1
Detail of Pan Bhat sari,
Silk, double ikat,
Collection of
Chotalal Salvi, Patan

15

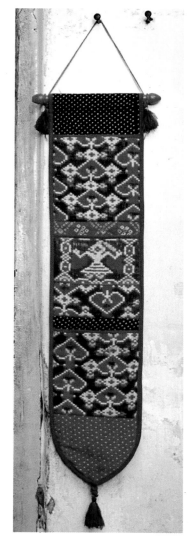

16.1

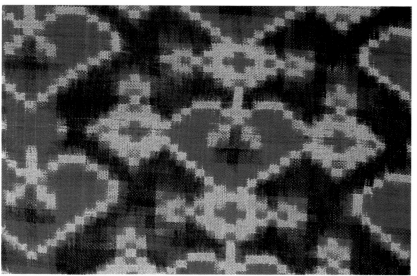

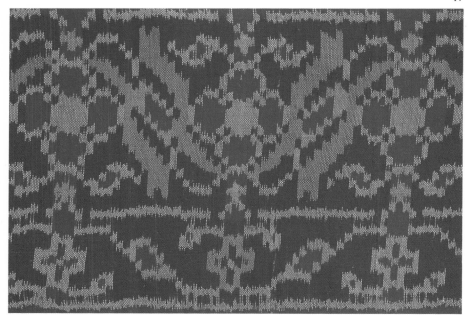

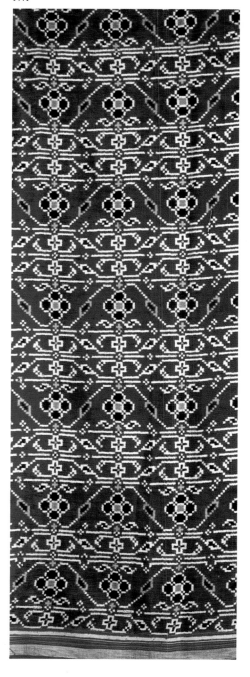

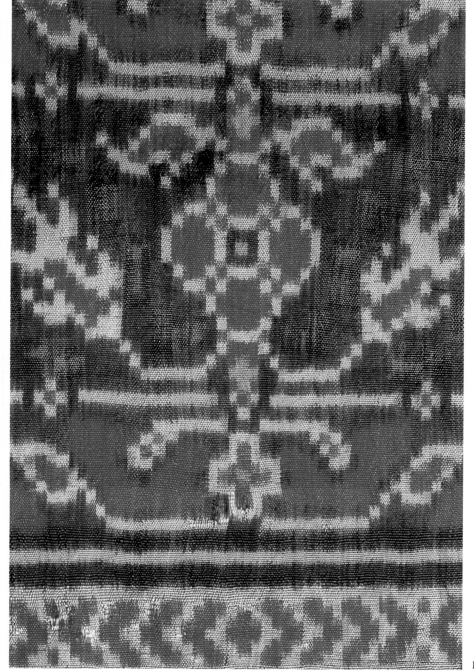

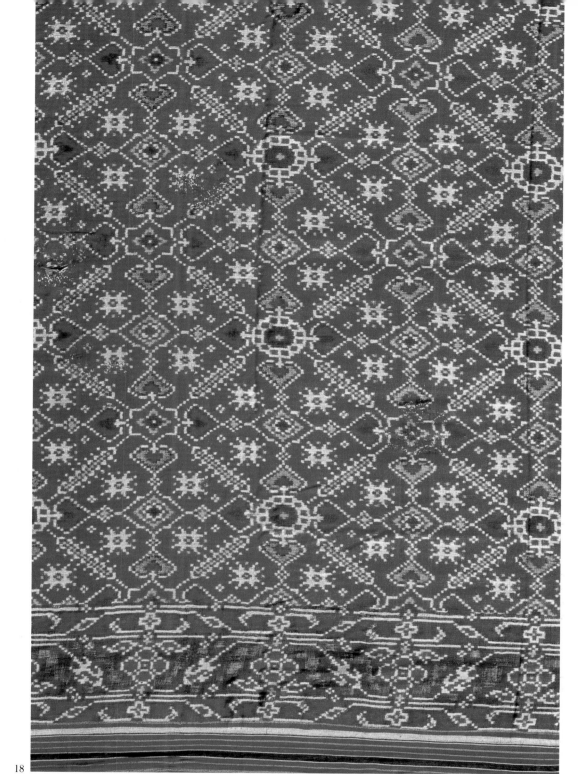

17
Detail of border
from Vohra Gaji Bhat
Sari, silk, single ikat,
Collection of
Savitaben Amin, Baroda

17.1
Section of patolu sari
Double ikat, silk
Collection of
Tarlaben Morakhia,
Bombay

17.2
Motif from patolu
Sari border, silk,
Double ikat,
Collection of
Weaver's Service Centre,
Ahmedabad

18
Section of
Vohra Gaji Bhat, silk
Patolu sari, double ikat.
Collection of
Weaver's Service Centre,
Ahmedabad

19
Detail of patolu sari,
Variation on
Vohra Gaji Bhat,
Collection of
Mrs Kapasi, Bombay

20
Detail of border
Vohra Gaji Bhat, silk
Double ikat sari,
Collection of
Chotalal Salvi, Patan

18

19
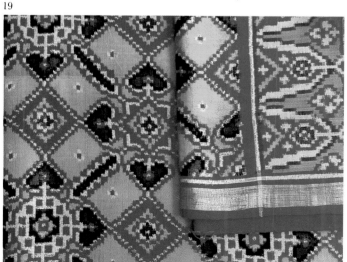

20
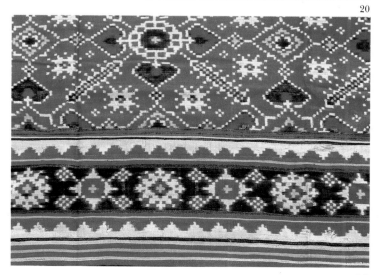

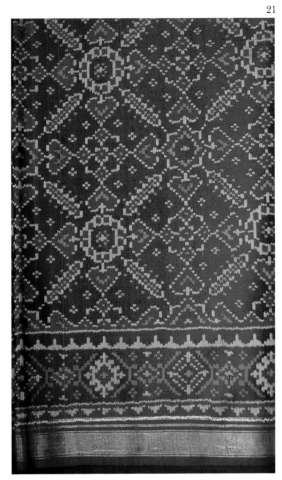

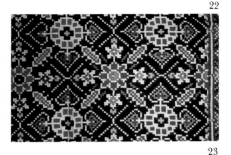

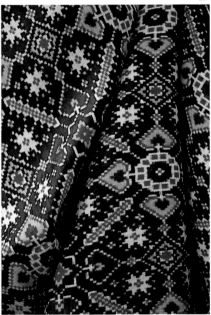

21
Section of
Vohra Gaji Bhat,
Silk patolu sari
Produced by
Rajkot Rashtriya Shala
Single ikat,
Collection of
Niruben Tanna, Bombay

22
Detail of Scarf, silk
Vohra Gaji Motif,
Double ikat,
Collection of
Lataben Jhaveri, Bombay

23
Section of Vohra Gaji
Bhat, Silk
Patolu sari, double ikat
Collection of
Satyavati Jhaveri
Bombay

24
Section of
Vohra Gaji Bhat, silk
patolu sari, double ikat,
Collection of
Ramaben Patel, Bombay

25
Vohra Gaji Motif,
Silk, patolu, double ikat,
Collection of
Chawla Patel,
Ahmedabad

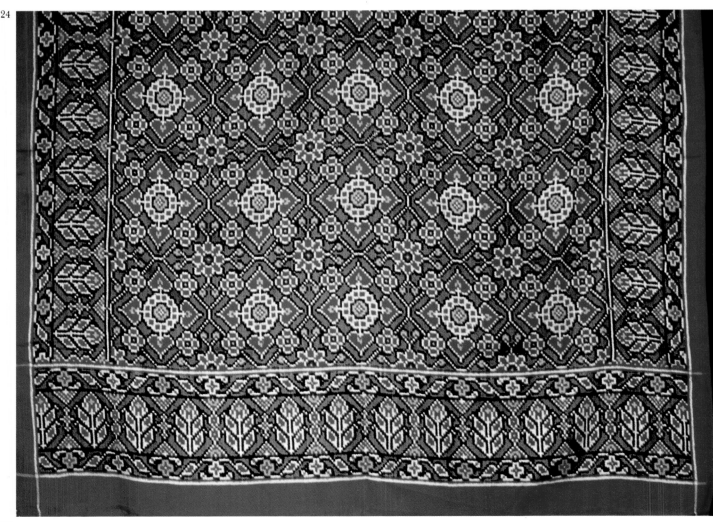

30

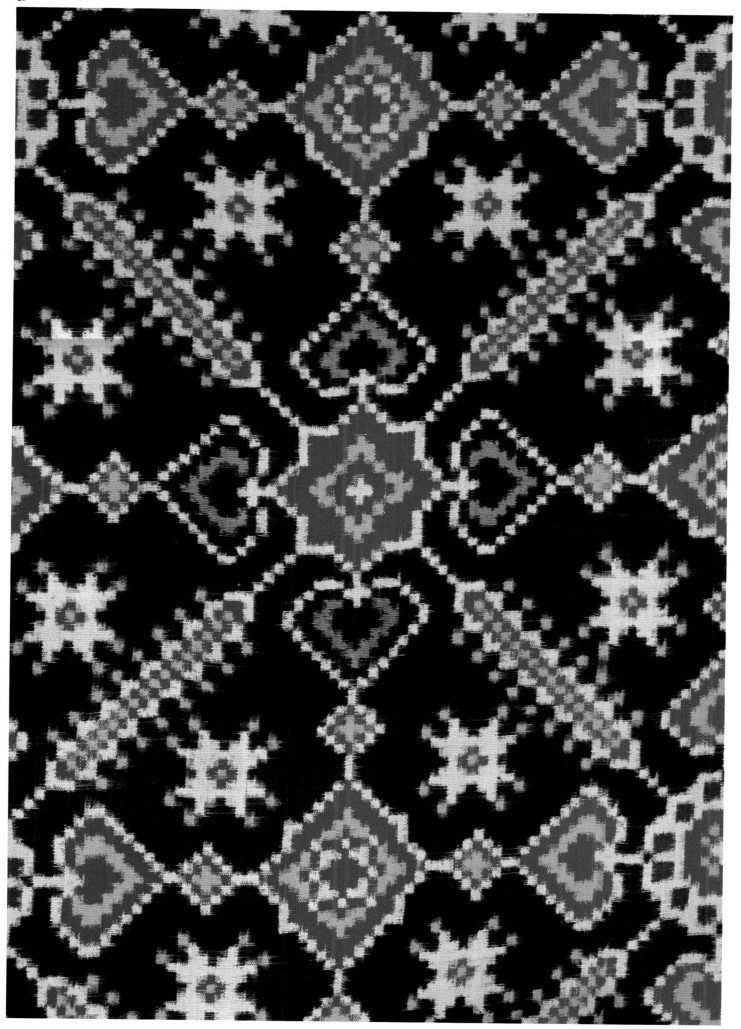

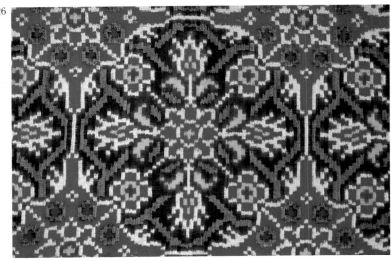

27

26
Chaabdi Bhat Motif,
Silk, Patolu, double ikat
Collection of
Sulochanaben Patolawalla,
Bombay

27
Section of Chaabdi Bhat
Sari, silk patolu,
Double ikat,
Woven by
Chotalal Salvi, Patan

28
Chaabdi Bhat motif,
Silk, patolu, double
ikat, produced by
Kanubhai Patolawalla,
Patan

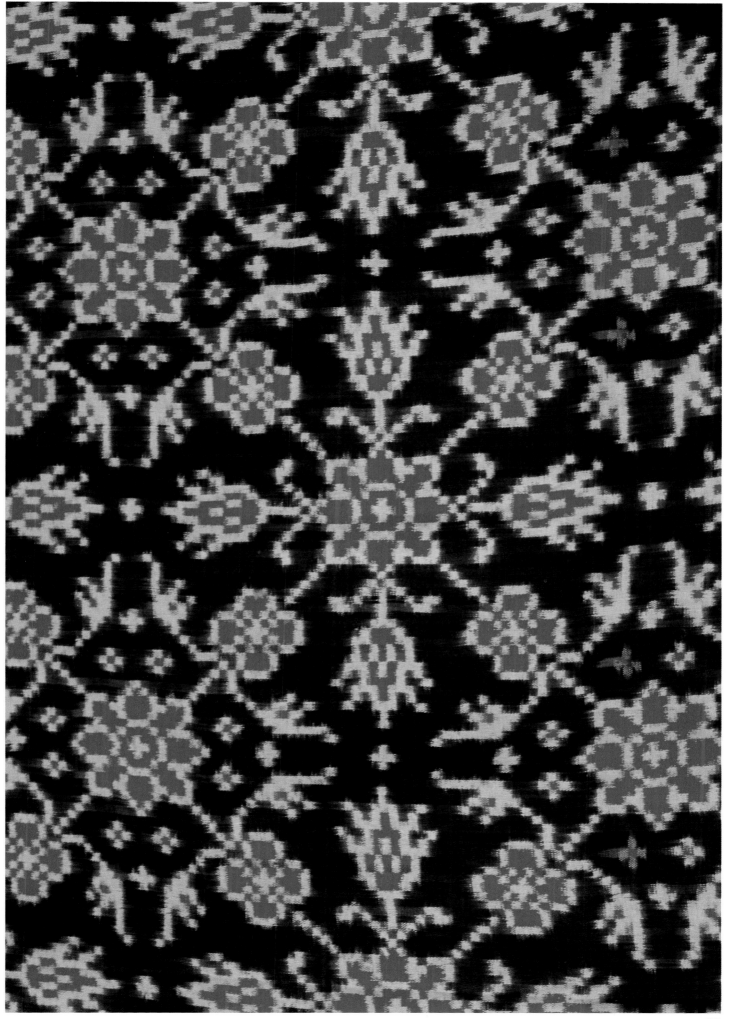

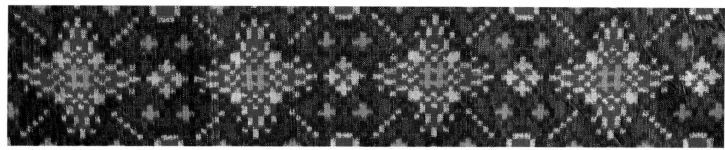

29 - 30
Sections of
Taralia Bhat Motifs,
Silk, double ikat patola
Collection of
Mrs. S.M.Shah,
Bombay

31-32
Sections of
Taralia Bhat saris,
Silk, patola,
Double ikat,
Collection of
Sulochanaben Patolawalla,
Bombay

30

31

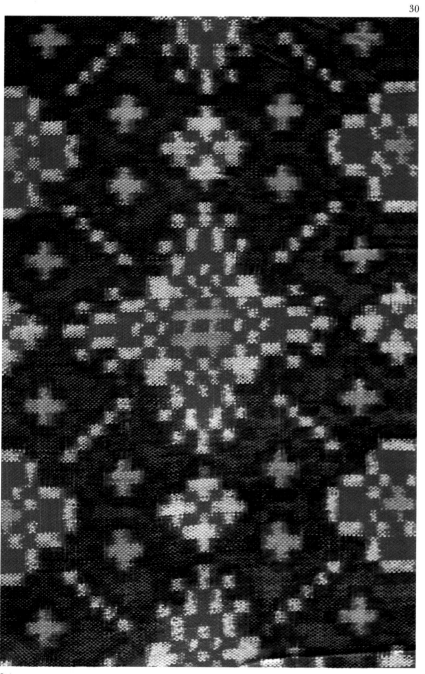

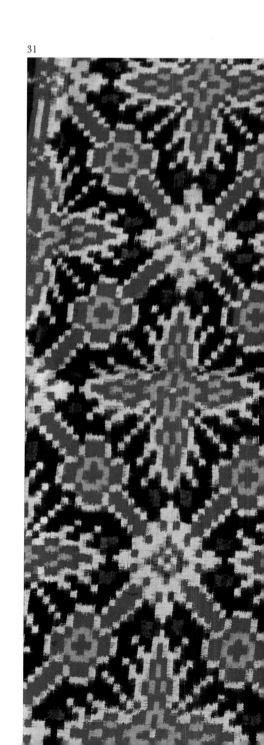

32

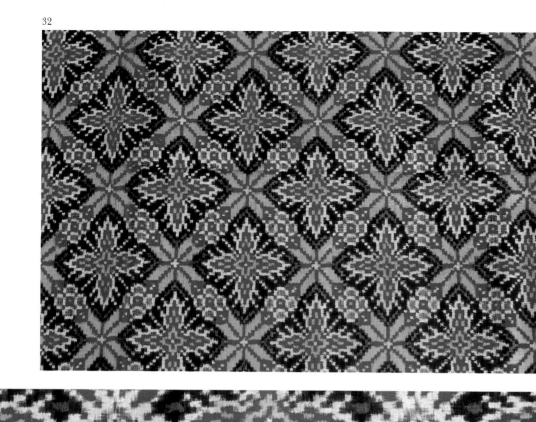

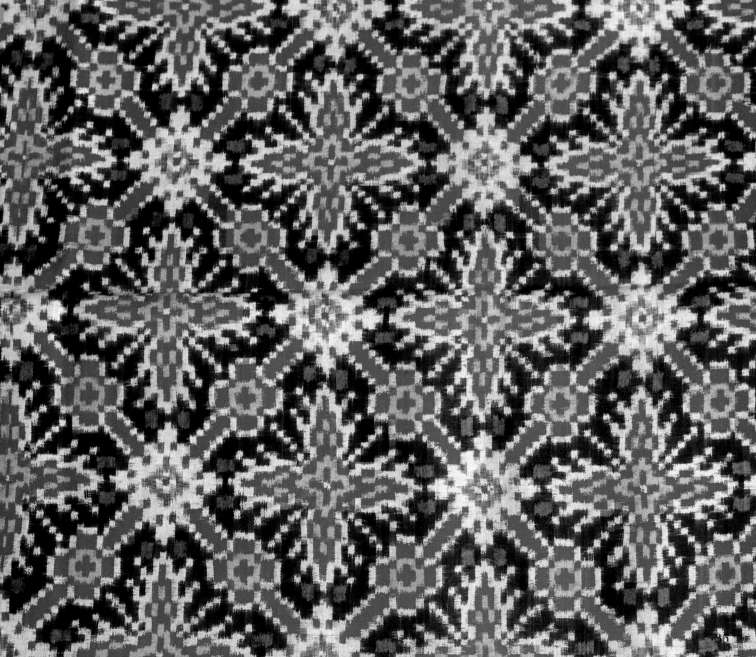

35

33

34

33
Detail of border
with swastika symbol,
silk, Single ikat border,
Collection of
Chotalal Salvi, Patan

34
Section of
Pallav of patolu
Sari, silk,
Double ikat,
Collection of Vasumati
Parekh,
Bombay

35
Section of
Dado Bhat, sari
Silk, double ikat,
Collection of
Tarlaben Morakhia,
Bombay

35

36
Detail of Patolu
Sari, silk,
double ikat,
Collection of
Chotalal Salvi, Patan

37
Patolu sari border,
Silk, double ikat.
Notice the front
and reverse side
of the ikat fabric
is identical.
Collection of Tarlaben
Morakhia,
Bombay

36
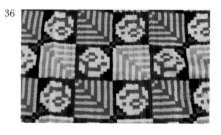

37
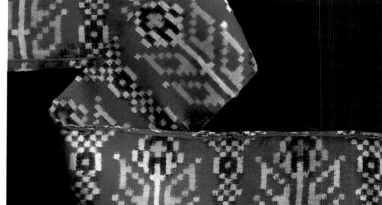

38
Section of
'Chaupar' cloth, cotton,
with the inscription:
'Salvi Manilal' in
Gujarati script.
Double ikat,
Collection of
Chotalal Salvi, Patan

39
Section of
Ratan Chowk Bhat,
Silk patolu, double
ikat, Collection of
Chotalal Salvi,
Patan

39

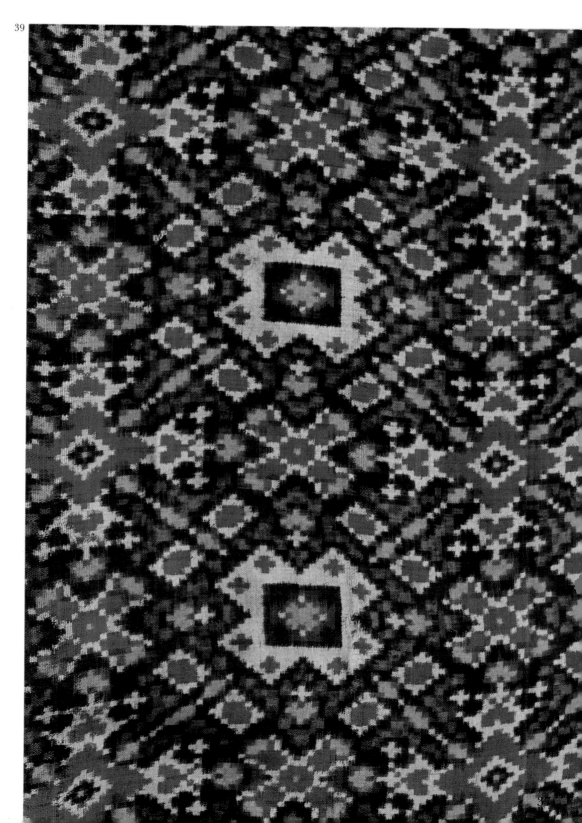

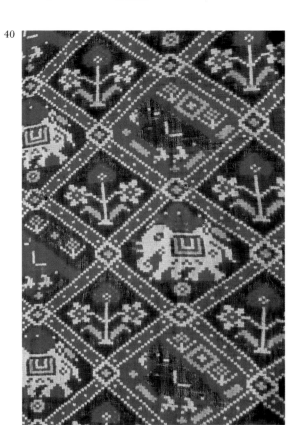

40

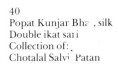

40
Popat Kunjar Bha , silk
Double ikat sari
Collection of:
Chotalal Salvi Patan

41
Popat Kunjar Bhat, silk
Detail of patolu sari
Double ikat,
Woven by:
Kanubhai Patolawalla,
Patan.

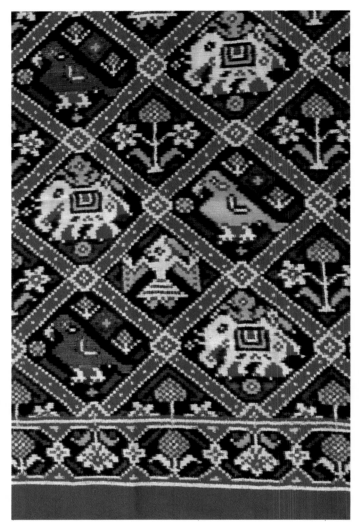

41

42
Kunjar Bhat, silk
Detail of patolu sari
Double ikat,
Pochampalli.
Collection of:
Savitaben Amin, Baroda

43
Popat Kunjar Bhat, silk
Double ikat sari,
Woven by :
Kanubhai Patolawalla,
Patan

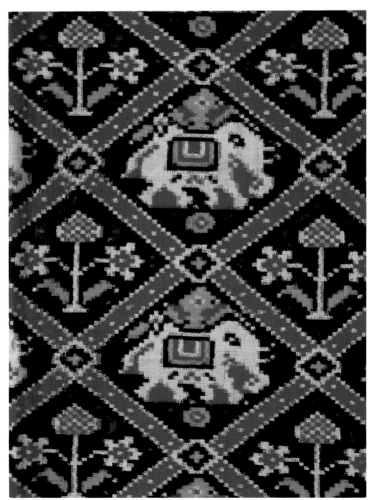

42

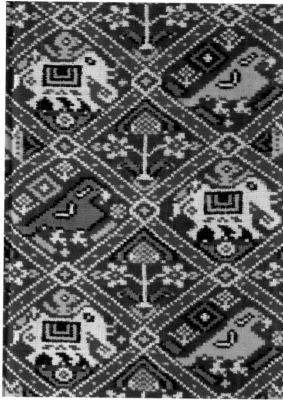

44
Popat Kunjar Bhat, silk
Detail of patolu, sari
Double ikat,
Woven by :
Kanubhai Patolawalla,
Patan

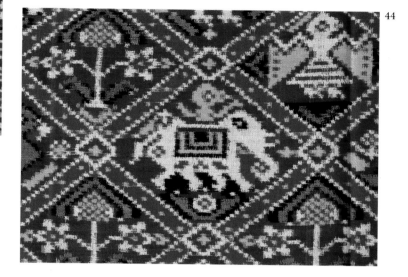

44

45
Nari Kunjar Bhat
Patolu sari, silk
Double ikat,
Collection of :
Ramaben Patel, Bombay

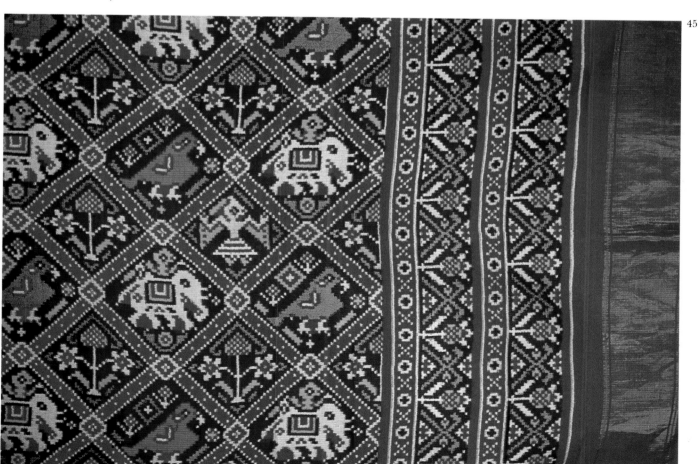

45

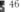

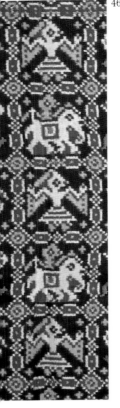

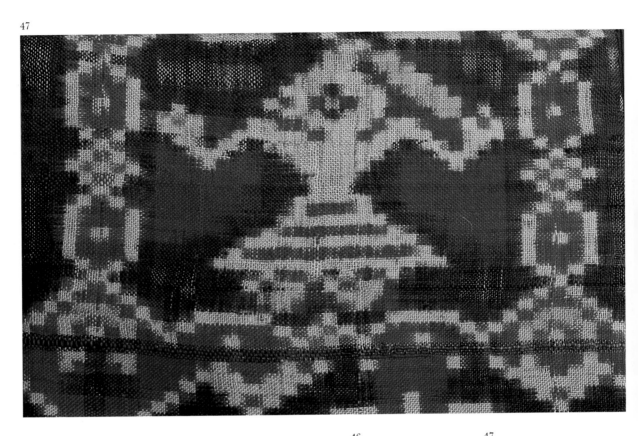

46
Panel from
Nari Kunjar Bhat,
Silk patolu sari,
Double ikat,
Collection of
Jyotsnaben Sheth,
Bombay

47
Detail of 'Nari' motif,
Silk, double ikat
Collection of
Chotalal Salvi, Patan

48
Section of
Nari Kunjar Bhat,
Silk, patolu sari,
Double ikat,
Collection of
Smitaben Ambani,
Bombay

49
Popat motif, silk,
double ikat border,
Collection of
Mrs. S.M.Shah, Bombay

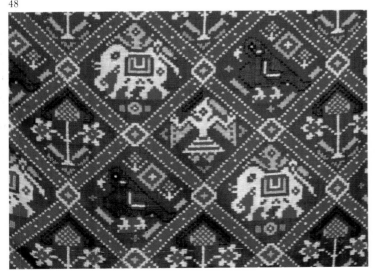

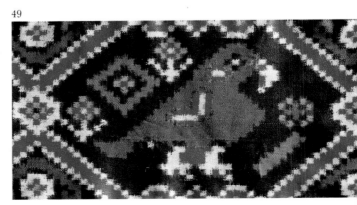

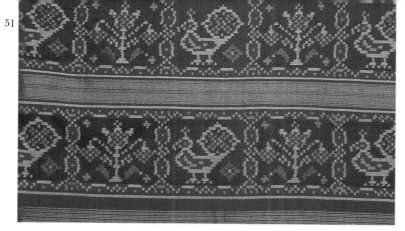

51

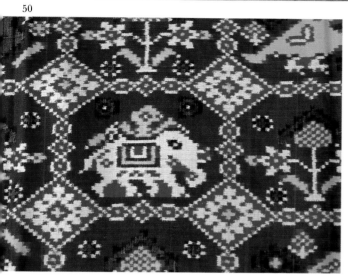

50

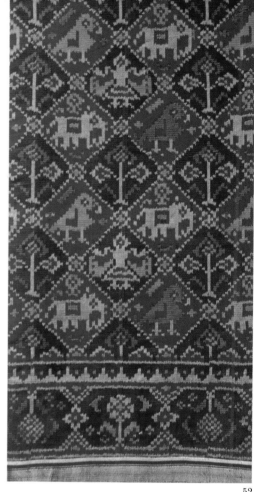

50
Detail from
Nari Kunjar Bhat,
Silk, double ikat,
Anonymous Collector

51
Pallav of sari,
Silk, single ikat
Collection of
Savitaben Amin, Baroda

52
Nari Kunjar Bhat
from Rajkot, silk,
Single ikat patolu,
Collection of
Shobhna Bhagat,
Bombay

52

53
Mor Patangyu Bhat,
Silk patolu, double
ikat sari Collection of
Mrs. S.M.Shah, Bombay

54
Nari motif, silk,
Patolu border,
Double ikat,
Collection of
Mrs. S.M.Shah, Bombay

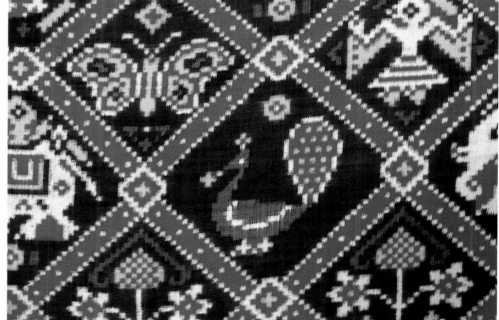

53

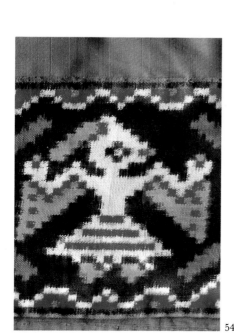

54

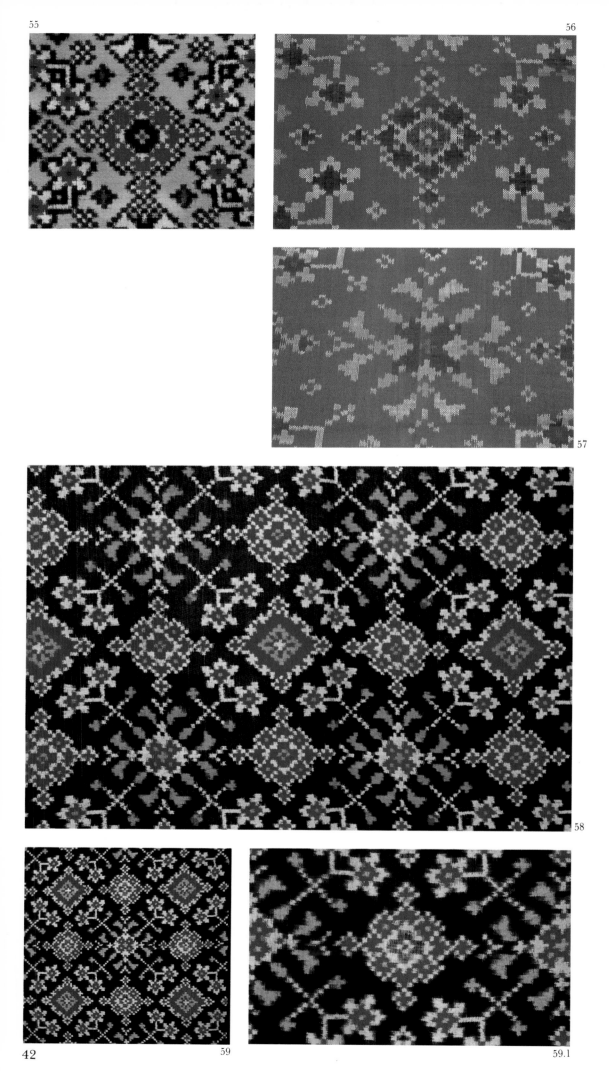

55

56

57

58

42 59

59.1

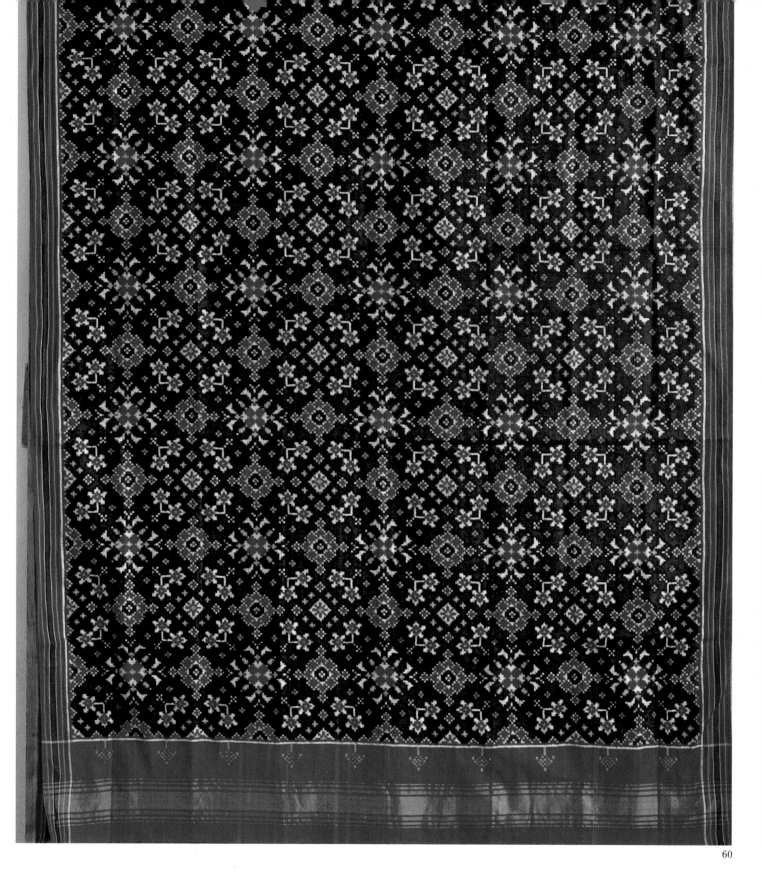

60

55
Navratna motif,
Detail from patolu
Sari, silk, Double ikat
Collection of
Mrs. Kapasi, Bombay

56, 57
Navratna motifs,
from silk
patola, double ikat,
Collection of
Chotalal Salvi,
Patan

58
Dadham Bhat,
(another name given
to the Navratna motif)
Section of silk patolu
Sari, double ikat
Woven by
Kanubhai Patolawalla,
Patan

59, 59.1
Motifs from
Dadham Bhat sari,
Silk, double ikat,
Collection of
Sulochanaben Patolawalla,
Bombay

60
Navratna Bhat Sari,
Silk patolu, double ikat,
Woven by
Chotalal Salvi, Patan

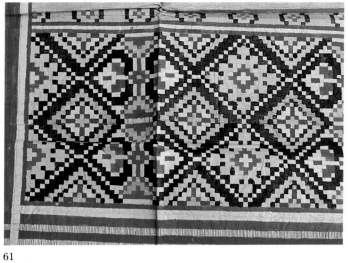

61

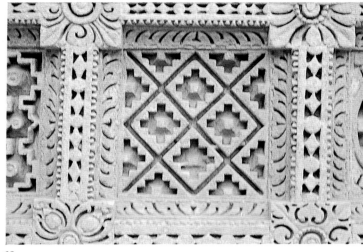

62

61
Ghar Bandhi Ful,
Design for patolu on
graph paper
Patan
Collection of:
Chotalal Salvi

62
Detail of wall panel,
Stone, 10th century
step well, Patan

63
Lehria Bhat, silk
Single ikat patolu
Collection of:
Mrs.Kapasi, Bombay

63

44

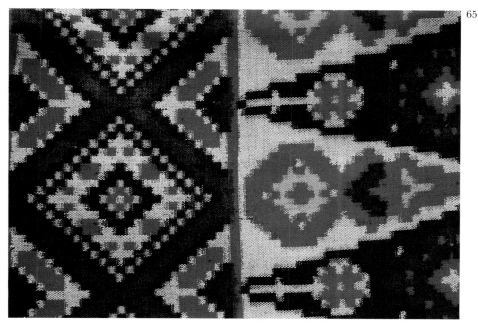

64

Ghar Bandhi Ful, silk,
Single ikat from Rajkot
Collection of:
Ramaben Patel, Bombay

65

Ghar Bandhi Ful, silk,
Double ikat patolu, Patan
Woven by:
Chotalal Salvi

65

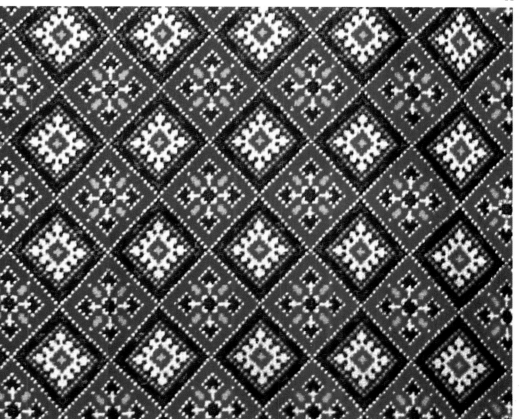

66

Ghar Bandhi Ful, silk
Double ikat patolu,
Collection of:
Ramaben Patel, Bombay

67

Patola sari border
Silk, double ikat,
Collection of:
Ramaben Patel,
Bombay

66

67

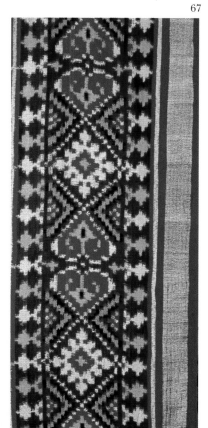

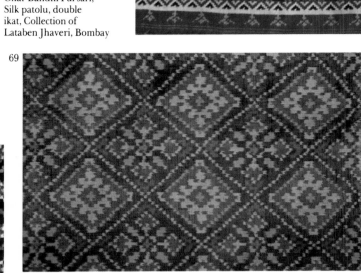

68

72
Section of Galo sari
Silk, doube ikat,
Collection of
Vasumati Parekh, Bombay

73
Section of
Ghar Bandhi Ful sari,
Silk patolu, double
ikat, Collection of
Lataben Jhaveri, Bombay

68
Section of Galo Bhat
Pallav, silk, double ikat,
Collection of
Lataben Jhaveri, Bombay

69
Section of
Ghar Bandhi Ful, silk
Sari, single ikat patolu,
Collection of
Mrs Kapasi,
Bombay

70
Detail of Dado Bhat
Motif, Silk sari,
Double ikat patolu,
Collection of
Ramaben Patel, Bombay

71
Section of Dado Bhat
Sari, silk, double ikat
Collection of
Lataben Jhaveri,
Bombay

69

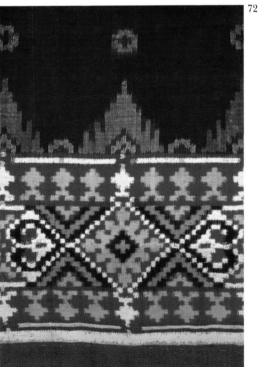

70

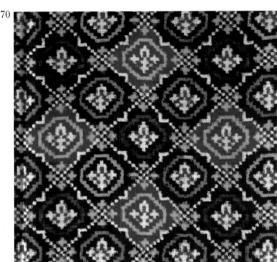

72

71

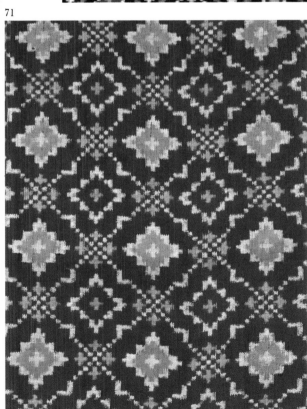

73

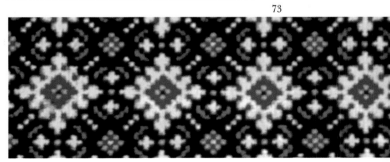

46

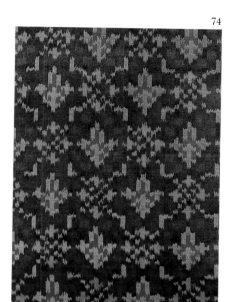

74
Detail from Dado
Bhat sari, silk
Patolu, single ikat,
Collection of
Tarlaben Morakhia,
Bombay

75
Section of
Ghar Bandhi Ful
Sari, silk patolu,
Double ikat,
Woven by
Chotalal Salvi,
Patan

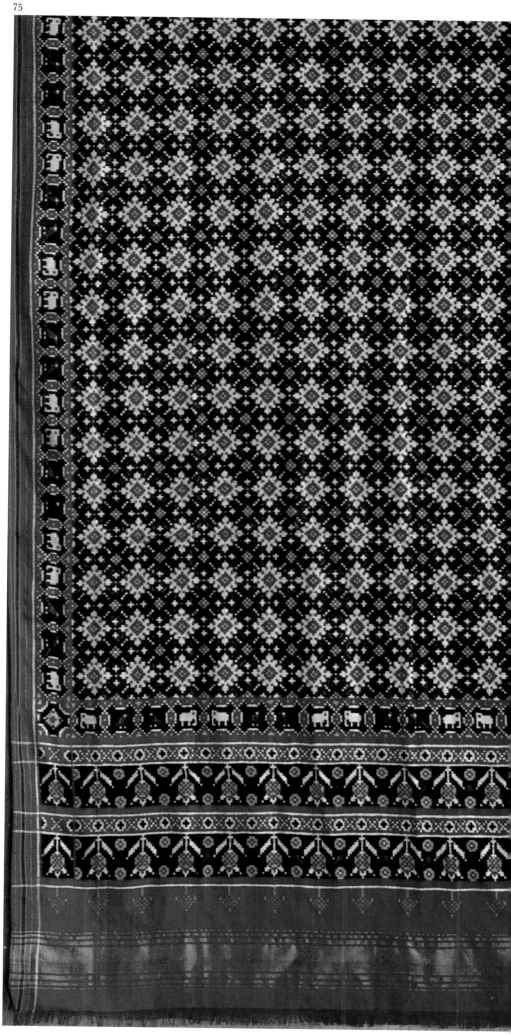

76
Section of the
Warp after completion
of tying and dyeing,
ready to be
woven. Silk yarn,
In the workshop of
Chotalal Salvi, Patan

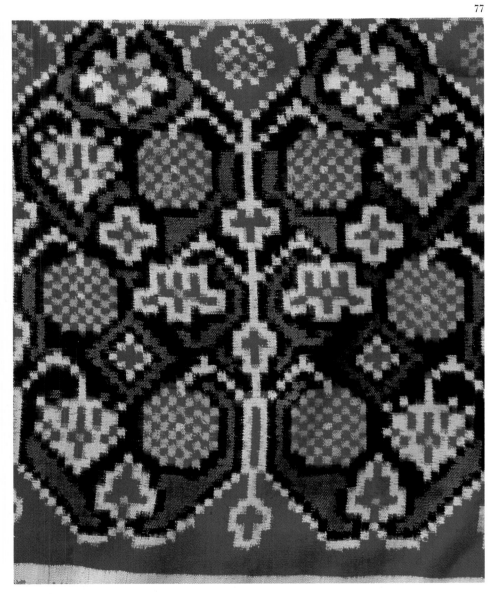

77
Plant motif from
Patolu pallav, silk,
Double ikat,
Collection of
Chawla Patel,
Ahmedabad

78
Section of floral
border, silk,
Double ikat,
Collection of
Maya Desai,
Bombay

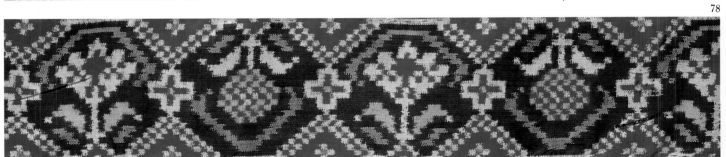

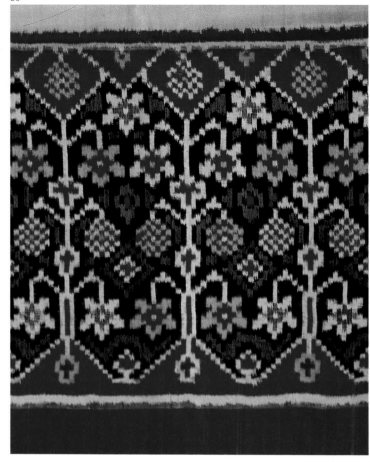

79

79
Motif from
Raas Bhat sari,
Silk, double ikat,
Collection of
Kanubhai Patolawalla
Patan and Baroda

80
Detail of Floral
Panel from patolu
Sari, silk,
double ikat,
Collection of
Sulochanaben Patolawalla,
Bombay

81
Galo Bhat pallav,
Silk sari,
Double ikat patolu,
Collection of
Ramaben Patel, Bombay

81

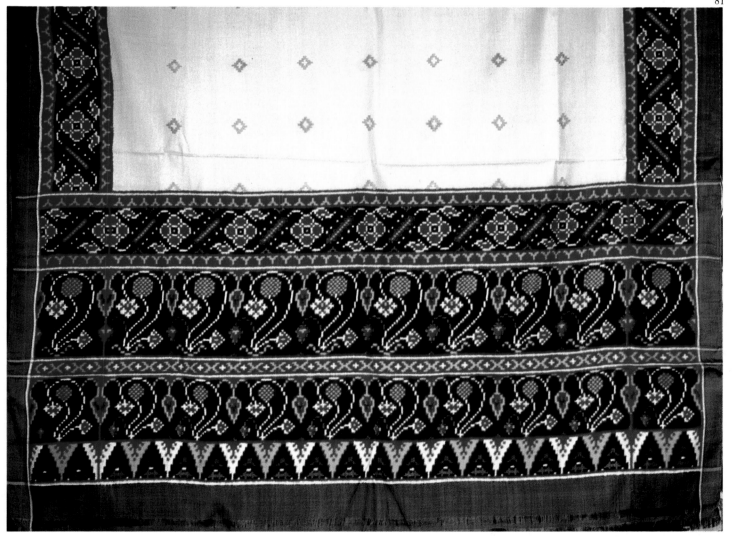

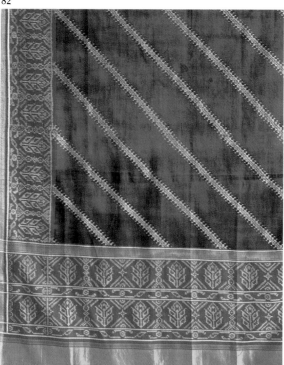

82

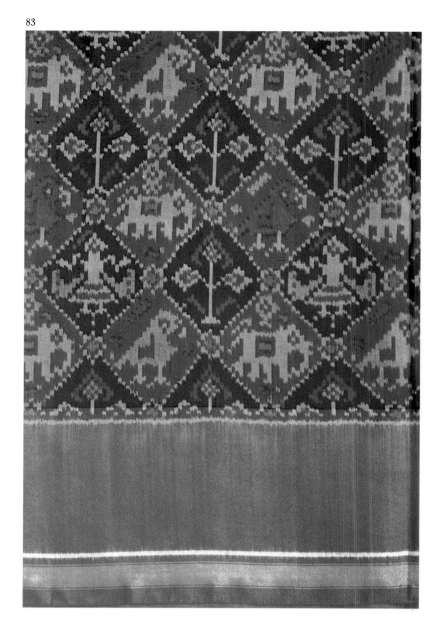

83

82
Section of Lehria Bhat
Sari, silk, single ikat
Collection of
Maya Desai, Bombay

83
Section of Nari Kunjar
Sari from Rajkot, silk,
Single ikat
Collection of
Mrs Kapasi, Bombay

84
Section of Pallav,
Silk, single ikat sari,
Collection of
Savitaben Amin, Baroda

85
Detail of patolu sari
border with fish motif,
Collection of Kanubhai
Patolawala,
Patan

86
Section of
Lehria Bhat sari,
Silk, Single ikat
Collection of
Savitaben Amin, Baroda

84

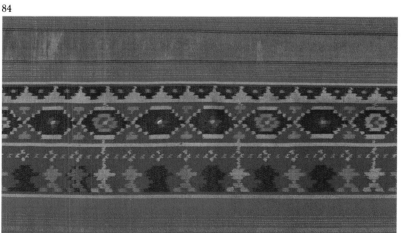

85

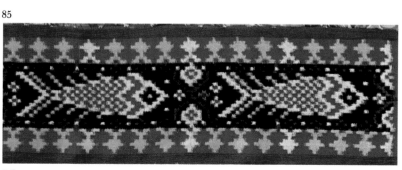

86

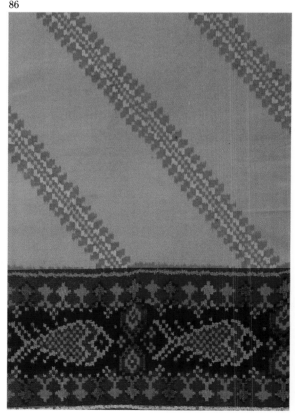

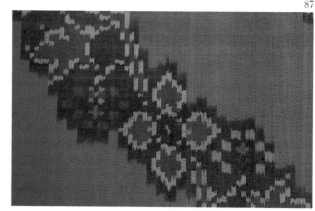

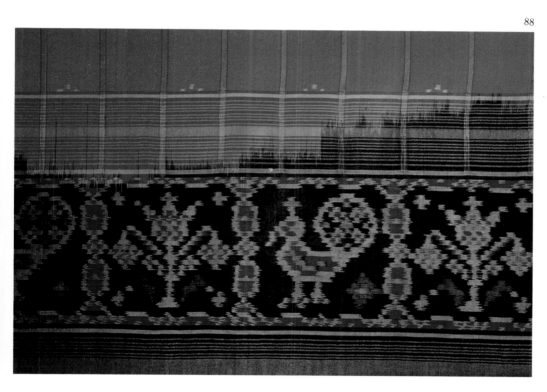

88

87
Flower motif from
Rajkot patolu, silk,
Single ikat,
Collection of
Niruben Tanna, Bombay

88
Section of sari, Silk patolu
from
Rajkot, Single ikat,
Collection of
Mrs Kapasi,
Bombay

89
Section of
Lehria Bhat sari, silk,
Single ikat patolu,
Collection of
Viraj Divecha Bombay

90
Motif from sari border,
silk, single ikat,
Collection of
Niruben Tanna, Bombay

89

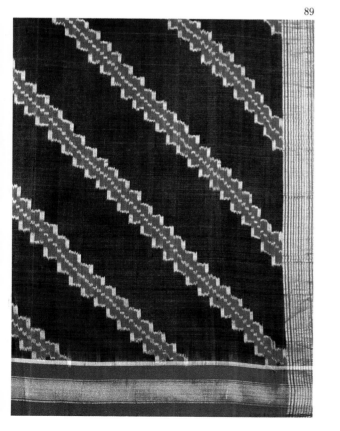

90

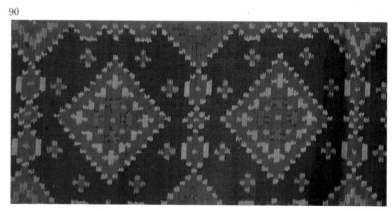

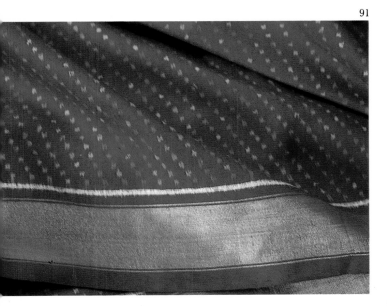

91

92

93

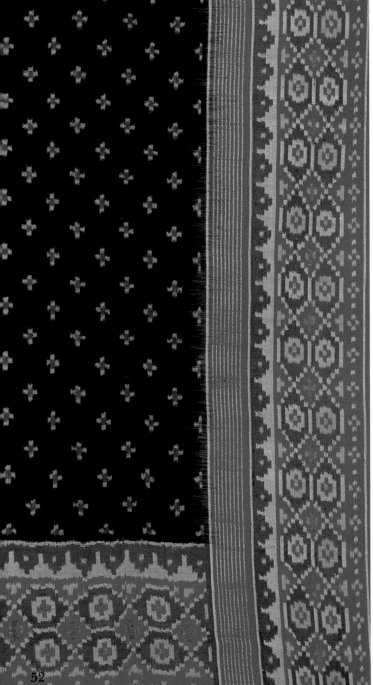

91, 92, 93, 96, 97, 98
Sections from Rajkot
Patola, silk, Single ikat,
Collection of
Niruben Tanna, Bombay

94, 95
Section of Rajkot
Patolu, silk,
single ikat,
Collection of
Jyoti Sheth, Bombay

52

94

95

96

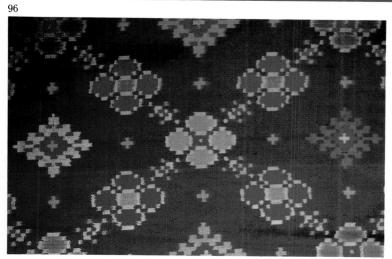

97

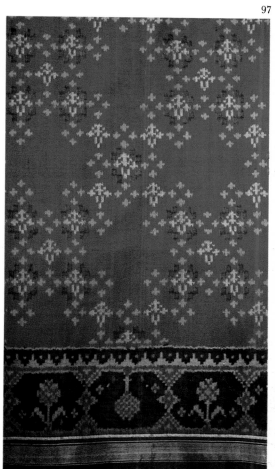

98

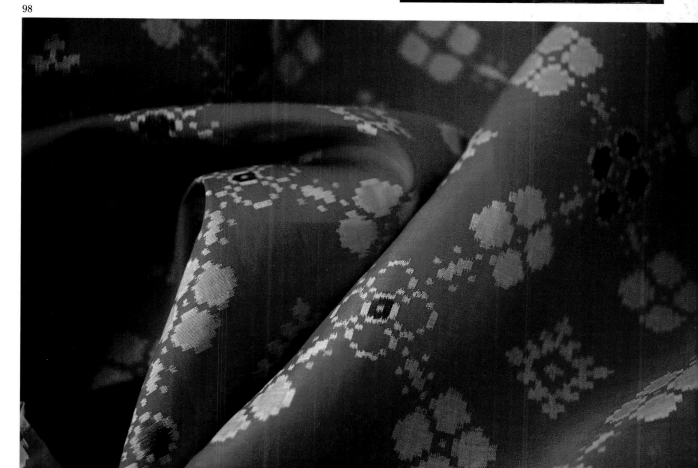

99
Section of
Lehria Bhat Sari,
Silk, Double ikat patolu,
Woven by
Chotalal Salvi, Patan

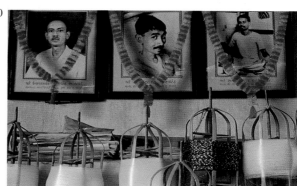

100
Photographs of ancestors
of the Salvi family,
Spindles with silk yarn
are seen in the fore
ground.
Workshop of the
Salvi family, Patan

101

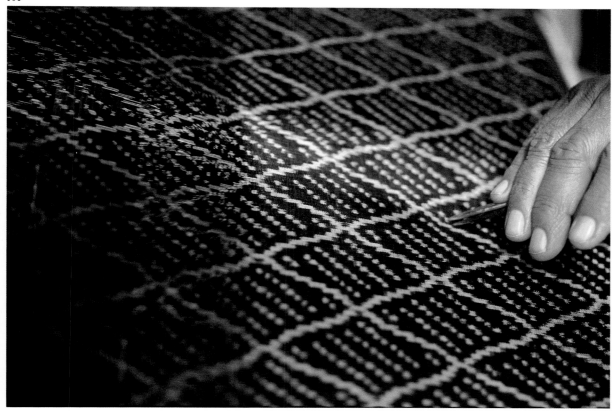

101
A patolu being woven,
Silk, double ikat,
Workshop of
Chotalal Salvi, Patan
102
Section of
Double ikat sari, silk,
Woven by
Chotalal Salvi, Patan

102

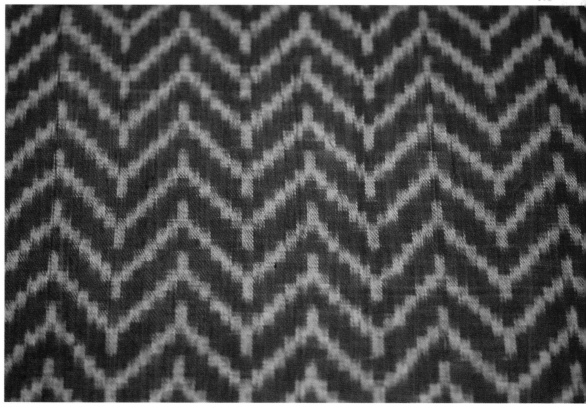

IKAT MASHRU TEXTILES

A glazed satin texture punctuated with vibrant multi-coloured stripes is the most distinctive feature of ikat mashru textiles.

Mashru textiles are usually grouped under 'mixed' fabrics. This is so primarily because they are composed of both silk and cotton yarn. Although they appear like silk fabrics, in actual fact they are semi-silk fabrics. To simulate this silken effect, they are woven in satin weave, whereby the silk warp covers most of the surface area, while the cotton weft lies on the under side.

Ikat mashru textiles are the only group of Indian ikat textiles in which figurative forms are never present. The strongest visual element is invariably the stripe, which is used in varied widths and colours to create new rythms and visual effects.

Chevrons[1] and diagonal patterns resulting from an ingenious variation in the ikat technique are also characteristic of ikat mashru textiles. In this process, the warp which contains dyed pattern areas in the form of blocks, is first stretched taut. Sections or parts of these blocks are then pulled to create new forms such as chevrons (or arrowheads) and diagonals.

The addition of plain and sometimes brocade warp bands along with 'pulled' ikat forms enriches the otherwise simple linear patterns. In another variation called 'khanjari',[2] wave-like formations are created in such a way so as to form horizontal (left to right) pattern repeats. This requires a high degree of skill, as it is the vertical warp which is pulled to create horizontal wave-like patterns. The value of such a mashru, depends on the number of 'khanjaris' or waves per unit.

Like most traditional fabrics, ikat mashru designs correspond to the needs of specific communities. The gradual breaking of traditional dress codes and the opening up of urban consumer markets have given rise to new ikat-mashru design variations.

1 see page 58 plate 2
2 see page 59 plate 5

Right – Ikat Mashru yardage being woven.

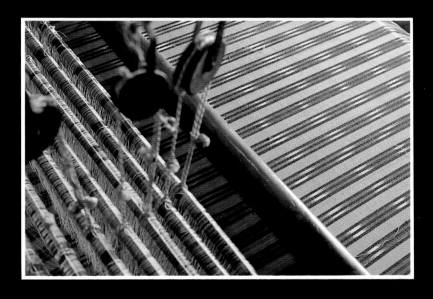

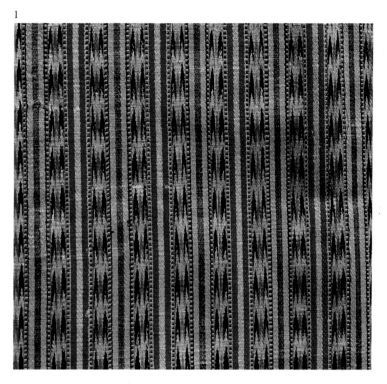

1
Mashru yardage,
Cotton and silk,
Single ikat
Collection of
Weaver's Service Centre,
Ahmedabad

2
Mashru yardage,
Cotton and silk
Chevron design,
Single ikat,
Collection of
Weaver's Service Centre,
Bombay

3
Section of Joth sari,
Extra wrap border
with single ikat, Silk,
Woven in Nagpur,
Maharashtra state,
Collection of
Weaver's Service Centre,
Bombay

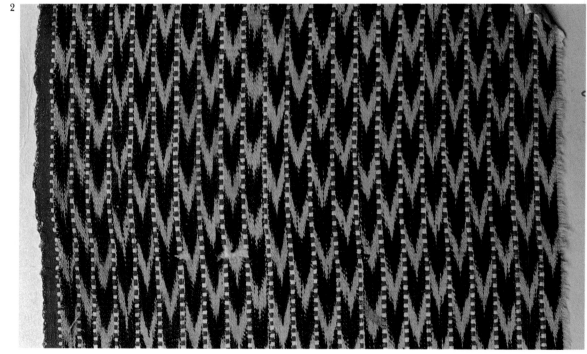

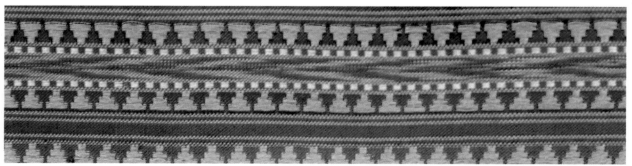

58

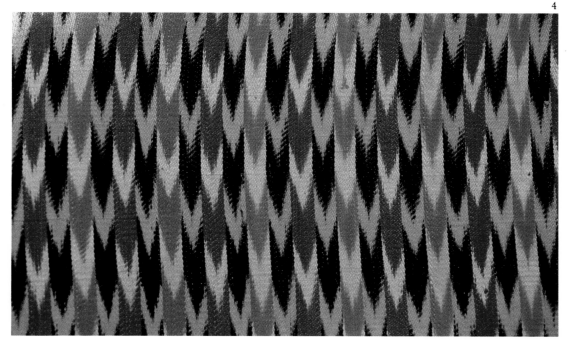

4
Mashru yardage,
Cotton and silk,
Chevron design,
Single ikat,
Collection of
Weaver's Service Centre,
Ahmedabad

5
Mashru Yardage
Cotton and silk
Single ikat,
produced at a
Mashru workshop
in Patan,
Collection of
C.Desai, Bombay

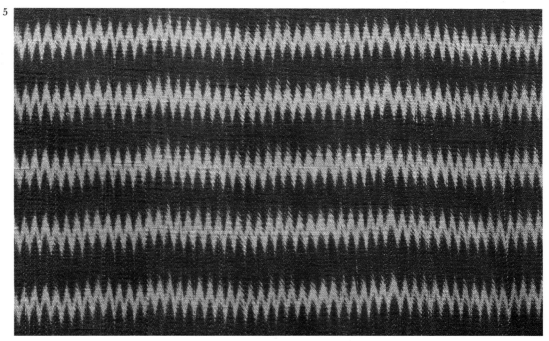

5

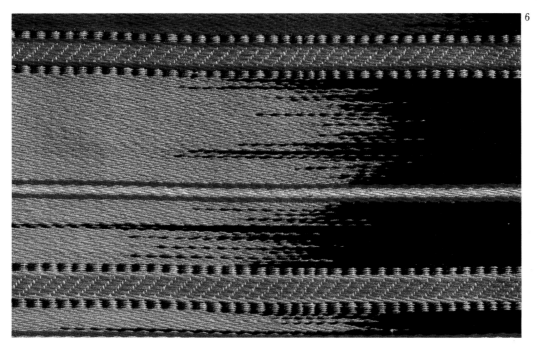

6

6
Detail from mashru
Bed spread,
Cotton and silk,
Single ikat,
Collection of
Weaver's Service Centre,
Ahmedabad

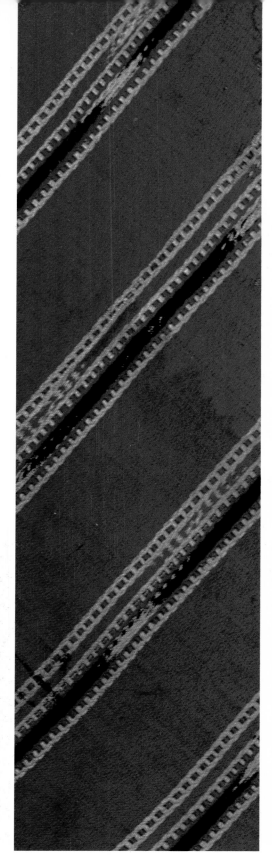

7
Mashru yardage
Cotton and silk,
Lehria design,
Collection of
N.I.D., Ahmedabad

8
Fragment from
Panch Patti Mashru sari,
Cotton & silk, single ikat,
Collection of N.I.D.
Ahmedabad

9
Section of
Mashru ghaghra or skirt,
Cotton and silk,
Single ikat,
Collection of
Krishna Patel,
Ahmedabad

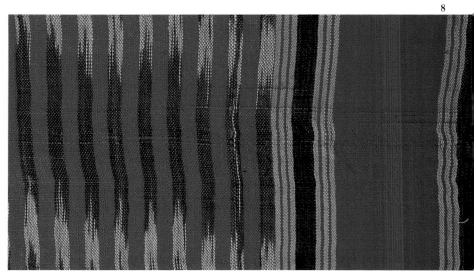

8

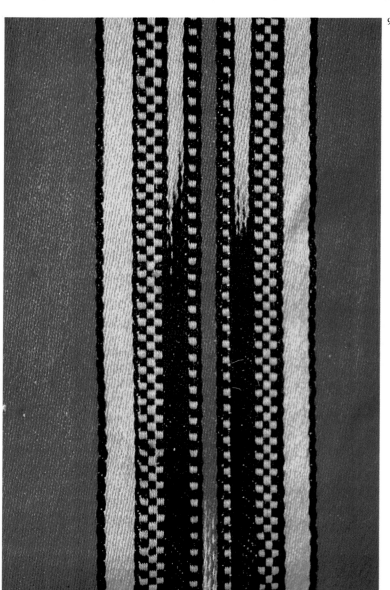

9

7

10
Mashru yardage
Cotton & silk,
Single ikat,
Collection of
Weaver's Service Centre,
Bombay

11
Mashru yardage,
Cotton and silk,
Single ikat,
Collection of
Weaver's Service Centre,
Bombay

10

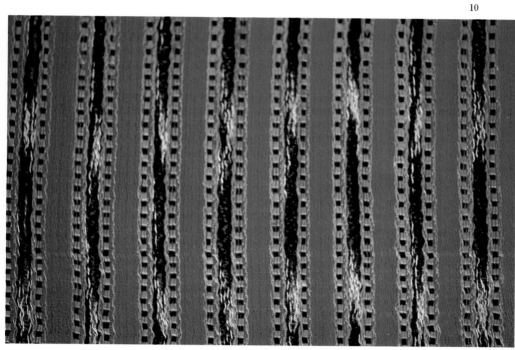

11

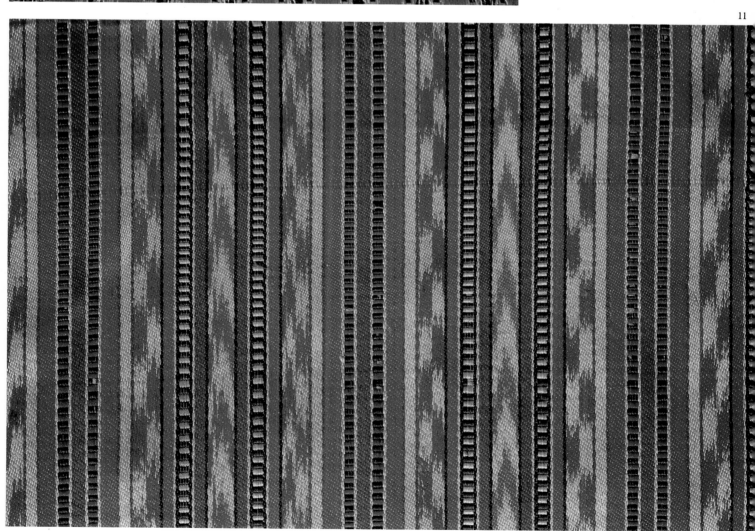

THE BANDHAS OF ORISSA

Ikat fabrics of Orissa, locally known as 'bandhas', have a distinct curvilinear appearance. The fluid, lyrical quality[1] of the ikat forms is invariably juxtaposed with linear brocade bands running along the sari border, end panels and occasionally the centre field. This play of gentle feathered forms with plain or brocade bands gives the bandhas of Orissa their unique identity.

In these textiles, forms are deliberately 'feathered' so that their edges appear hazy and fragile. This effect is achieved by the use of very fine count yarn, tied and dyed in very small sets, which when woven result in the jagged yet gentle curves so characteristic of bandha textiles.

The design vocabulary of these fabrics is wide and varied. With the exception of the 'saktapar'[2] sari in which block forms in double ikat predominate most bandhas consist of floral, figurative or geometrical patterns in single ikat.

The most striking section of a bandha is usually the ornate *'anchal'*[3] or end panel of a sari. There are numerous variations based on the classic 'Bichitrapuri anchal', which is composed of rows of floral and figurative forms, separated by fine stripes or brocade bands. Originally, bandha saris had two ornate anchals because both ends were exposed when draped in the traditional manner. The main field in contrast was more or less plain[4]. It is in the later 'saktapar' sari that this structure has been broken. In recent years, grid based designs[5] and linear pattern repeats[6] dominate the entire main field.

While numerous combinations based on traditional colours and motifs continue to be produced, other directions have also emerged. Designs inspired by various sources such as architecture,[7] mythology and religion,[8] painting,[9] folk art[10] and other textiles[11] have been interpreted in the ikat technique.

Apart from saris woven in cotton and silk, weavers have begun to diversify their product range. Today, yardage, furnishing-material, table and bed linen are some of the new products, woven for urban markets.

1 see back cover
2 see 69 page plate 14
3 see page 69 plate 15
4 see page 65 plate 3
5 see page 80 plate51

6 see page 92 plate 99
7 see page 83 plate58
8 see page 72 plate 23
9 see page 84 plate 67
10 see page 74 plate 31

Right – Detail of a fish motif

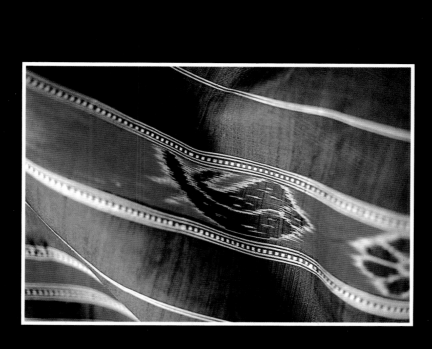

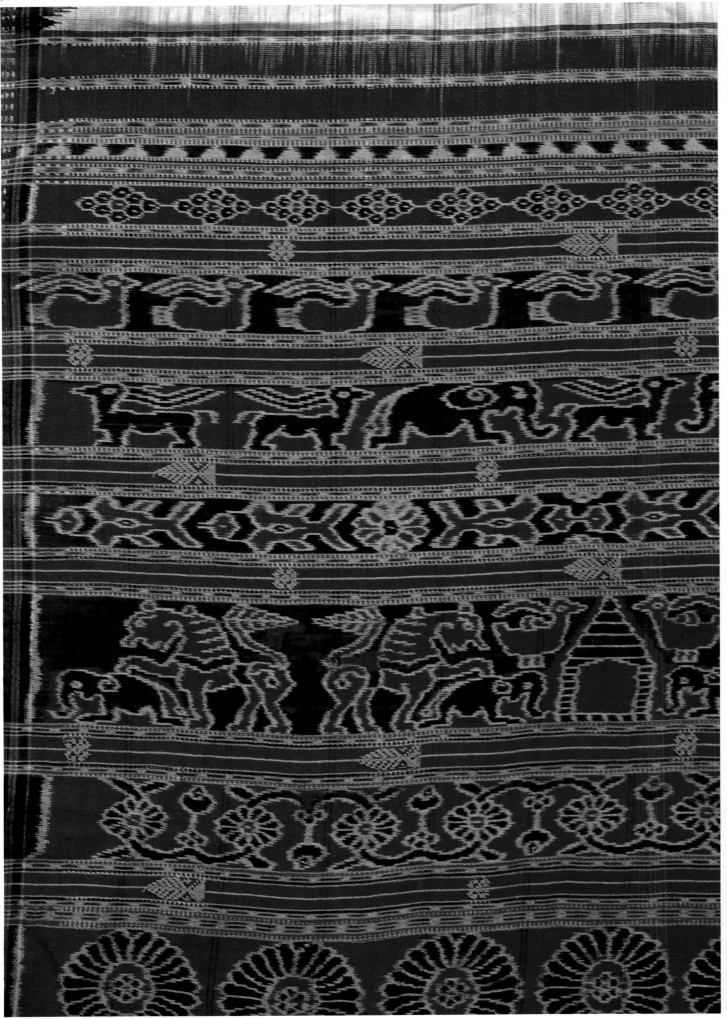

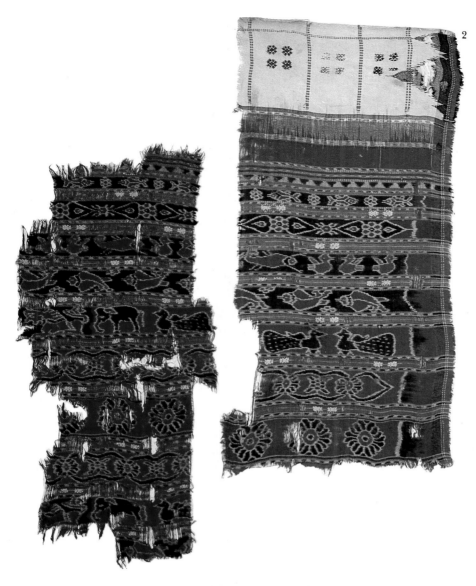

1
Anchal / end piece of
Kumbha Butta sari, domui
Cotton, ikat
Collection of:
Kailashchandra Meher,
Bhubaneshwar

2
Anchal fragments from
Kumbha butta sari, domui
Cotton, ikat
Collection of:
Mohan Meher, Sonepur

3
Butta Kumbha sari,
Tussar silk, ikat
Woven by : Madan Meher
Collection of: Kishanchandra
Meher, Bhubaneshwar

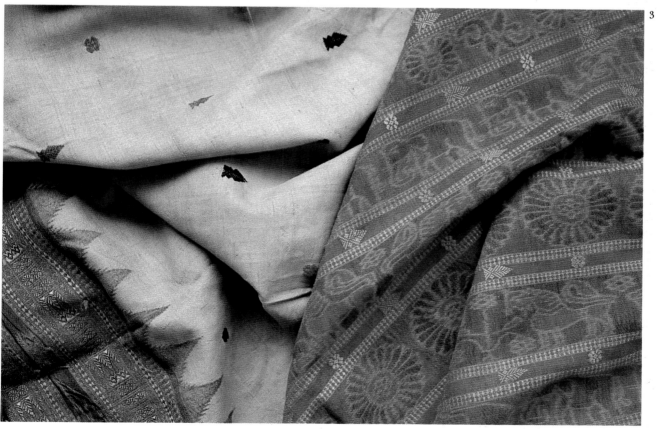

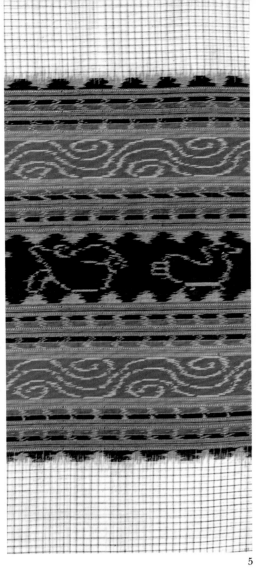

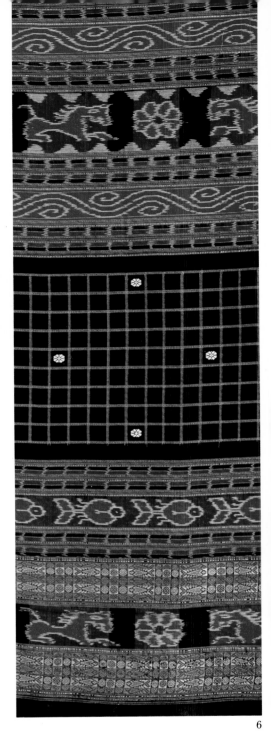

4

5

6

4.1

4, 4.1
Sections of Manipar
saris,
Cotton, ikat,
Produced by
Sambalpuri Bastralaya,
Bargarh

5
Section of a
Patnayakpar sari,
Cotton, ikat,
Produced by
Sambalpuri Bastralaya,
Bargarh

6
Section of a Bichitrapar
Sari, a variation on
the traditional
Bichitrapar
design, Cotton, ikat,
Produced by
Sambalpuri Bastralaya,
Bargarh

7
Section of a
Phulia sari, cotton
ikat,
Produced by
Sambalpuri Bastralaya,
Bargarh

8
Section of a
Bichitrapar domui sari,
Cotton, combined ikat,
Collection of
Mohan Meher, Sonepur

7

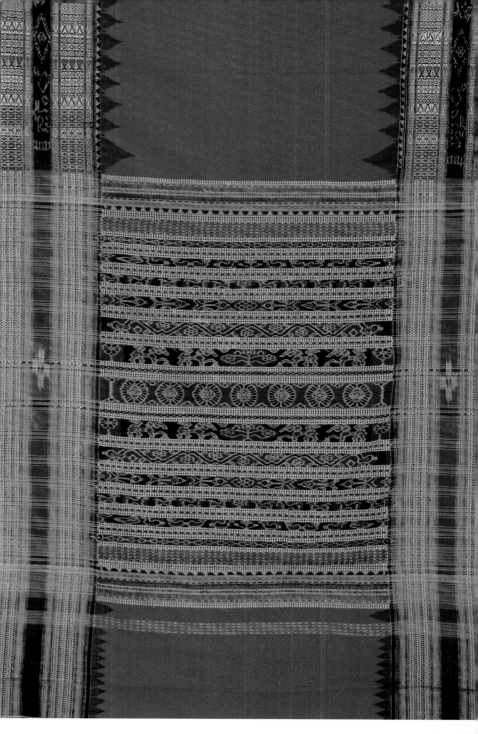

8

9
Detail of a
Bichitrapar Anchal,
tied and dyed,
ready to be woven.
Cotton, weft ikat
Produced at Barpalli

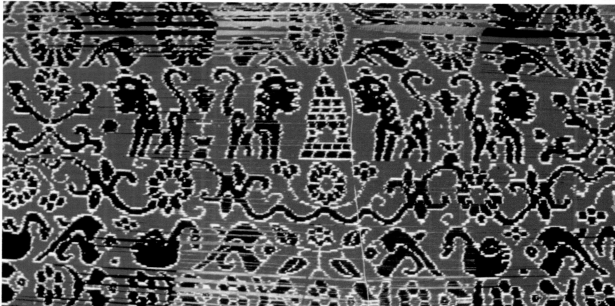

9

10

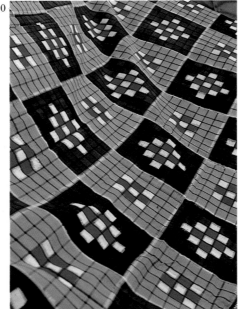

11

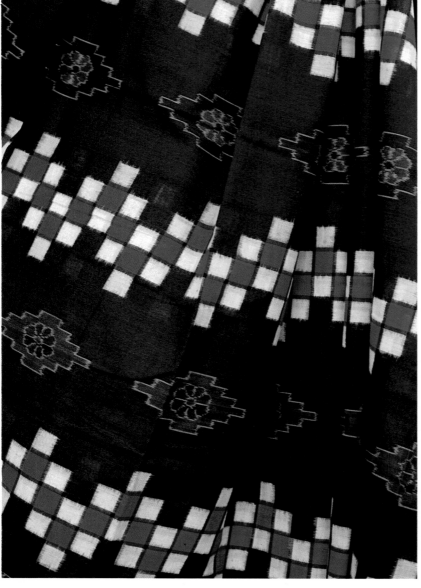

12

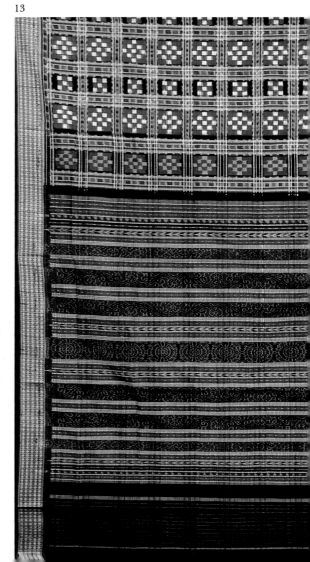

13

10
Detail of a table cloth
based on a Saktapar
design.
Cotton, double ikat,
Produced by
Sambalpuri Bastralaya,
Bargarh

11
Section of a sari,
based on a Saktapar
design,
Cotton, double ikat,
Produced by
Sambalpuri Bastralaya,
Bargarh

12
Section of
Saktapriya sari,
Cotton, double ikat
Produced by
Sambalpuri Bastralaya,
Bargarh

13
Section of a sari,
based on a Saktapar
design, silk
Produced by
Chaturbhuj Meher,
Sonepur

14, 14.1
Section of a
Traditional Saktapar
Sari, cotton
double and combined
ikat, Collection of
Mohan Meher
Sonepur

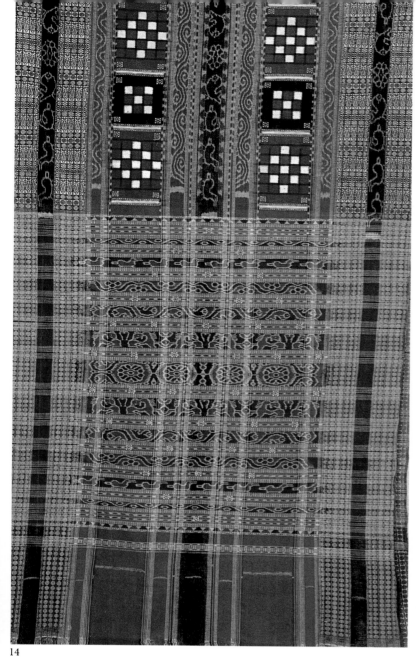

14

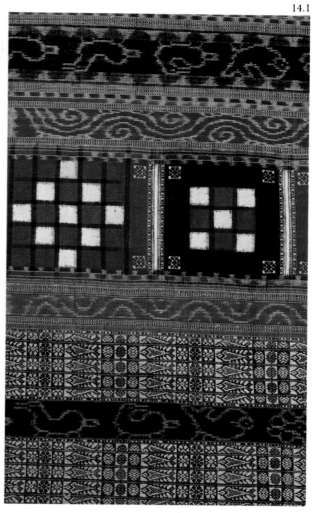

14.1

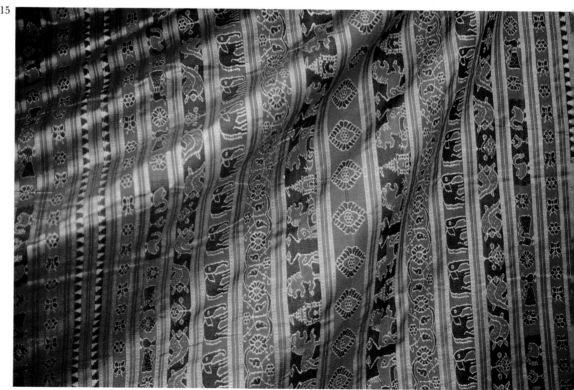

15

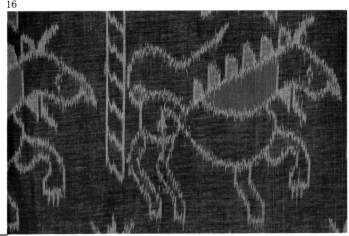

16

16

Horse motif from a
Khandua sari, cotton
Collection of
Ranjan Lakhani,
Bombay

16.1

Horse motif from a
Gajalaxmi sari,
Cotton, single ikat
Produced by
Sambalpuri Bastralaya,
Bargarh

17, 19

Section of a
Khandua sari,
Cotton, single ikat,
Collection of
Ranjan Jhaveri, Bombay

18

A man carrying
dyed yarn
Sambalpuri Bastralaya,
Bargarh

20

View of a temple
in Bhubaneshwar

21

Section of a
Wall hanging
depicting the
Jaganath temple,
at Puri,
Cotton, single ikat,
Woven by
Sudam Guin,
Nuapatna

16.1

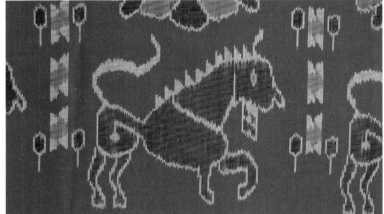

17

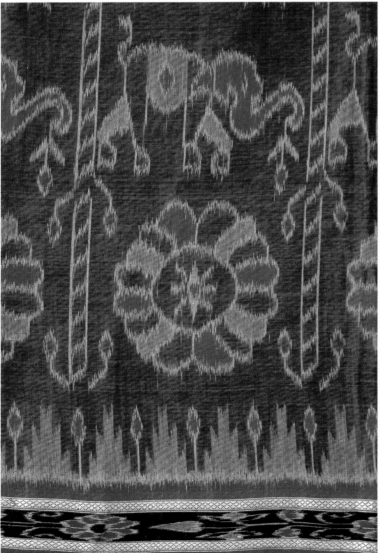

18

19

22
Section of a
Geet Gobind Pheta
being tied.
The script is Oriya.
Silk, single ikat,
Produced by
Sudam Guin,
Nuapatna

22.1
Section of a tied,
dyed and woven
Geet Gobind Pheta.
Silk, single ikat,
Produced by,
Sudam Guin,
Nuapatna

21

20

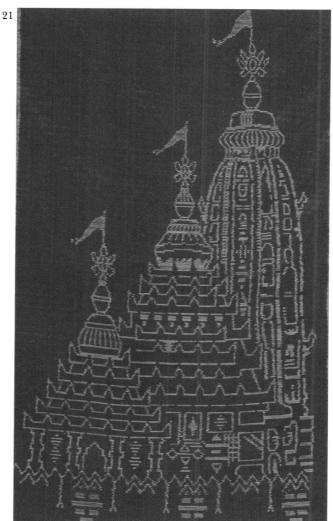

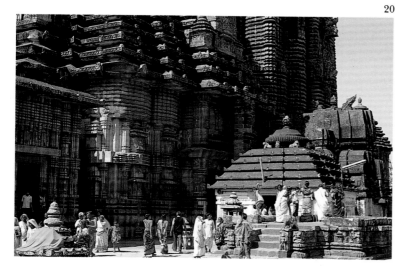

22

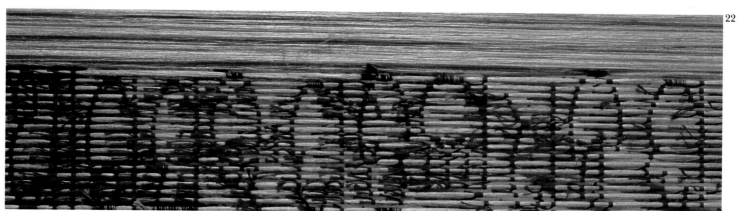

22.1

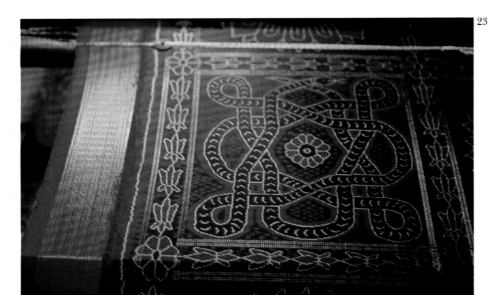

23

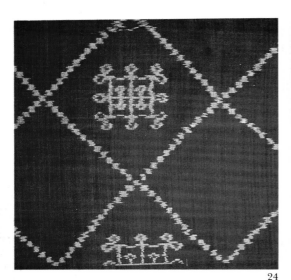

24

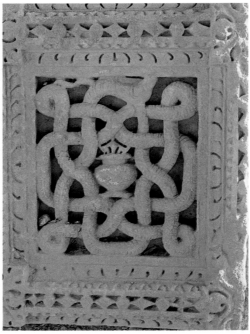

25

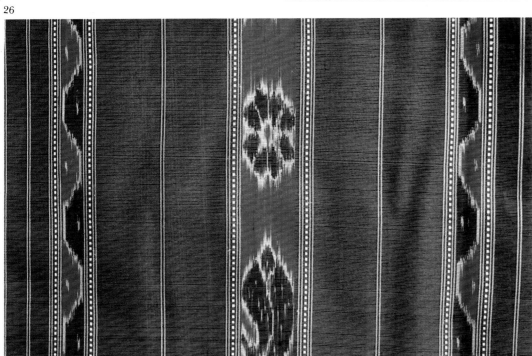

26

23
Section of a
Tantric Sarpa sari
on the loom,
Silk, single ikat,
Produced by
Chaturbhuj Meher,
Sonepur

24
Motif adapted from a
Traditional snake form,
Cotton yardage, single
ikat,
Designed by: Rebanto
Goswami, Collection
of Utkalika,
Bhubaneshwar,
Woven in Nuapatna

25
Detail of a panel,
Coiled serpent,
stone,
found near a
10th century step-well,
Patan, Gujarat

26
Silk yardage,
single ikat with
extra weft bands,
Collection of
Chawla Patel,
Ahmedabad

27, 28
Details from a
Tussar silk sari,
Single ikat,
Designed and
Woven by Mohan
Meher.
Collection of
Weaver's Service Centre,
Bhubaneshwar

29
Section of a
Tussar silk sari,
Single ikat,
designed and woven
by Mohan Meher for
Weaver's Service Centre,
Bhubaneshwar

27

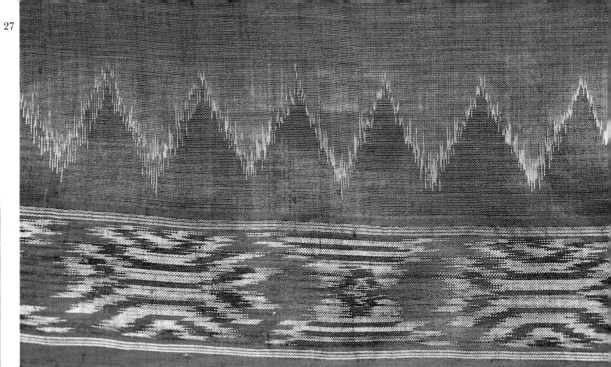

28

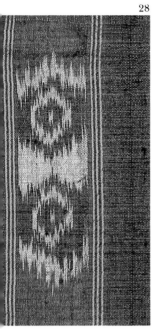

29

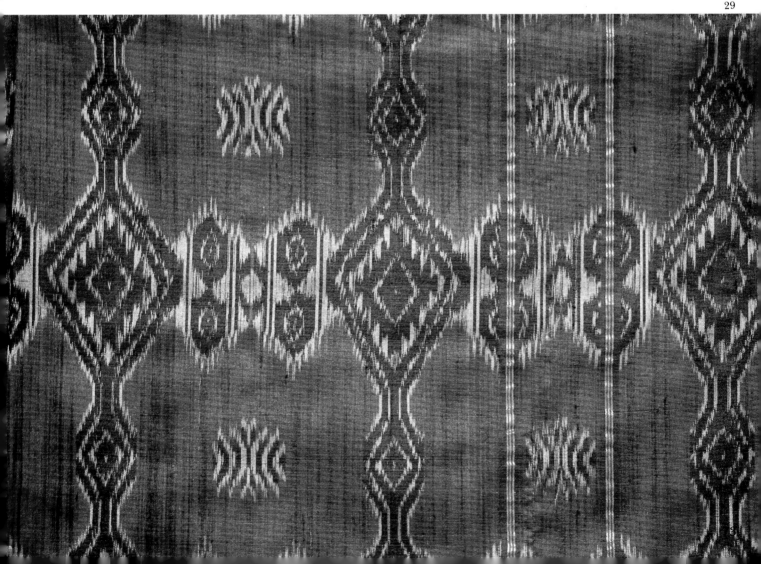

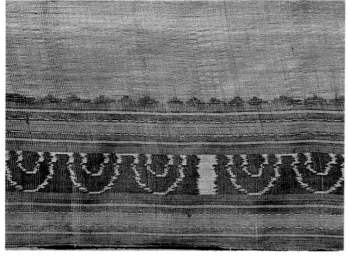

30

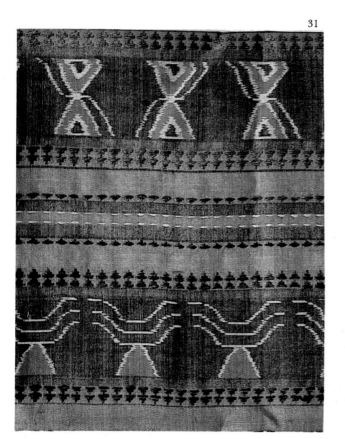

31

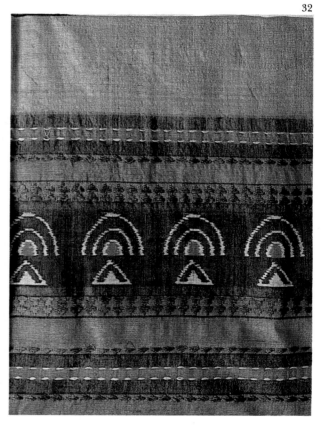

32

30 to 32
Tussar silk sari
based on Jhatti
patterns, single ikat.
Woven by: Harilal
Meher.Collection of:
Rebanto Goswami
Weavers Service Centre
Bhubaneshwar

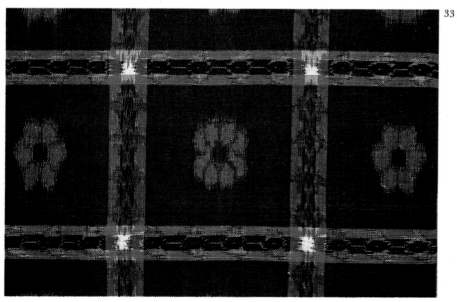

33

33
Detail of bedcover
Mathamani design
Cotton, combined ikat
Collection of:
Weavers Service Centre
Bhubaneshwar

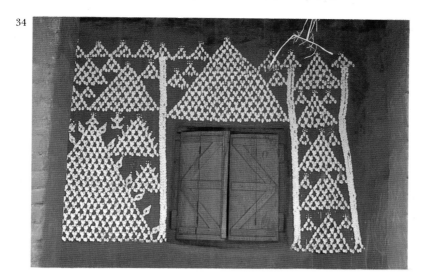

34

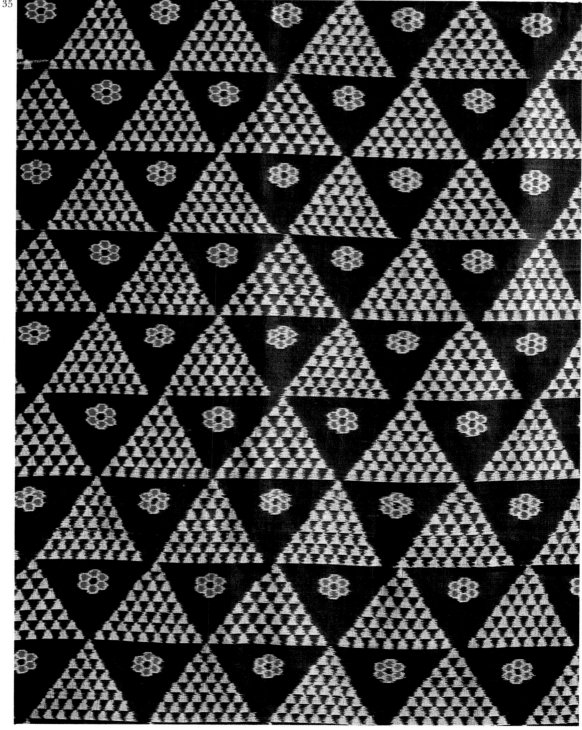

35

34
Jhatti or Chitta wall
patterns, Nuapatna
These are symbols of
goodluck & prosperity

35
Silk sari based on
Jhatti patterns,
Single ikat,
Collection of:
Maya Desai, Bombay

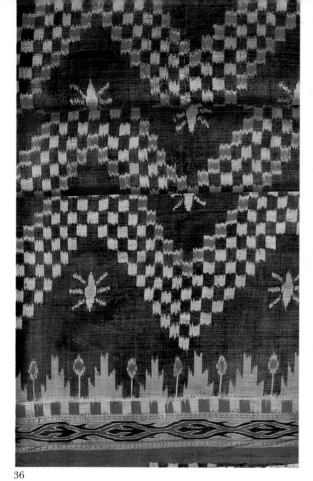

36

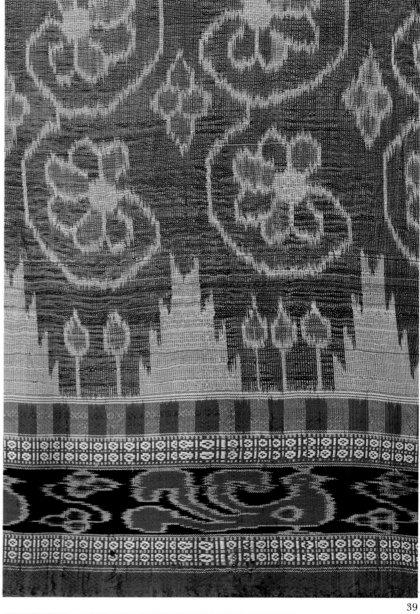

36
Section of a Tarabali
Silk sari, combined ikat
Chambray,
Collection of
Minakshi Desai,
Bombay

38

37

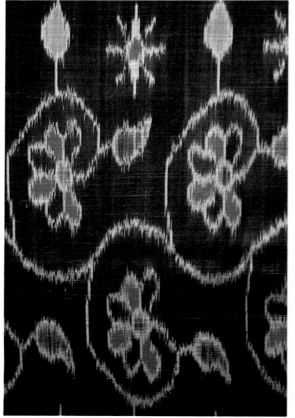

39

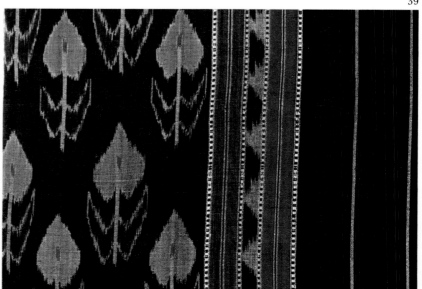

37
Detail from a
Khandua sari,
Silk, single ikat
Collection of
Satyavatiben Jhaveri,
Bombay

38
Section of a
Ful dali sari,
Silk, combined ikat,
Collection of
Savitaben Amin, Baroda

39
Section of
Silk sari,
Single ikat,
Collection of
Savitaben Amin, Baroda

40
Section of a
Tussar silk sari,
Single ikat
Collection of
Ranjan Lakhani,
Bombay

41, 42
Section of a
Silk sari, ikat
Collection of,
Ranjan Jhaveri,
Bombay

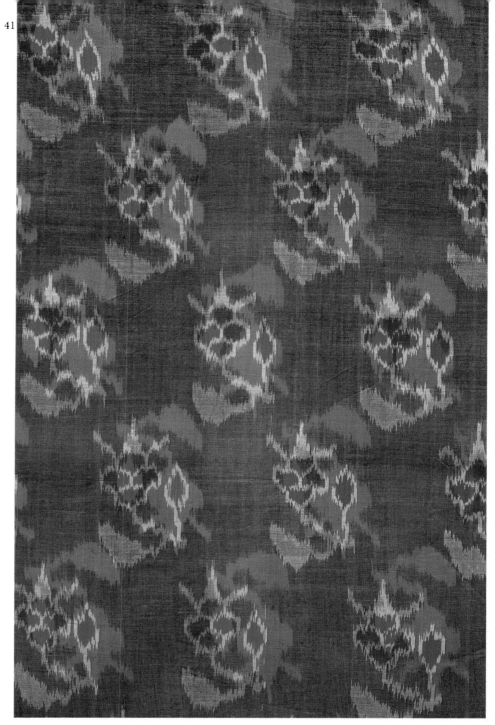

41

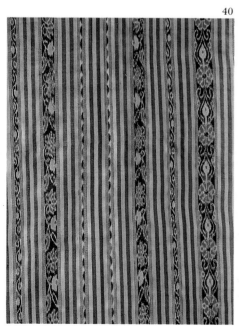

40

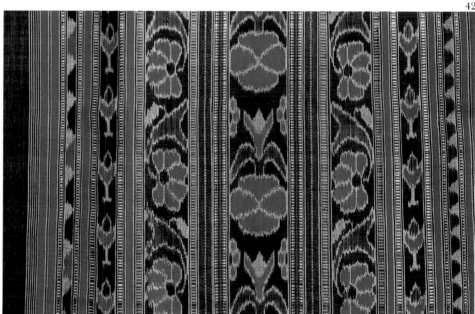

42

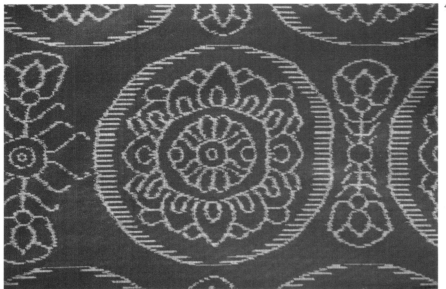

43

43
Detail from a
Silk sari,
Single ikat
Produced by
Mr. H.N. Sahu,
Bhubaneshwar

44
Section of a
Khandua sari,
Silk, Combined ikat.
Traditionally the
Khandua sari, was
worn by a bride on
her wedding day. This
was customary in certin
parts of Orissa

45
Detail of a
Border from a silk sari,
Combined ikat,
Collection of
Maya Desai, Bombay

46
Mandala motif from a
Kunjifulbedi sari, silk,
combined ikat
Collection of
Savitaben Amin, Baroda

44

47
Section of a
Kunjifulbedi sari,
Silk, combined ikat
Collection of
Maya Desai, Bombay

48
Flower motif from a
Silk sari,
Single ikat,
Collection of
Savitaben Amin, Baroda

45

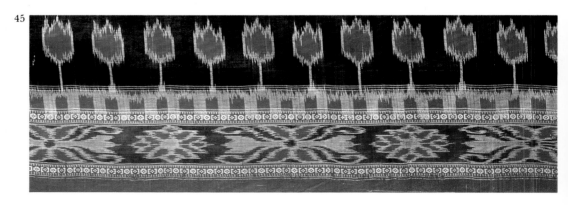

47

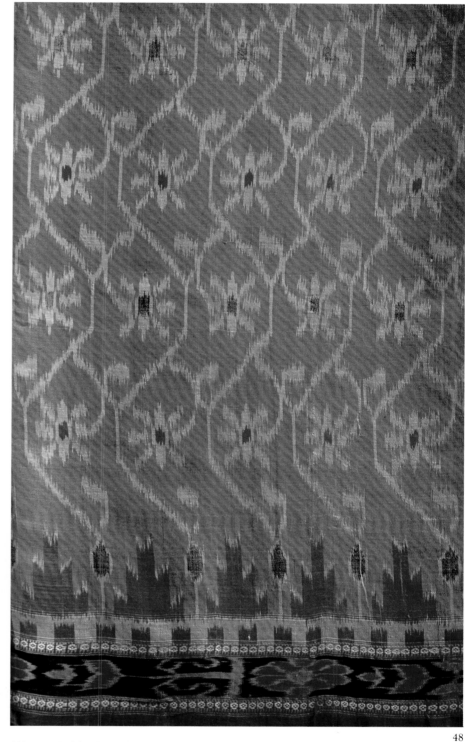

46

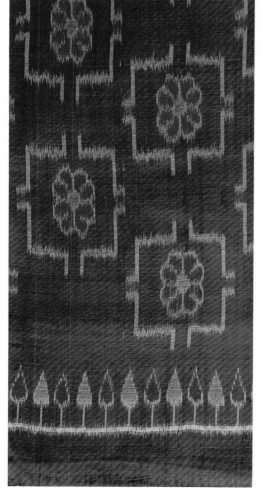

48

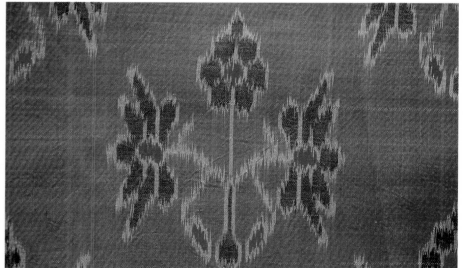

79

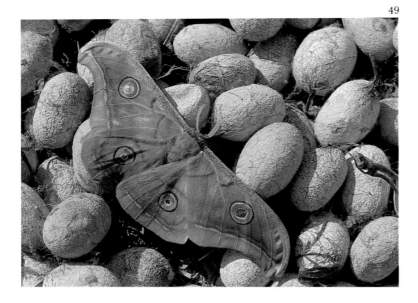

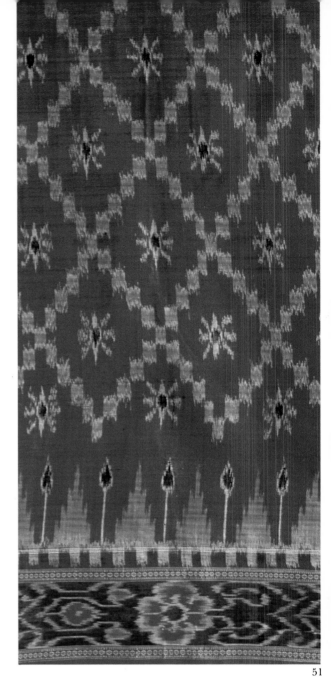

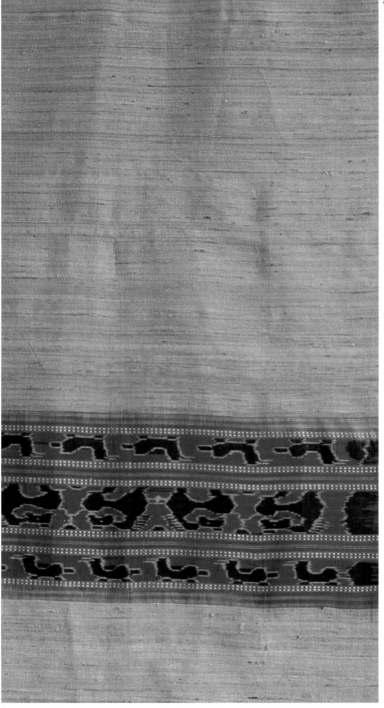

51

49
View of a Bogai Tussar
moth resting on cocoons.
The yarn produced
from the filament of this
moth gives tussar silk its
rich, uneven texture.
Approximatley 6000
cocoons are required for
the prepartion of one
sari (5.5 meters) The
other silk varieties
produced in India are
Mulberry, Mooga and
Endi

50
Tussar silk Dupatta,
Single ikat, from
Bargarh
Collection of
Lalna Lakhani, Bombay

51
Section of
Tarabali sari,
Silk, combined ikat,
Produced by
Mr. R.N.Sahu,
Bhubaneshwar

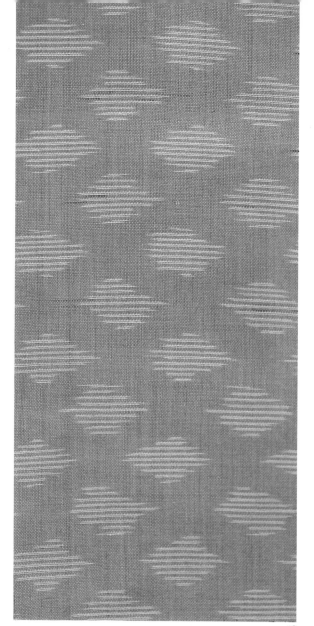

53

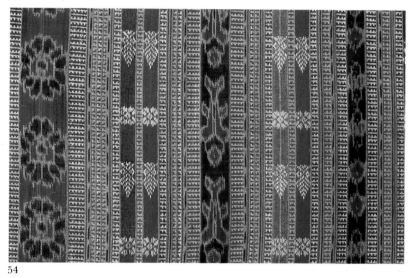

52 54

52
Section of cotton sari,
Single ikat,
Collection of
Bhavna Shah, Bombay

53
Preparing the warp, at
Sonepur Training
Centre,
Sonepur

54
Section of a Domui
Than, single ikat
with extra weft bands.
Collection of
Ranjan Lakhani,
Bombay

55
Anchal of a cotton
Sari, Combined
ikat with
extra weft bands
Collection of
Bhavna Shah, Bombay

55

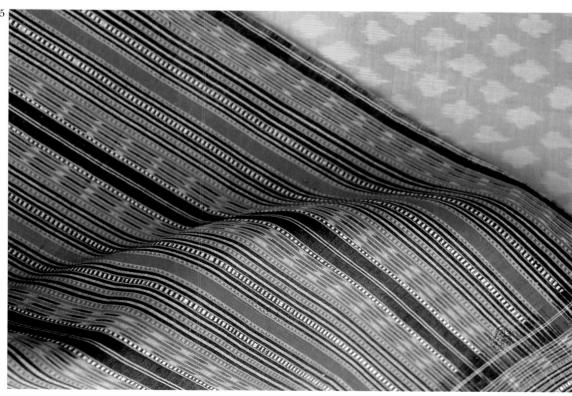

55

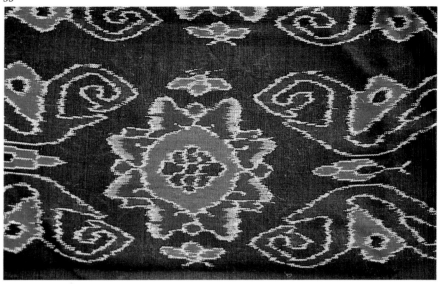

56

57

Flower & butterfly motif
Cotton, single ikat
Collection of :
Chawla Patel, Ahmedabad

56
Flower motif
Cotton, single ikat
Collection of :
Chawla Patel, Ahmedabad

57
Sari border, cotton ikat,
Produced by :
Sambalpuri Bastralaya,
Bargarh

57

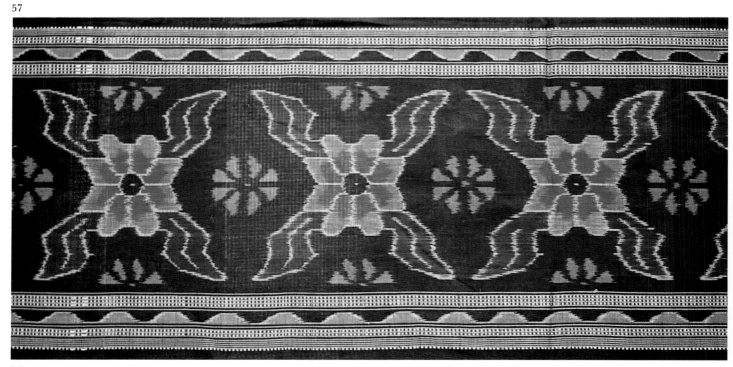

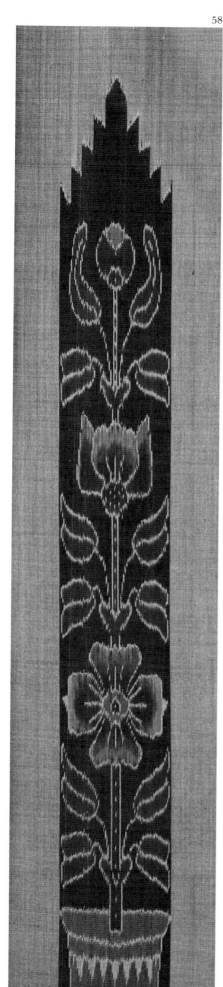

58

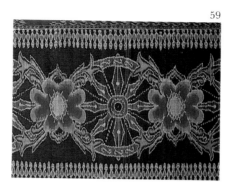

59

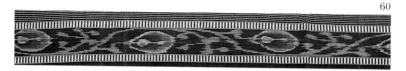

60

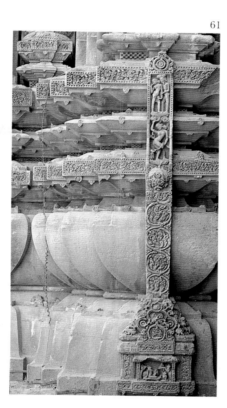

61

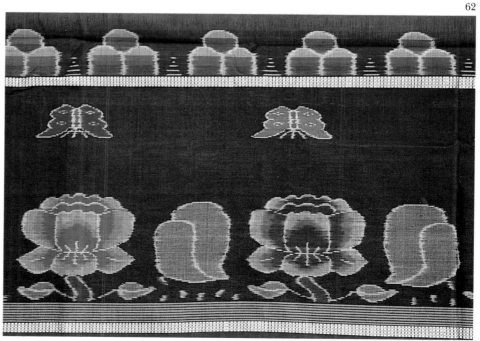

62

58
Kalingasundari design
Cotton ikat sari
Produced by: Sambalpuri
Bastralaya, Bargarh

59
Tajsiai design border
Cotton ikat sari
Produced by: Sambalpuri
Bastralaya Bargarh

60
Detail from Tajsiai design
Cotton ikat sari
Produced by: Sambalpuri
Bastralaya, Bargarh

61
Panel from 12th century
Raja Rani temple,
Bhubaneshwar

62
Kalingasundari design
Cotton ikat sari border
Produced by: Sambalpuri
Bastralaya, Bargarh

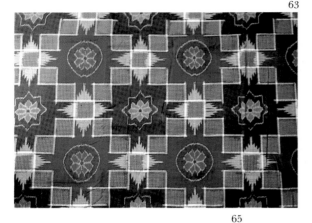

63

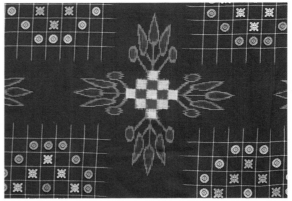

64

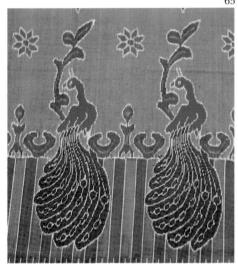

65

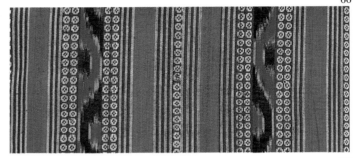

66

63, 65, 66, 69, 71
Details of cotton saris,
Produced for local
consumption in villages
and towns of Orissa,
Single and combined
ikat.
Produced by
Sambalpuri Bastralaya,
Bargarh

64
Detail of a flower motif
from a cotton sari.
Combined ikat with
cotton
brocade motifs
Collection of
Weaver's Service Centre,
Bombay

67
A well crafted
Wall Hanging,
Cotton, single ikat
Produced by
Sambalpuri Bastralaya,
Bargarh

68

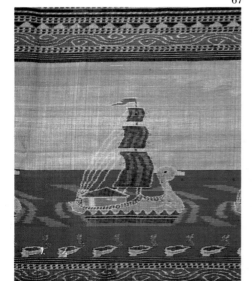

67

68
Folded saris, stacked
together, ready to
be sold. Bargarh

70
A man selling printed
imitations of ikat
designs. Priced much
lower than their hand
crafted ikat
counterparts, these
printed saris are eating
into the original ikat
textile market

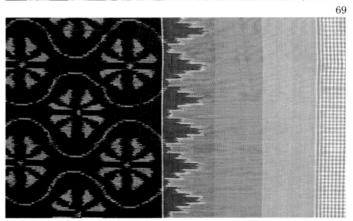

69

72
Deer motif, detail
from Wall Hanging
Cotton, Single ikat,
Produced by
Sambalpuri Bastralaya
Bargarh

73
Section of a
Bed cover,
Cotton, single ikat
Produced by
Sambalpuri Bastralaya,
Bargarh

74
Section of a
Gaja Sinha bedcover
(Lion and Elephant
design)
Designed by
Deepak Ghosh,
Weaver's Service Centre,
Benares

70

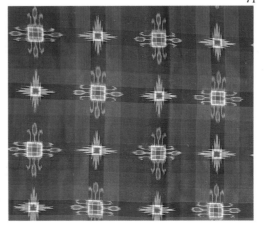

71

75
Detail of
Lion and Elephant
forms, carved in
stone, Bhubaneshwar.
This symbol is
frequently found
in temple architecture of
Orissa.
It is said, the
Lion is symbolic of
the Ruling Force
while the elephant
symbolises
Power of the Masses

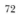

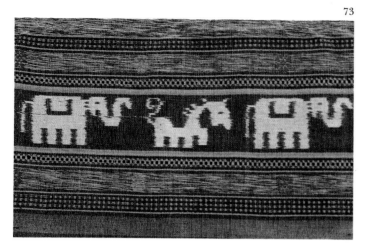

73

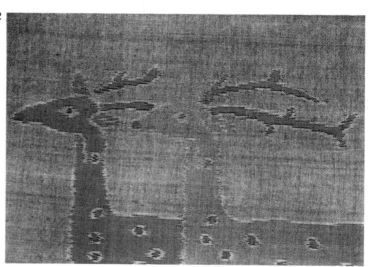

72

74

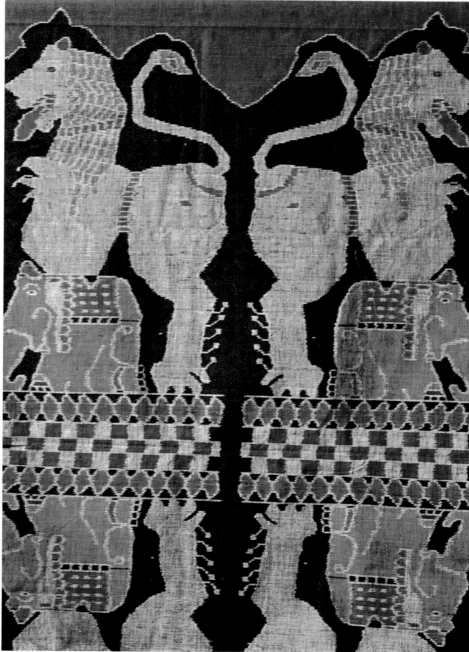

75

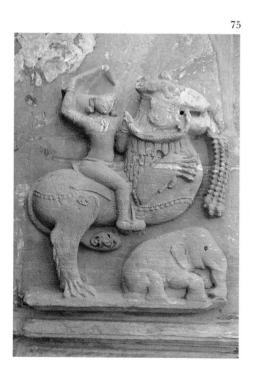

85

78

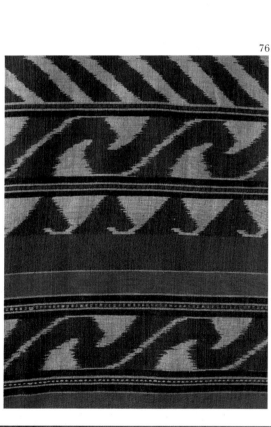

76

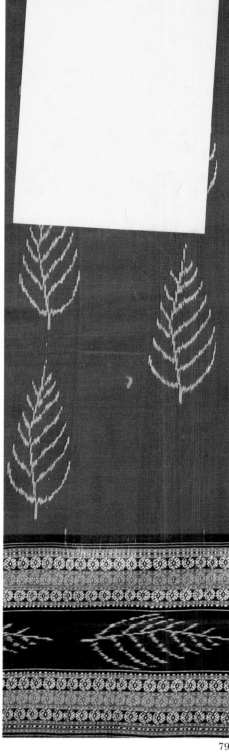

79

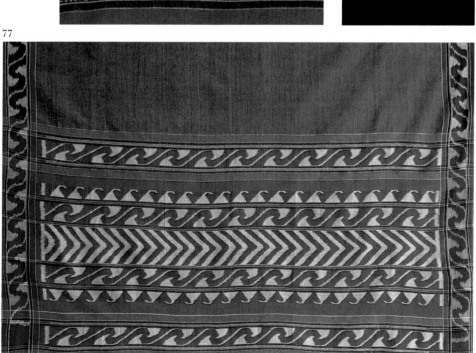

77

76, 77
Sections of a cotton
Sari, Combined ikat,
Collection of
Ranjan Lakhani,
Bombay

78
Section of a cotton
Sari, combined ikat,
Produced by
Sambalpuri Bastralaya
Bargarh,
Collection of
Lalna Lakhani,
Bombay

79, 80
Sections of Patrarekha
Saris, Cotton,
Combined ikat,
Produced by
Sambalpuri Bastralaya
Bargarh

79 — Collection of
Lalna Lakhani
80 —Collection of
Maya Desai, Bombay

81
Detail of a conch
motif.
On the left is
the colour sketch
painted on paper.
On the right is it's
woven, ikat counterpart.
Sample collection
Rebanto Goswami,
Weaver's Service Centre,
Bhubaneshwar

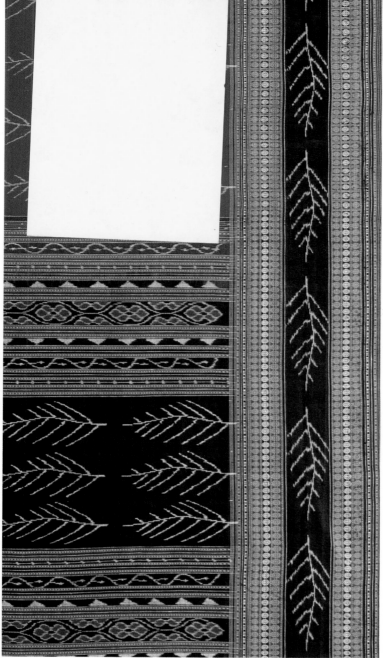

80

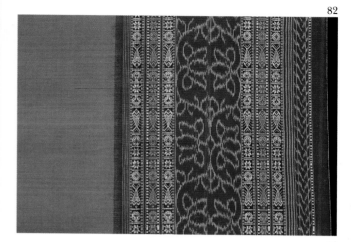

82

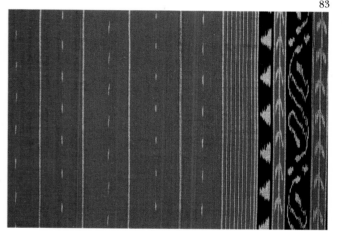

83

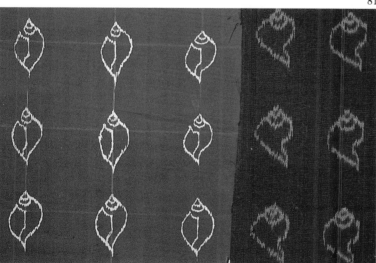

81

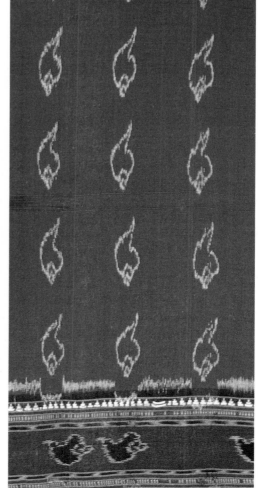

82
Detail of cotton
ikat sari with
Lotus motif
single ikat,
Collection of
Maya Desai, Bombay

83
Section of a cotton
sari, single ikat,
Produced by
Sambalpuri Bastralaya,
Bargarh

84
Section of a Shankha sari,
Cotton, combined ikat,
Woven by
Harilal Meher,
Collection of
Rebanto Goswami
Weaver's Service Centre,
Bhubaneshwar

84

87

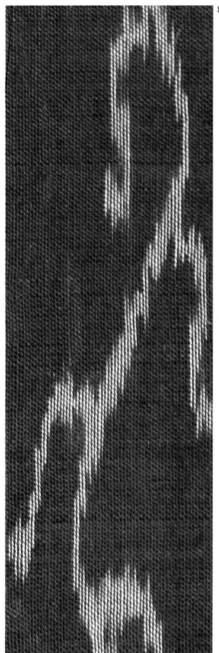

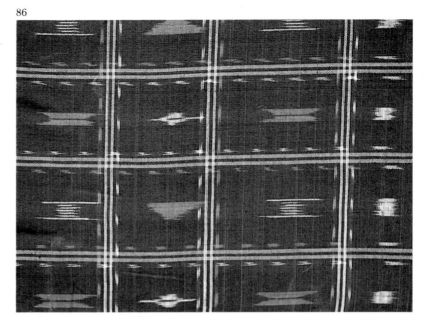

87

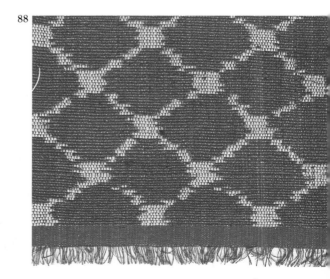

85
Detail of a cotton sari,
Single ikat
Produced by
Mr R.N. Sahu,
Bhubaneshwar

86, 90
Cotton yardage
single ikat

88
Furnishing material
Cotton, single ikat

89
Sections of Cotton
Saris, Combined ikat

86, 90, 88, 89
Designed by
Rebanto Goswami
Weaver's Service Centre,
Bhubaneshwar

87
Details of Lata
Pattern
Cotton Sari,
single ikat
Collection of
Siddhitaben Trivedi
Bombay

88

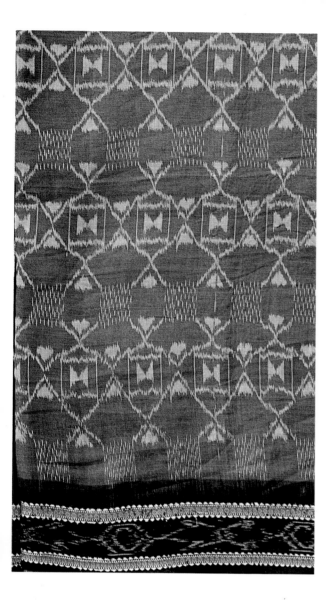

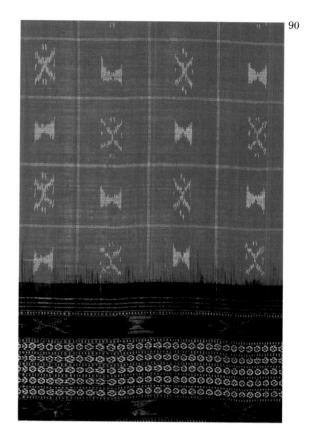

91
Section of a sari anchal
Cotton, Single ikat
with extra weft
bands,
Collection of
Kusumben Shah,
Bombay

90

91

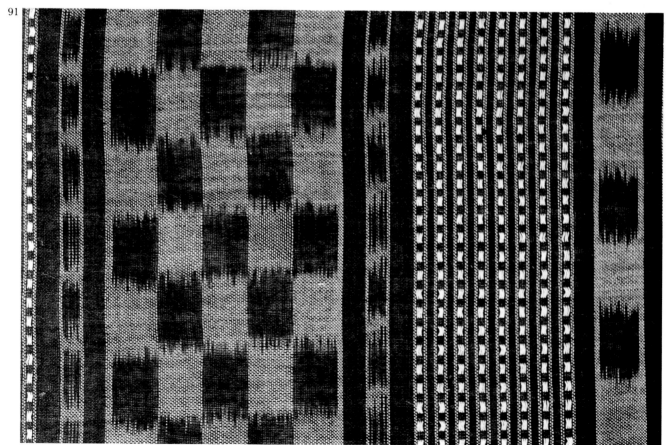

91.1

92

91.1
Detail of a silk sari
Single ikat
In the showroom of
Vama Dept. Store,
Bombay

92, 95
Sections of silk saris
Single ikat,
From the showroom of
Roopkala saris,
Bombay

93, 94
Section of silk saris,
Single ikat,
Collection of
Siddhitaben Trivedi,
Bombay.

96
Section of a
Silk sari,
combined ikat,
Produced by
Chaturbhuj Meher,
Sonepur

93

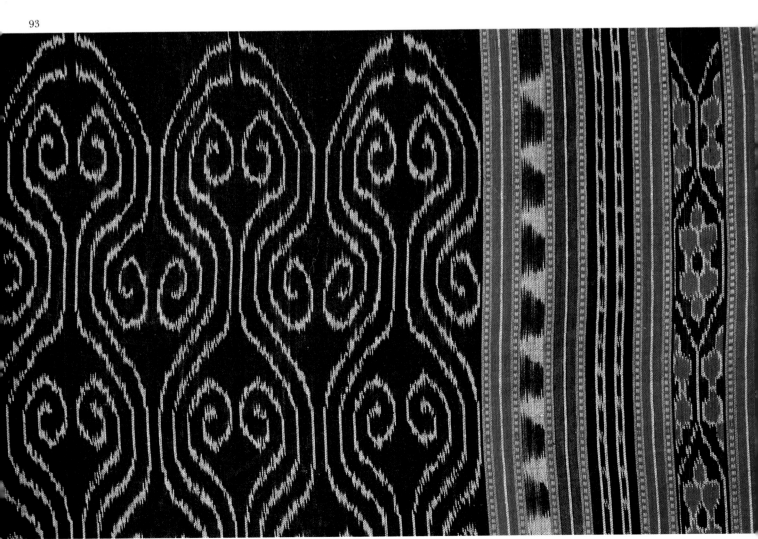

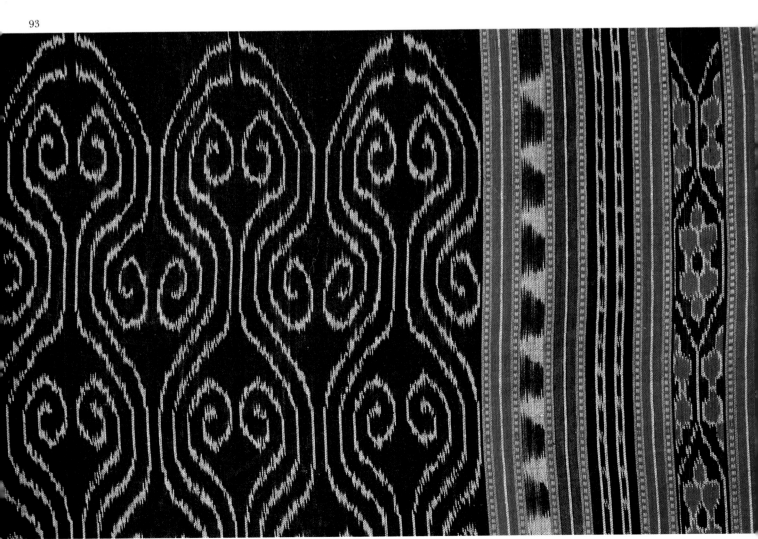

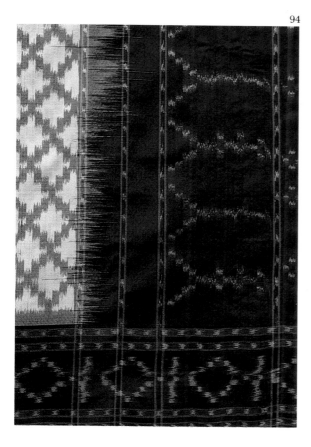

94

95

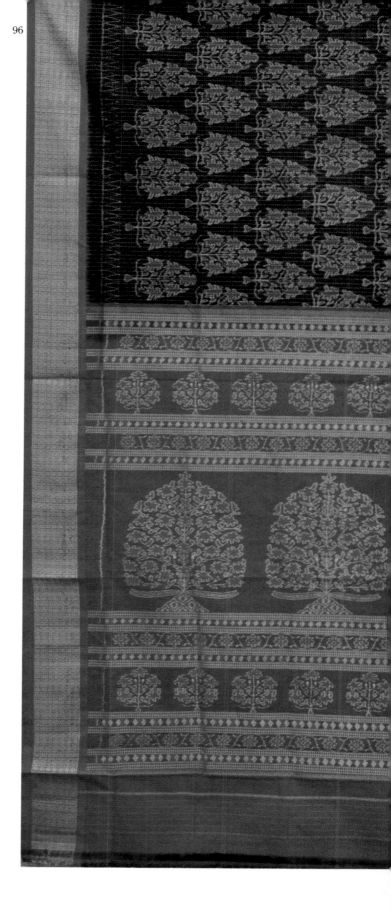

96

91

97

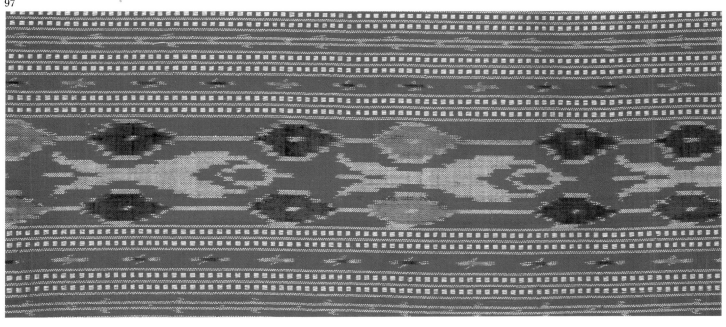

98

99

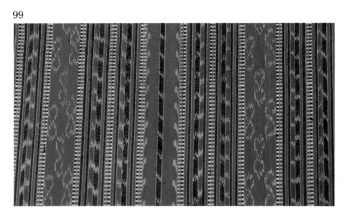

100

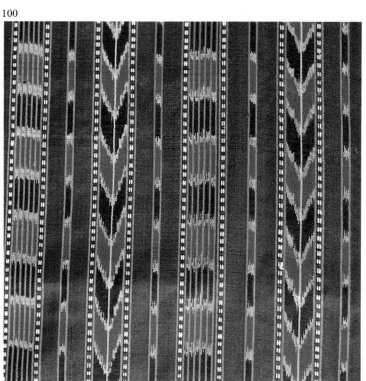

101

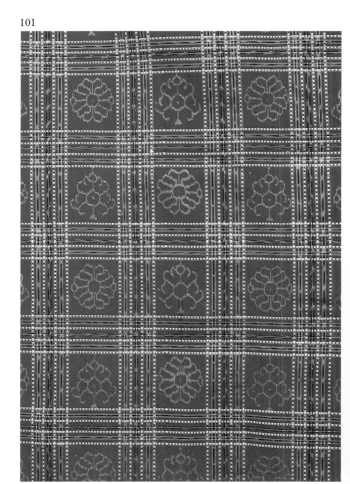

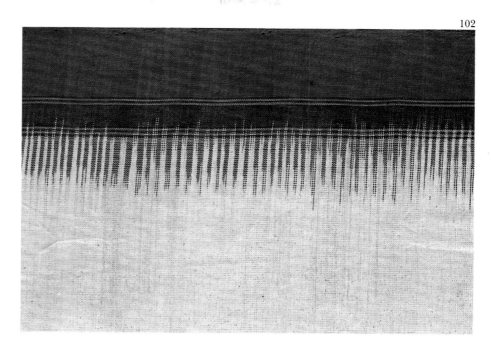

97
Section of a silk
sari, single ikat
with extra weft bands
Collection of
Tinu Mehta Bombay.

98, 99, 100
Sections of
Striped ikat
saris, silk
single ikat with
extra weft bands,
Produced by
Chaturbhuj Meher,
Sonepur

101
Silk Chowka sari,
silk, single ikat
with extra weft
and warp borders,
Produced by
Chaturbhuj Meher,
Sonepur

102
Detail of a
Domui sari border.
A typical
example woven by
the Meher community
of Sonepur.
Woven by
Netramani Meher,
Collection of
Kailashchandra Meher,
Weaver's Service Centre,
Bhubaneshwar

103
Section of a
Lehria sari,
silk, single ikat
with extra weft
bands,
Produced by
Ramji,
Weaver's Service Centre,
Sonepur

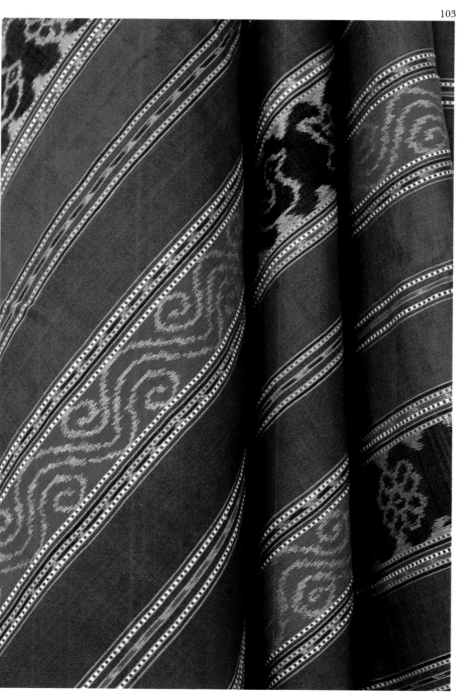

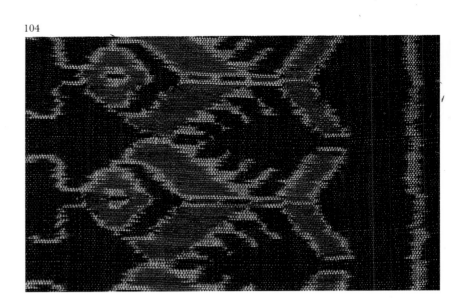

104

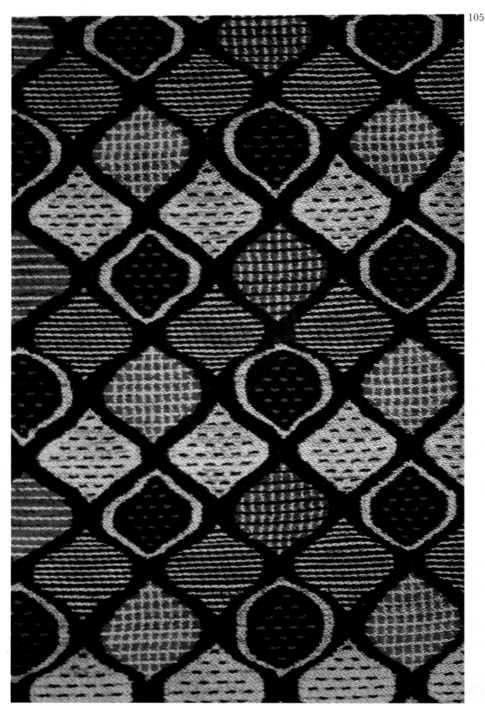

105

106

107

94

104
Furnishing Material
cotton and noil,
single ikat
Design: Rebanto
Goswami
Weaver's Service Centre,
Bhubaneshwar

105
Bed cover
cotton, Double ikat
Produced by
Chaturbhuj Meher,
Sonepur

106
Detail of Cotton
sari, single ikat,
Collection of
Ranjan Lakhani,
Bombay

107
Semi tye-dyed
yarn,
Sambalpuri Bastralaya,
Bargarh

108, 109
Cotton yardage
Design: Rebanto
Goswami,
Weaver's Service Centre,
Bhubaneshwar

110
Cotton Bedspread
ikat,
Produced by
Sambalpuri Bastralaya
Bargarh

111
A basket of flowers,
to be sold as
offerigs for temple
dieties
Bhubaneshwar

108
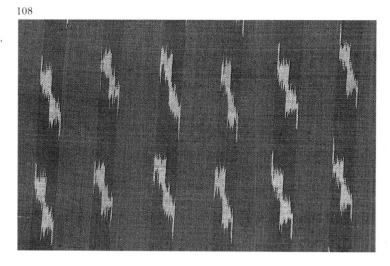

109
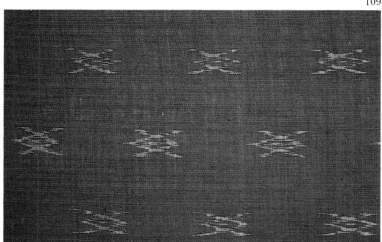

111

110
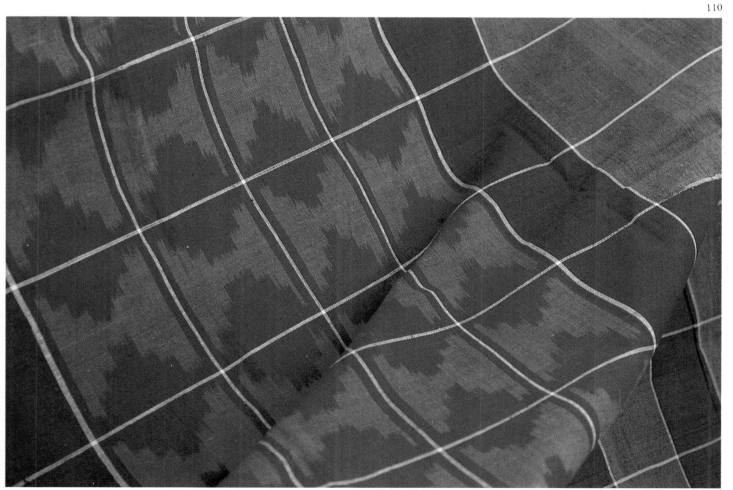

IKAT TEXTILES
OF ANDHRA PRADESH

Introduced only two or three generations ago, the ikat technique is relatively new to the weavers of Andhra Pradesh. The only 'traditional' ikat fabrics from this region are the cotton *Telia Rumals* admeasuring 55cms x 75cms square.

The basic structure of a telia rumal is composed of a very strong diagonal[1] or square grid[2], in which geometrical, floral or figurative motifs in double ikat are woven. These two elements combine to form the 'hauz' or central unit, which is invariably framed by a broad red border. The overall colour scheme is usually red, black and white, pink being a recent addition.

Most of the other double ikat textiles produced in Andhra Pradesh have been strongly influenced by the patolu textiles of Gujarat[3]. Over the years, modifications in colour and form have resulted in design variations, commonly identified as Pochampalli patola[4].

In recent times, diversification of the product line from saris to *yardage* has completely transformed the design vocabulary of this region. Today, a wide variety of fabrics in single, combined and double ikat in both cotton and silk is produced.

Ikat yardage, is primarily designed for urban and international consumers. The design vocabulary is therefore based on modern aesthetic sensibilities. From the vast range of ikat yardage produced, four distinct trends have emerged.

In the first, multi-coloured weft ikat designs, with striped and chevron forms, are the dominant pattern repeats[5]. The interplay between figure and ground has resulted in an endless array of design alternatives.

In the second approach, the isolation of abstract motifs spread over larger ground areas has been explored . Quite often, these textiles are woven in combined ikat, with monochromatic colour schemes[6]. In the third, grid patterns dominate the entire fabric. These designs rely heavily on simulated textures, colour gradations and size variations to form fascinating visual networks[7]. In the last variation, the accent is on colour, rather than form. Here, very soft pastel shades are used. Occasionally, figure and ground blend to produce very subtle, sophisticated textures[8].

1 see page 103 plate 14
2 see page 104 plate 16.3
3 see page 99 plates 5, 6
4 see page 98 plates 1, 1.1, 3
5 see pages 112, 113 plates 25, 27, etc.,
6 see page 121 plates 74, 75
7 see page 124 plate 90
8 see page 126-127 plates 100, 101

Right — Detail of a 'chowka' sari

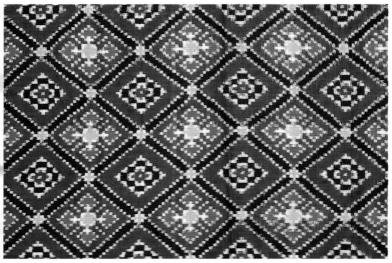

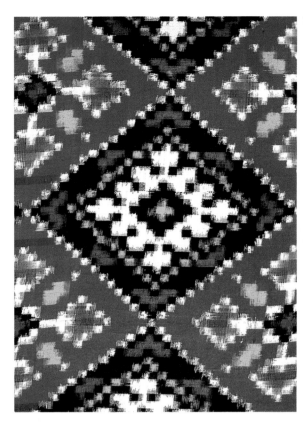

1

1, 1.1
Motif from a
Pochampalli patolu,
Silk, double ikat,
Collection of:
Rajul Shah, Bombay.

2

Section of a sari border,
Silk, double ikat,
Collection of
Savitaben Amin,
Baroda

3

Chowka sari, silk,
Single ikat,
Collectioin of
Rajul Shah, Bombay

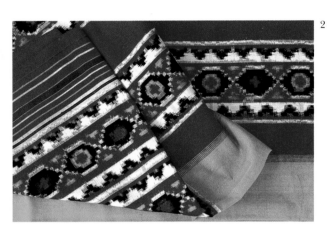

2

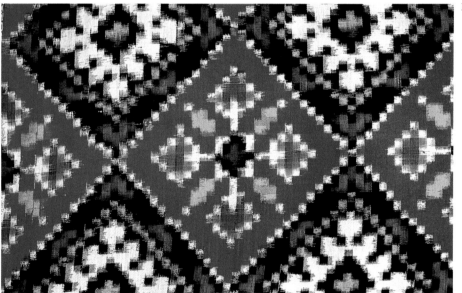

1.1

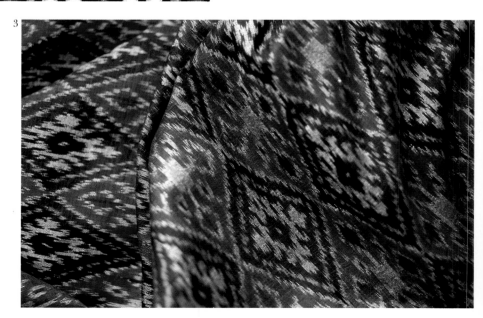

3

98

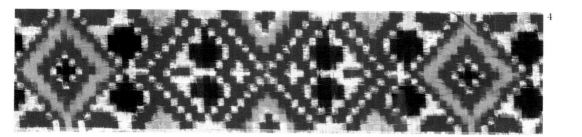

4

Section of a Pan-Chowka
border, silk,
Double ikat sari,
Collection of
Ranjan Lakhani,
Bombay

5

Detail of a Vohra Gaji
Motif, patolu imitation,
Silk, double ikat sari,
Collection of
Ranjan Lakhani,
Bombay

6

Chowka sari, silk, double
ikat,
Collection of
Ranjan Lakhani,
Bombay

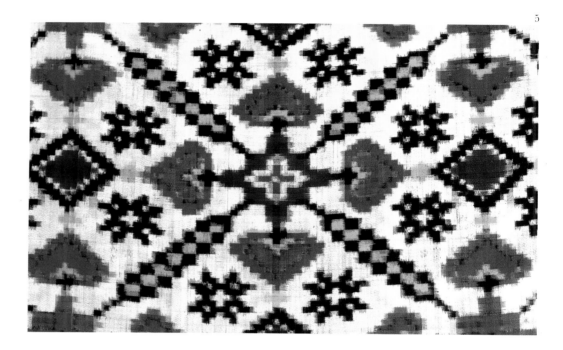

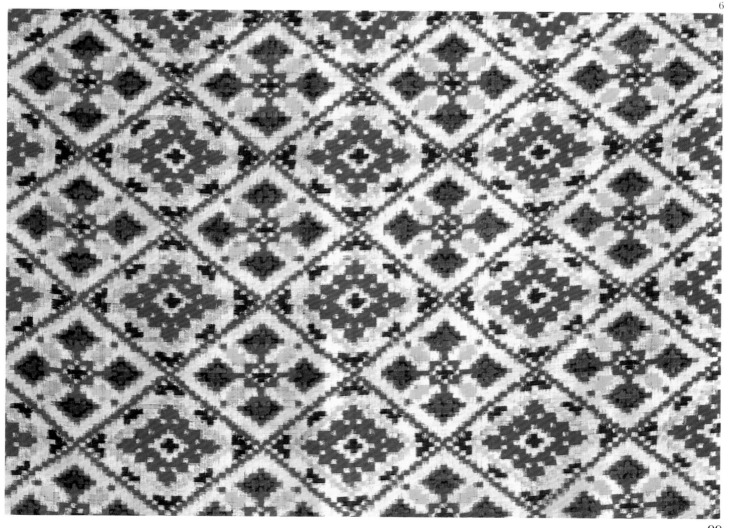

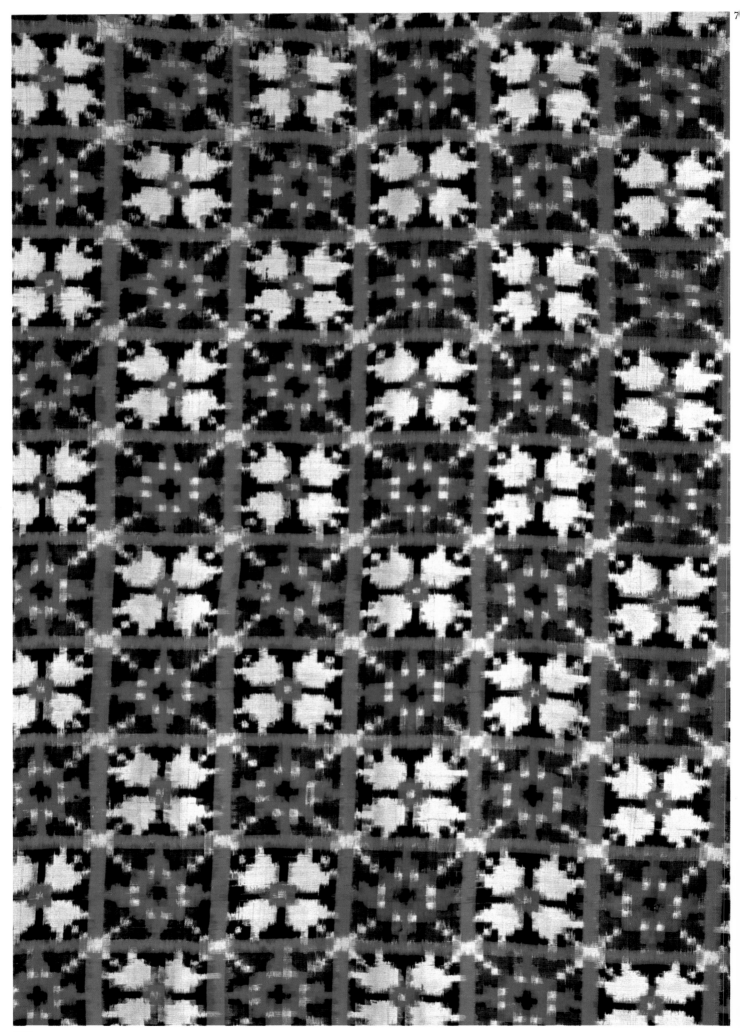

7
Section of a Pochampalli
sari, silk,
Double ikat,
Collection of
Nayana Jhaveri,
Bombay

8
Interior of a Weaver's
house (beams and
ceiling)
decorated with multi-
coloured paper cut
streamers.
Koyalaguddam

8.1
Detail of paper-cut
streamer motif. The
Peacock is a very
popular motif, the
use of which is
frequently made
in ikat saris from
this region.

9, 10
Peacock motifs
on a sari borders.
Silk, Single ikat.
Both in the collection
of Ranjan Lakhani,
Bombay

8

9
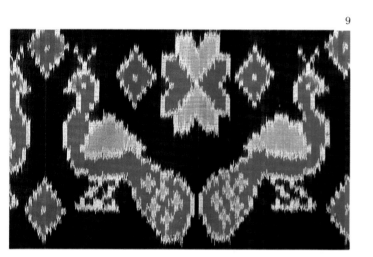

8.1
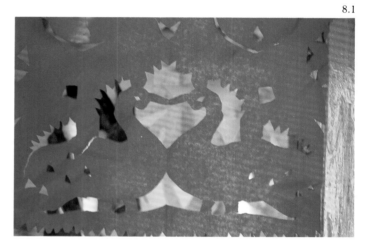

10
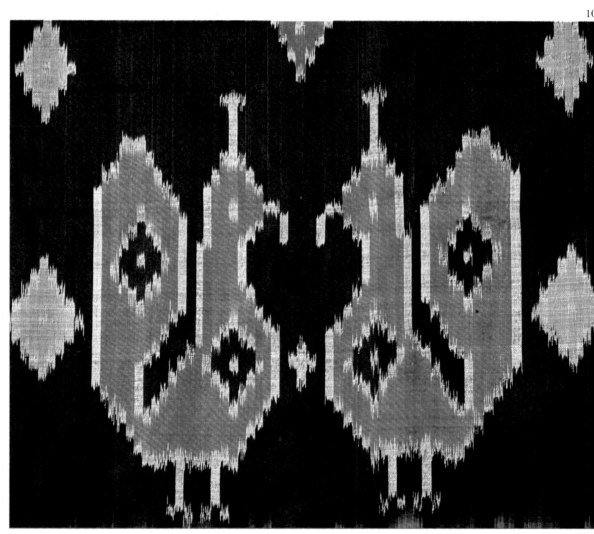

101

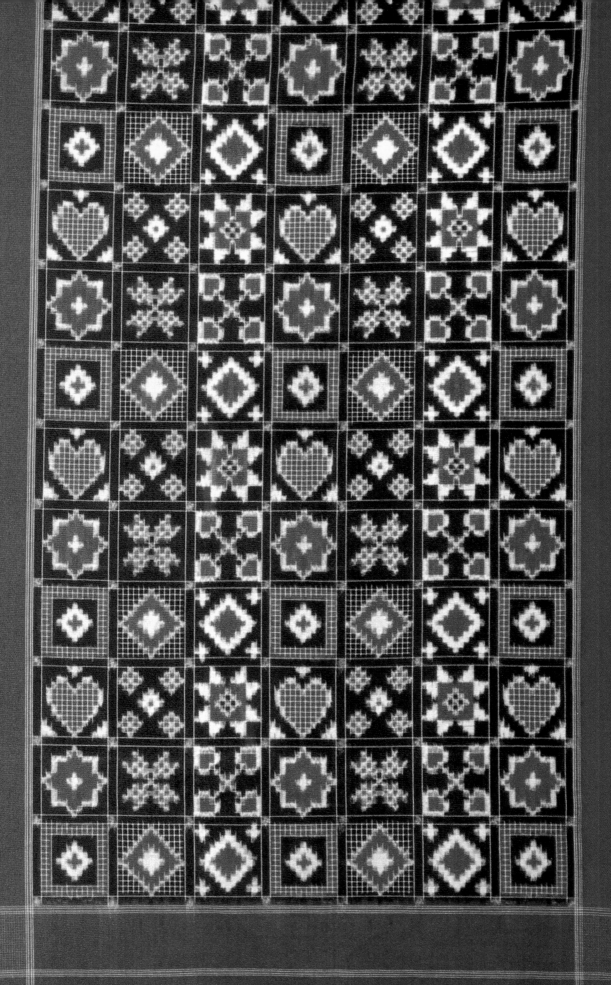

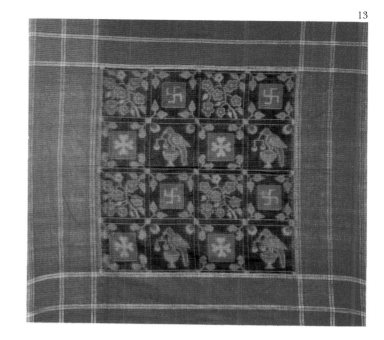

11
Cotton sari,
Double ikat,
Collection of
Weaver's Service
Centre, Hyderabad

12
Cotton bedspread,
Single ikat,
Collection of:
Weavers Service
Centre, Hyderabad

13 to 15
Telia Rumals
Cotton double ikat
Collection of:
Weavers Service
Centre, Hyderabad

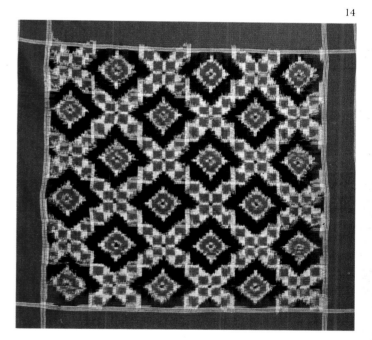

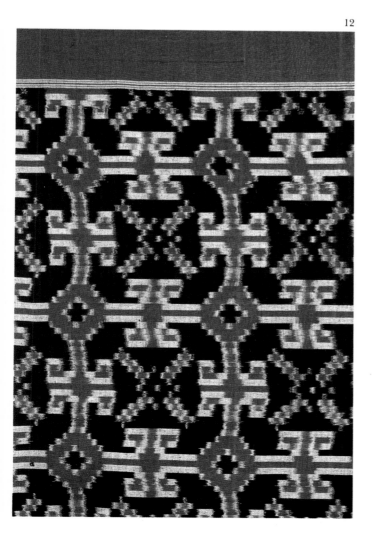

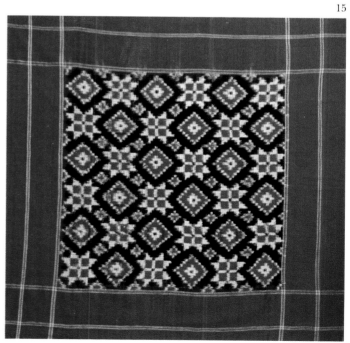

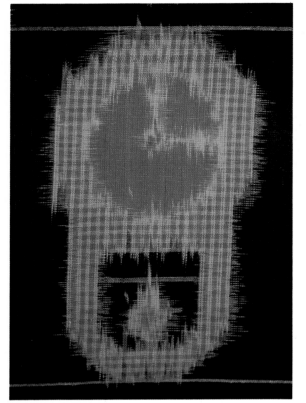

16

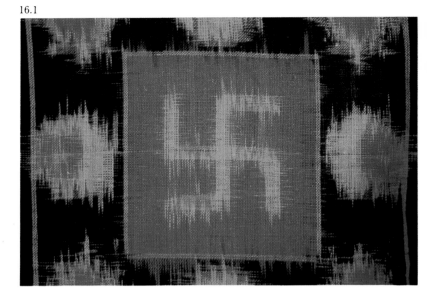

16.1

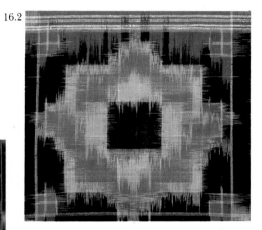

16.2

17.2, 17.3.
Section of a Dupatta,
Cotton, double ikat,
Collection of
C. Desai, Bombay

16
Clock motif from a
Telia Rumal,
pillow case, Cotton,
Double ikat,
Collection of C. Desai,
Bombay

16.1
Swastika symbol
from a Telia Rumal,
Pillow case, cotton,
Double ikat,
Collection of
C. Desai, Bombay

16.2 ,16.3, 16.4
Detail of a Chowka
motif from Telia Rumal,
Cotton, Double ikat
Collection of
C. Desai, Bombay

17, 17.1
Section of Telia
sari, Cotton,
Double ikat,
Collection of
C. Desai, Bombay

16.3

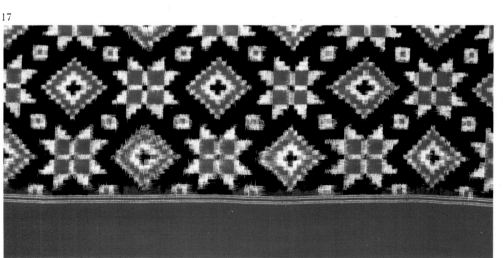

17

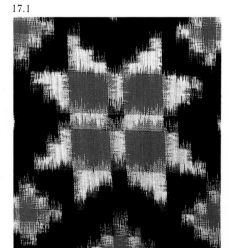

17.1

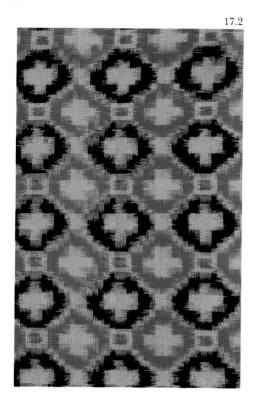

17.2

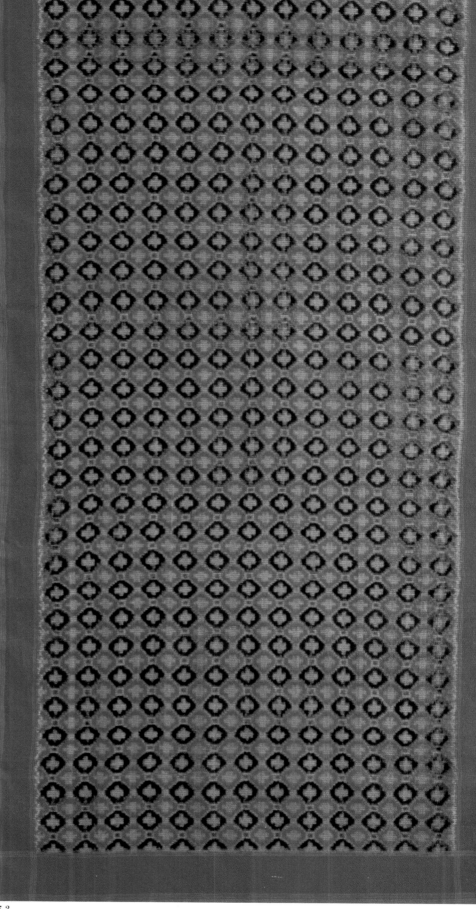

17.3

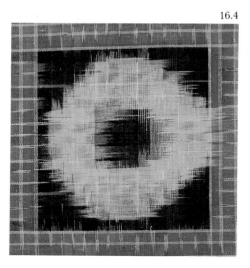

16.4

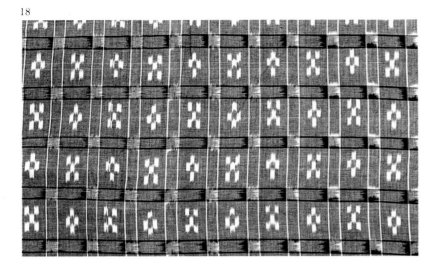

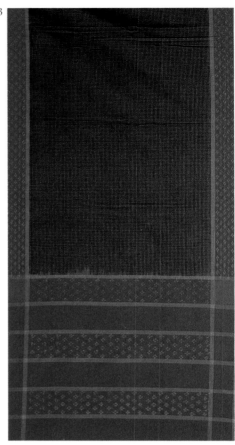

18.1

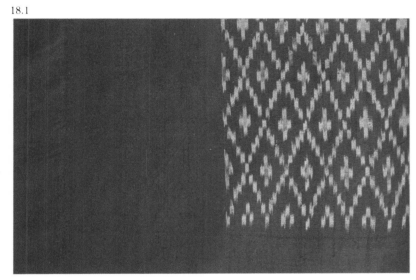

18.1
Section of a cotton
Sari, single ikat.
Collection of
Savitaben Amin,
Baroda

18, **18.4**, 18.7
Cotton yardage,
Combined ikat
In the collection of:
Shafali Fabrics Pvt Ltd,
Hyderabad

18.2

18.4

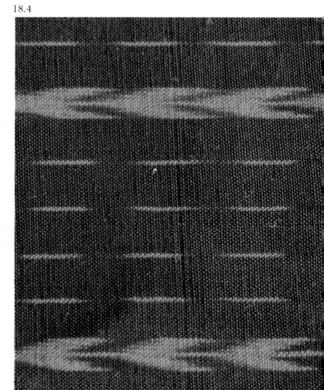

18.5

18.2, 18.3, 18.5, 18.6
Sections of
Contemporary cotton
single,
Combined and
double ikat saris
Collection of
Weaver's Service Centre,
Hyderabad

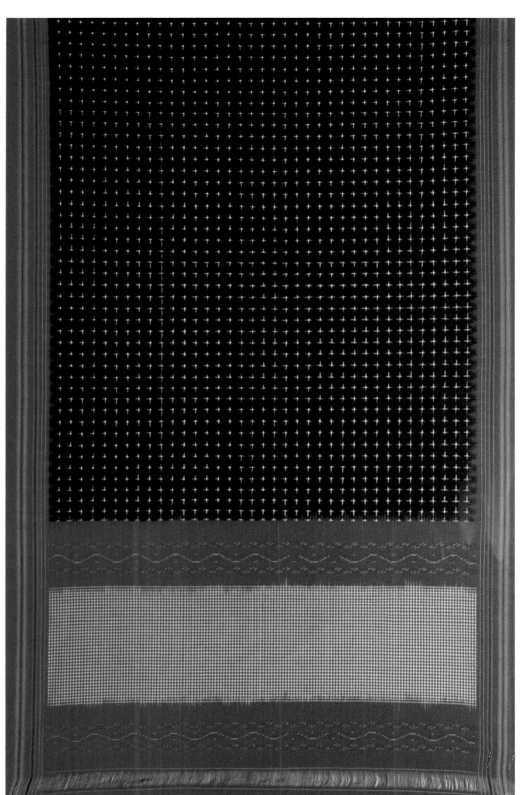

18.6

18.7

19

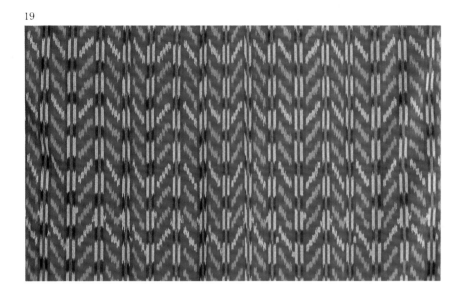

19.1

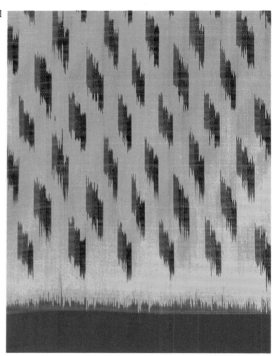

19.1, 20, 20.1, 20.2
Sections of modern
Silk saris,
Single ikat,
From the showroom of:
Roopkala Saris, Bombay

19.2

19.3

19, 19.3
Sections of saris,
Silk, single ikat
From the showroom of :
Vama Dept. Store,
Bombay

19.2
Section of a silk sari,
double ikat
From the showroom of
Vama Dept. Store,
Bombay

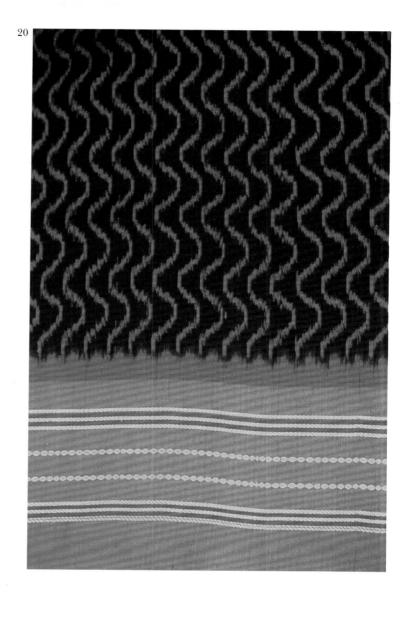

20.1

20.2

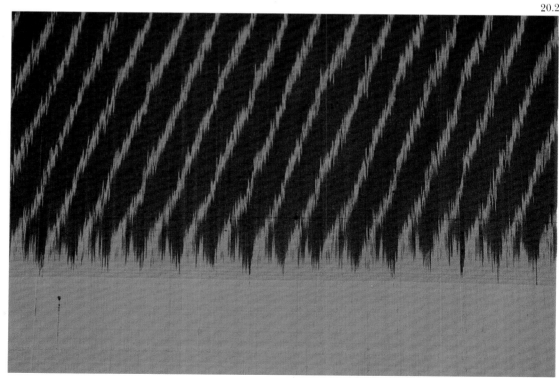

21

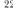22

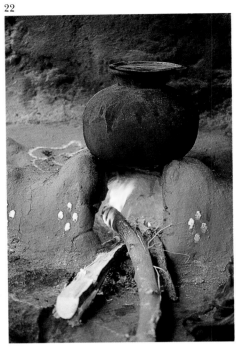

21.1

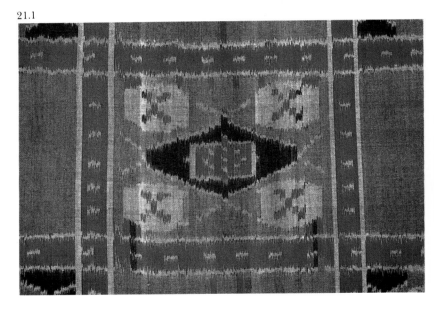

21.2

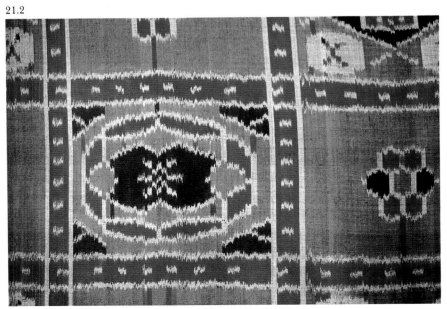

21, 21.1, 21.2
Motifs from a
Cotton sari, Single ikat,
Collection of
Ranjan Jhaveri,
Bombay

22
Dye stuff being
boiled in a
metal container,
Koyalaguddam

23
Contemporary
Cotton yardage
Double ikat,
Produced by
Laxmaiah for
Shafali Fabrics Pvt, Ltd.

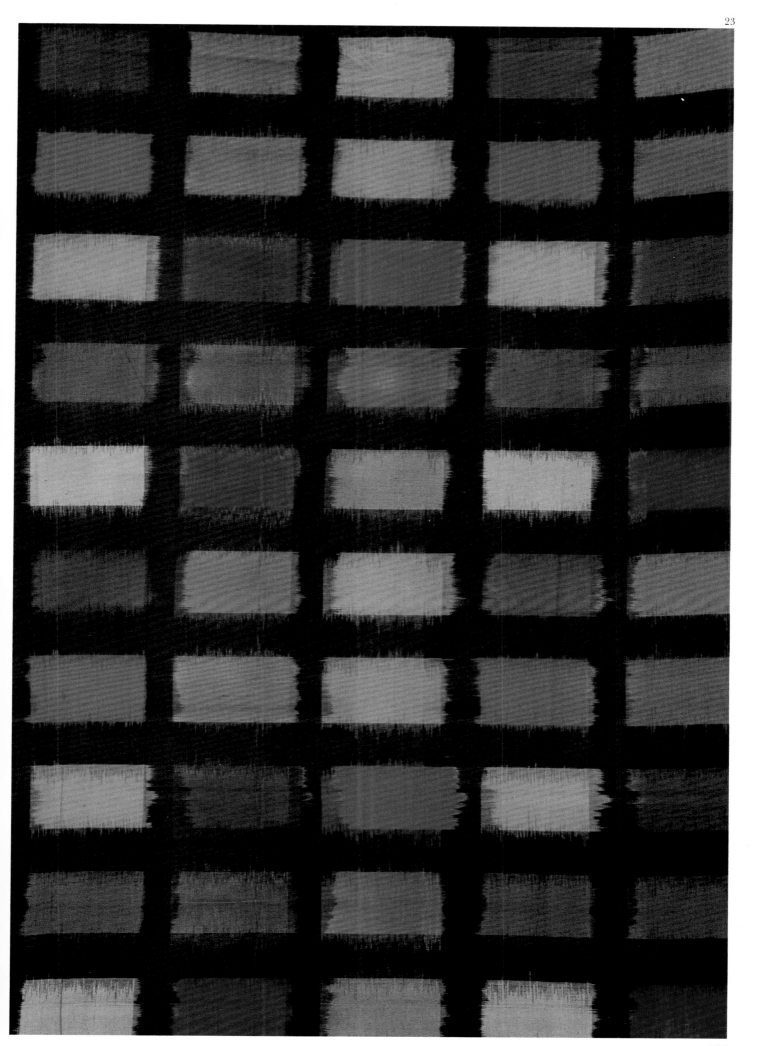

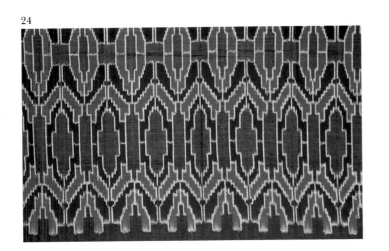

24

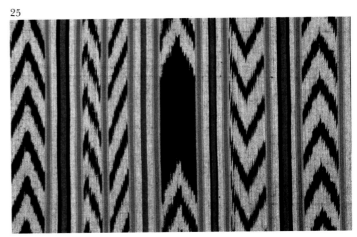

25

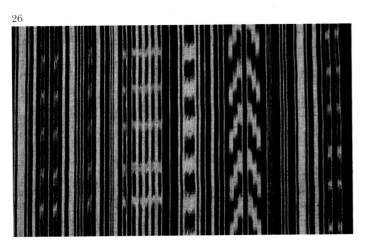

26

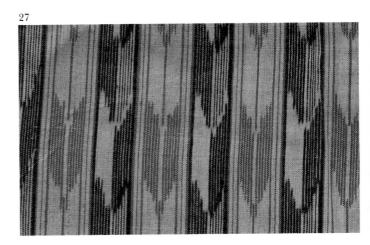

27

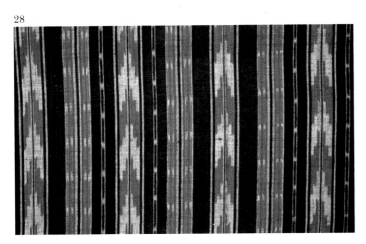

28

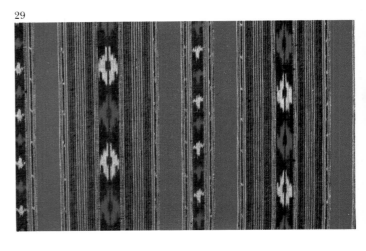

29

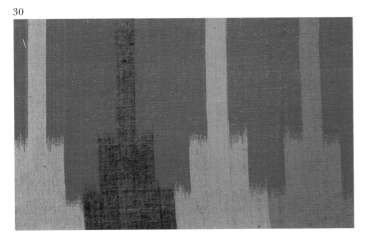

30

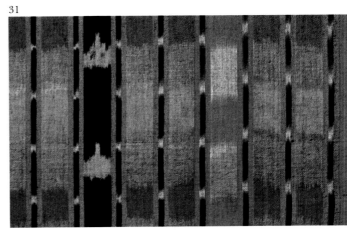

31

Striped and Chevron
Cotton yardage for
urban markets
Single ikat.

24, 25, 27, 29, 30, 33, 34
35, 36, 37, 38
Collection of

Shafali Fabrics Pvt, Ltd,
Hyderabad

26, 28, 31, 32, 39
Collection of
C. Desai, Bombay

Cotton yardage
single ikat.

112

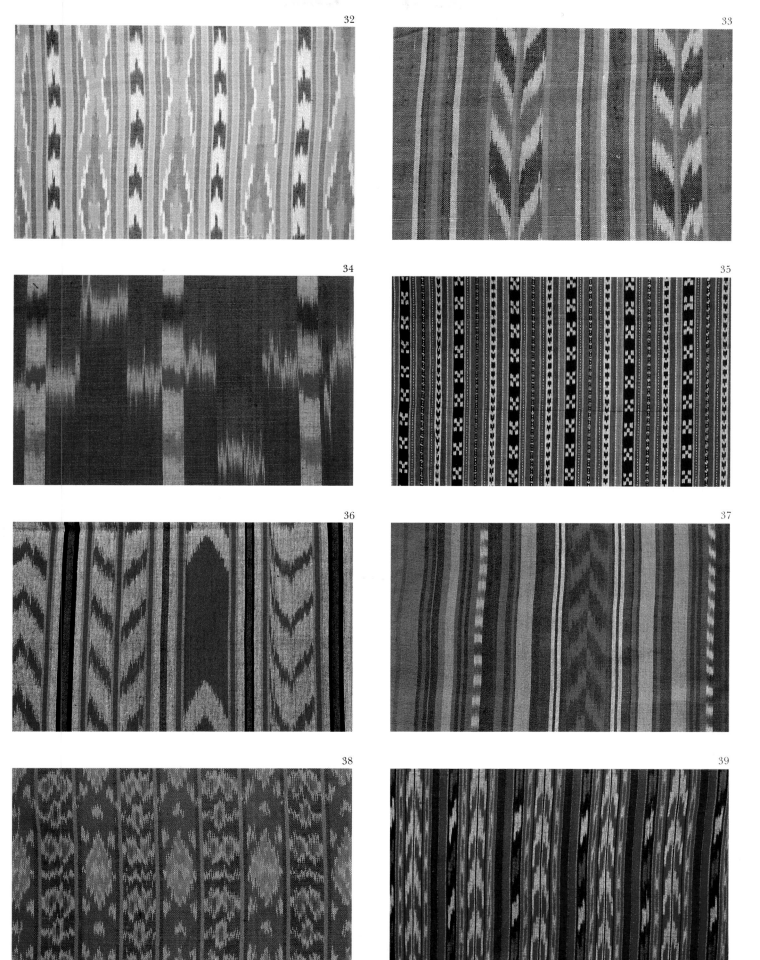

32

33

34

35

36

37

38

39

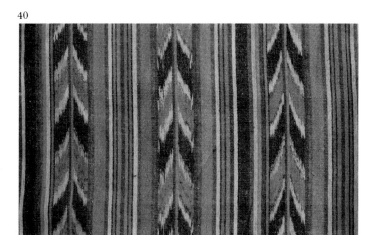

40

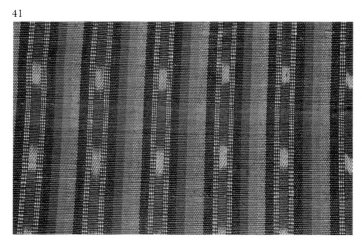

41

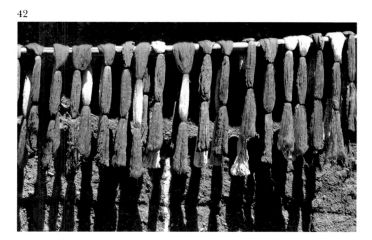

42

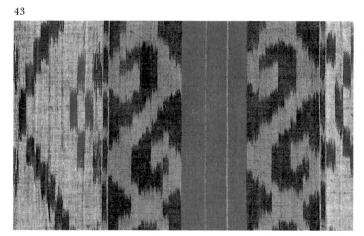

43

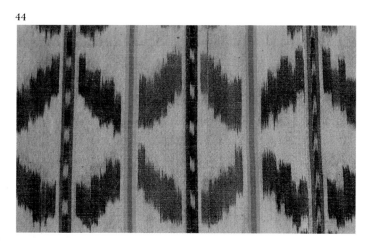

44

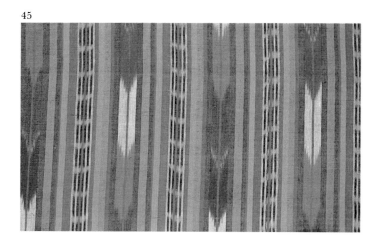

45

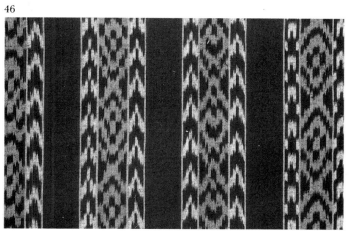

46

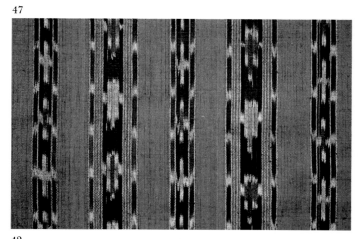

47

40, 41, 43, 44, 45, 46, 47, 50
Collection of
Shafali Fabrics Pvt, Ltd.
Hyderabad

48, 49, 51, 52, 53, 54, 55
Collection of
C. Desai, Bombay

42
Dyed cotton yarn hung
out to dry.

114

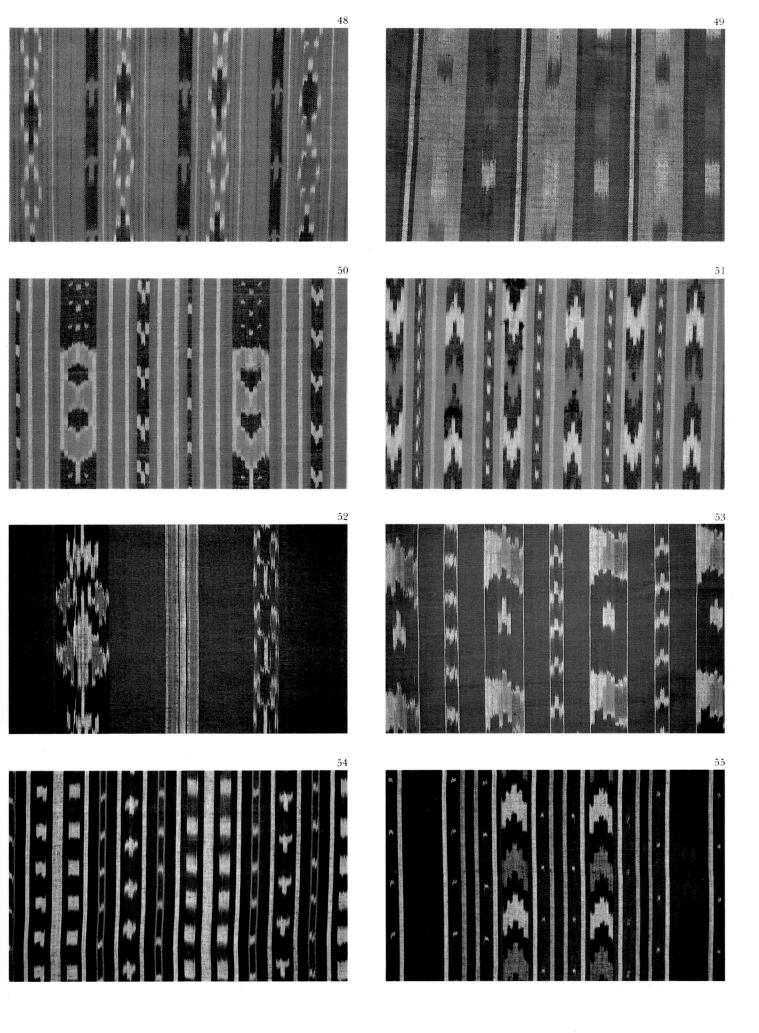

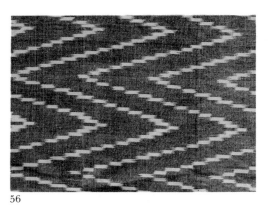

56

56, 57, 59.1, 59.2, 61
Cotton yardage,
Single ikat,
Collection of
Shafali Fabrics Pvt, Ltd.

58
Bed Cover,
Cotton, single ikat,
Collection of
Weaver's Service Centre,
Hyderabad

59
Furnishing material,
Cotton. Single ikat,
Collection of Shafali
Fabrics, Pvt, Ltd.

60
Cotton yardage,
Single ikat,
Collection of
C. Desai, Bombay

58

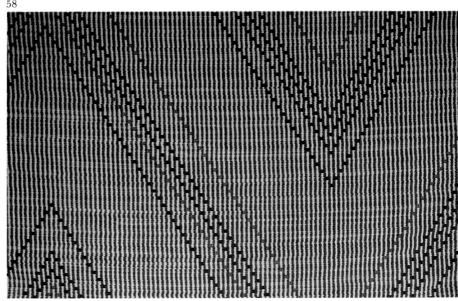

57

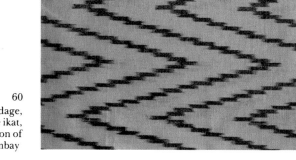

59

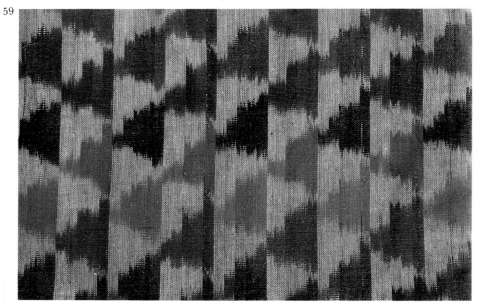

59.2

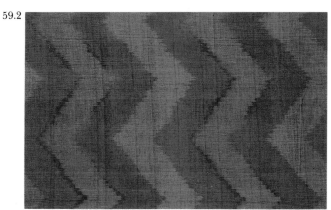

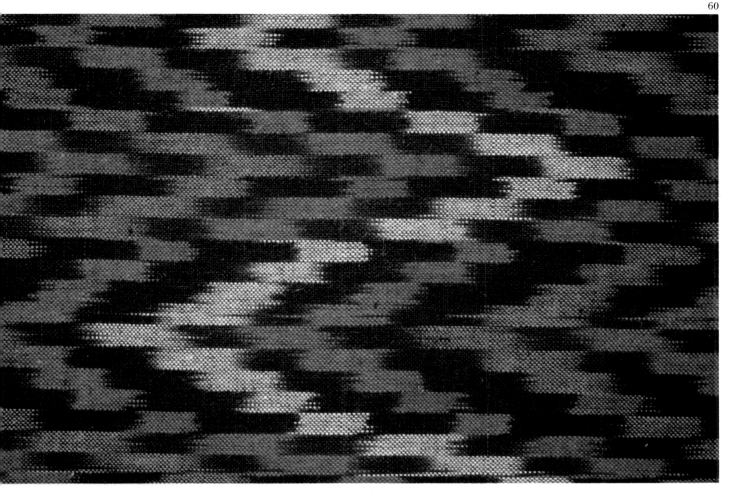

59.1

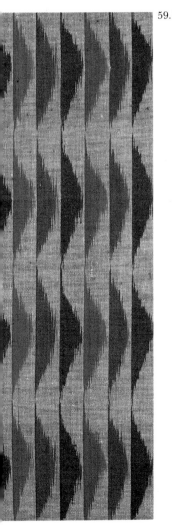

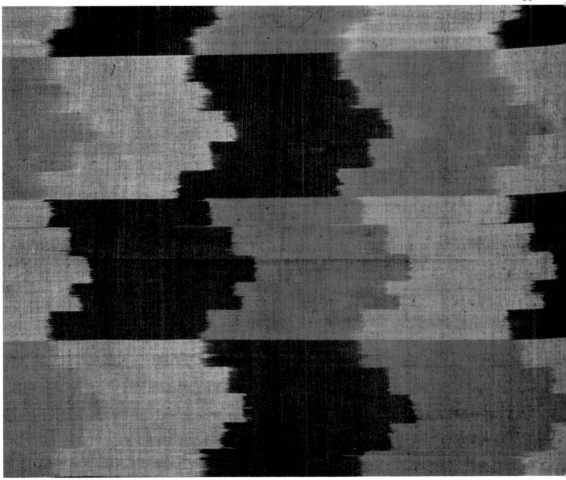

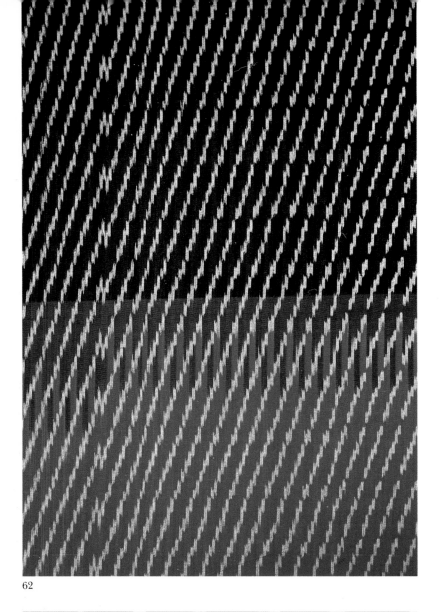

62

62.1

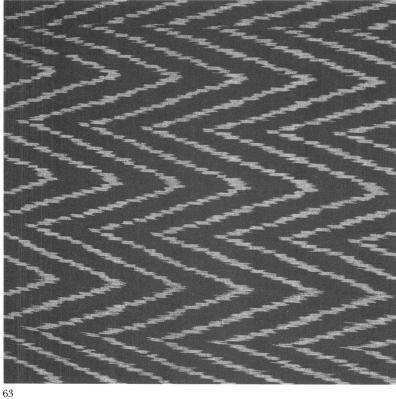

63

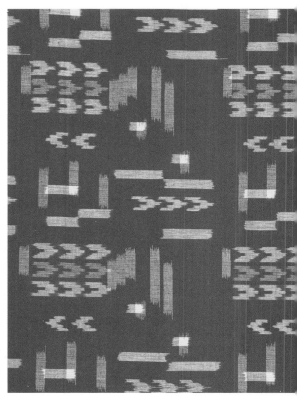

64

118

66

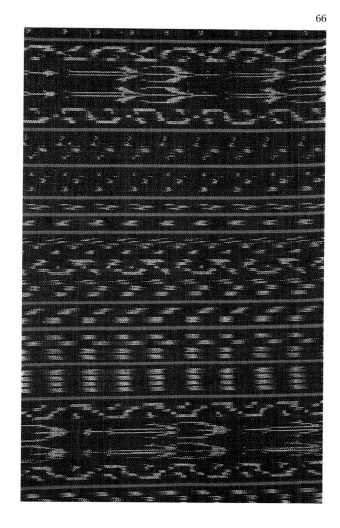

67

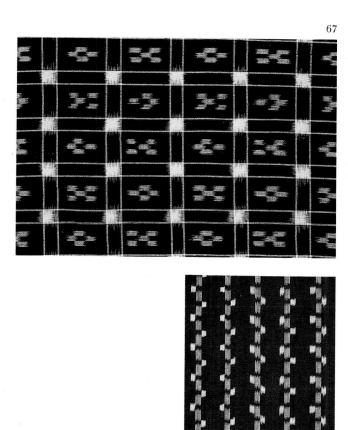

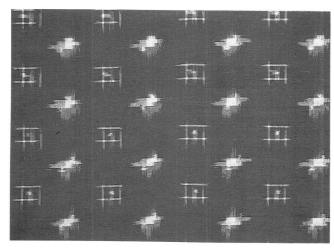

68

68.1

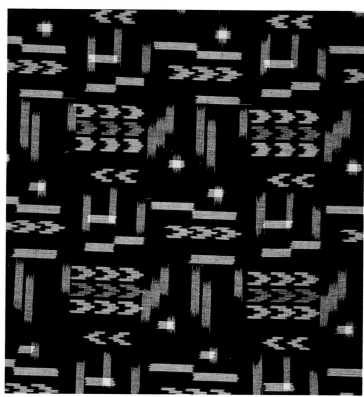

68.1

62 to 68.1
Cotton yardage for
export
ikat,
Collection of:
Shafali Fabrics,
Private Limited, Hyderabad

65

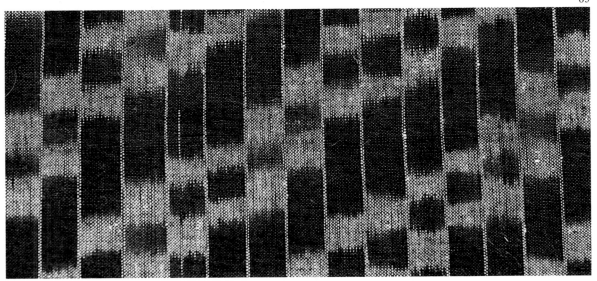

69

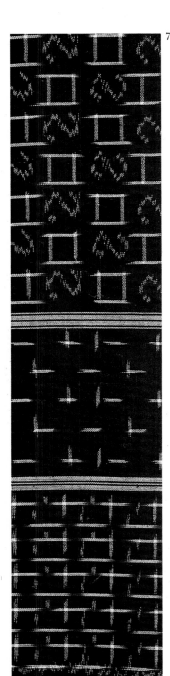

70 Cotton Yardage
69, 73, 75, 76, 77
Single ikat

70, 74
Combined ikat
Collection of
Shafali Fabrics Pvt, Ltd,
Hyderabad

71
Cotton yardage, single
ikat
Collection of
C. Desai, Bombay

72
Yarn from bobbins
being wound around a
warping wheel.
Koyalaguddam

78
Cotton yardage
Double and combined
ikat,
Produced in
Nalgonda District for
Rhuta Jhaveri, New
York

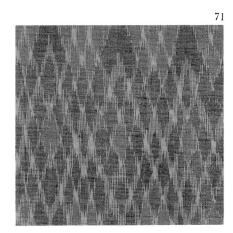

71

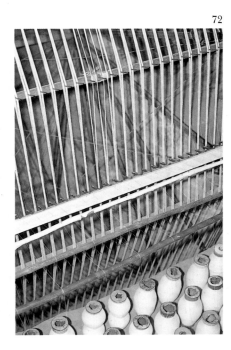

72

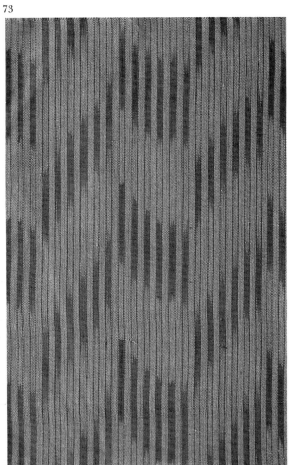

73

74

75

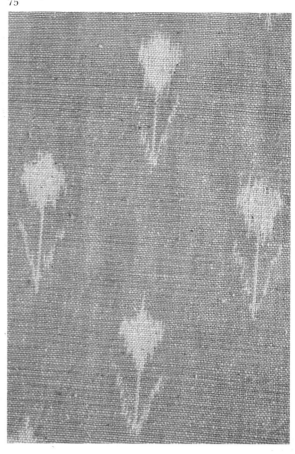

76

77

78

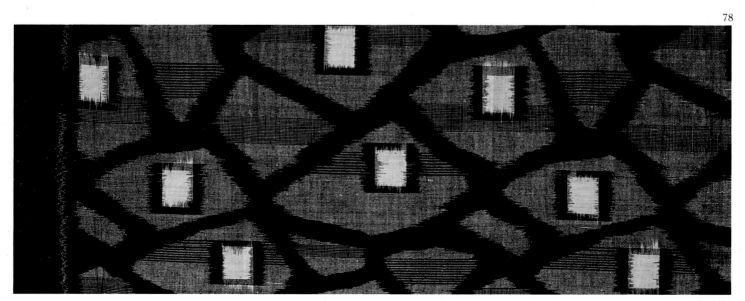

79, 80, 85, 86, 87, 88, 89
Cotton yardage
Double ikat

81
Cotton yardage,
Single ikat
Collection of
Shafali Fabrics Pvt, Ltd,
Hyderabad

82
Dyeing of yarn
in an earthen
dye pot.
Koyalaguddam

83
Cotton yardage
Combined ikat,
Collection of
Angana Jhaveri, New
York

84
Cotton yardage
Single ikat,
Collection of
Rose DeNeve, New York

79
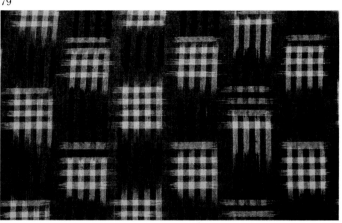

80
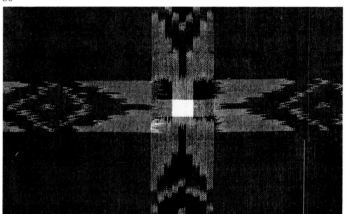

81
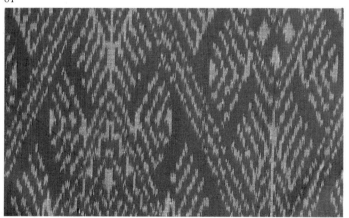

82
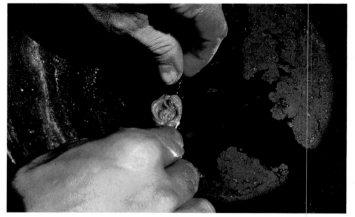

83
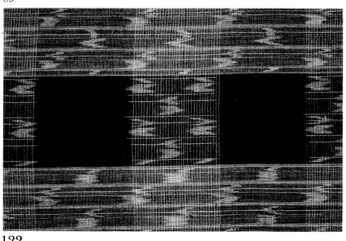

84
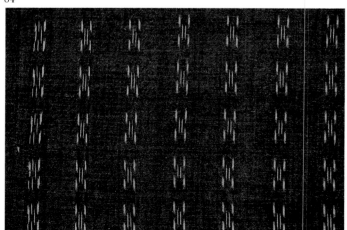

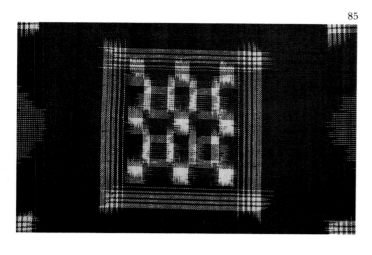

85

86

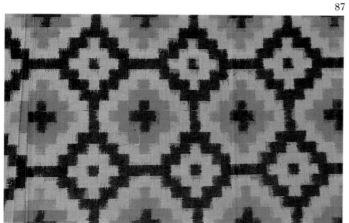

87

88

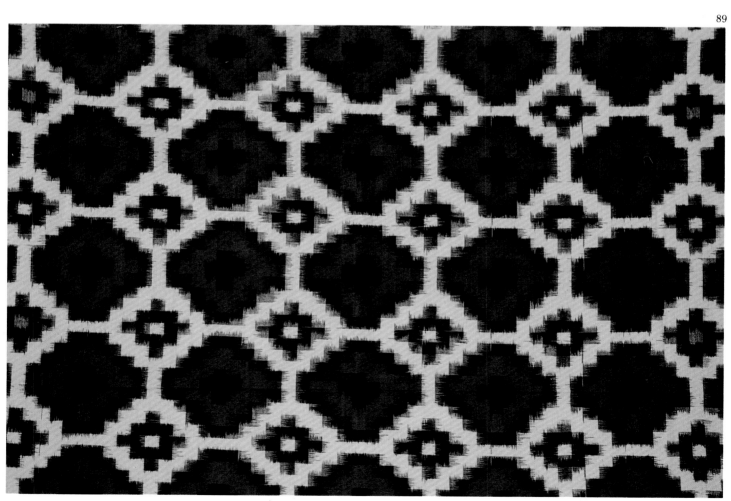

89

90

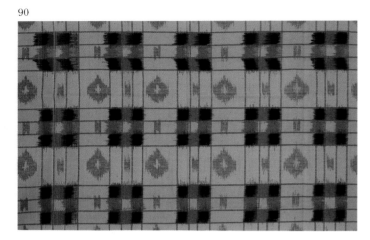

91

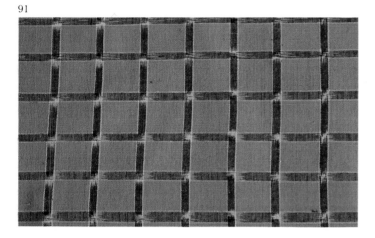

92

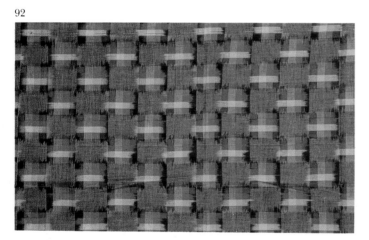

93

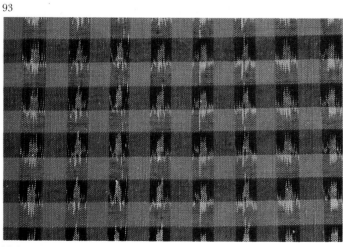

124

94

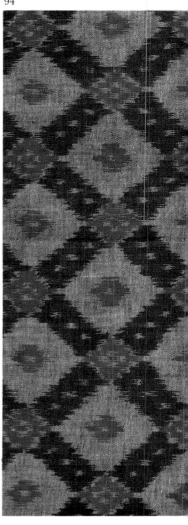

96

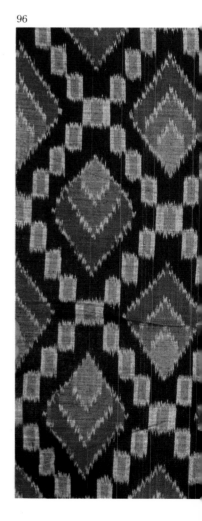

90, 91, 92, 93

Cotton yardage,
Double and combined
ikat,
Collection of Shafali
Fabrics Pvt, Ltd.
Hyderabad

94, 95, 96

Furnishing material,
Cotton, Single ikat,
Collection of
Shafali Fabrics
Pvt, Ltd. Hyderabad

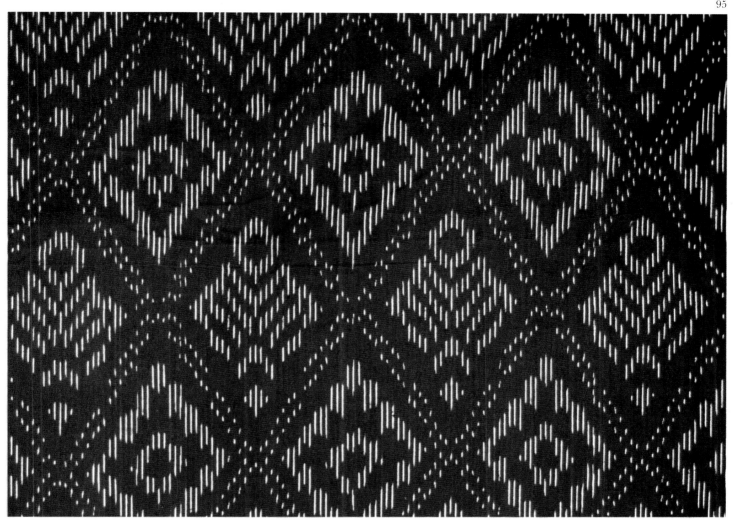

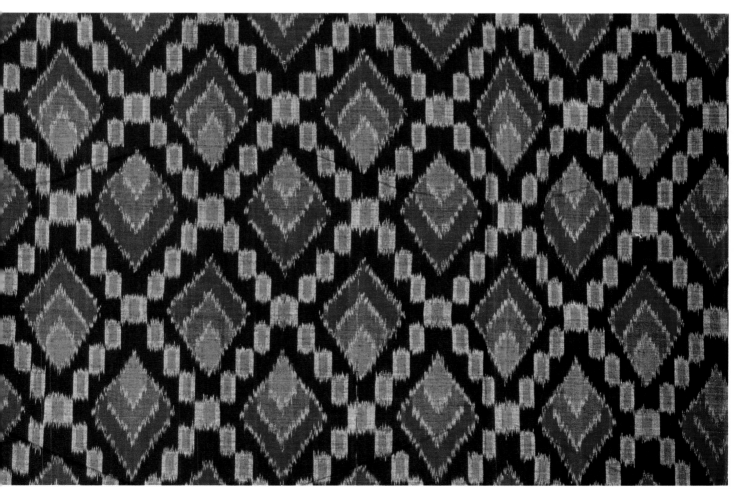

97

98

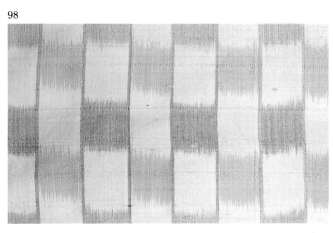

99

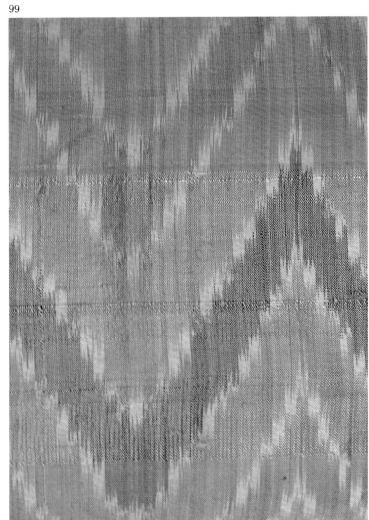

100

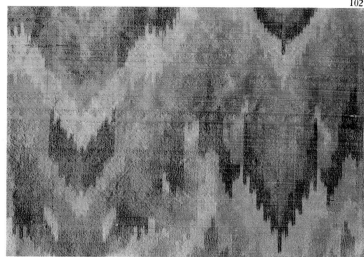

102.1

97
Silk pillow cases,
single ikat,
In the home of
Niruben Tanna,
Bombay

98, 99, 100
Silk yardage,
Single ikat
From the showroom of
Roopkala Saris, Bombay

101, 102, 102.1
Silk yardage,
Single ikat
Produced by
Shyam Ahuja,
Collection of
C. Desai, Bombay

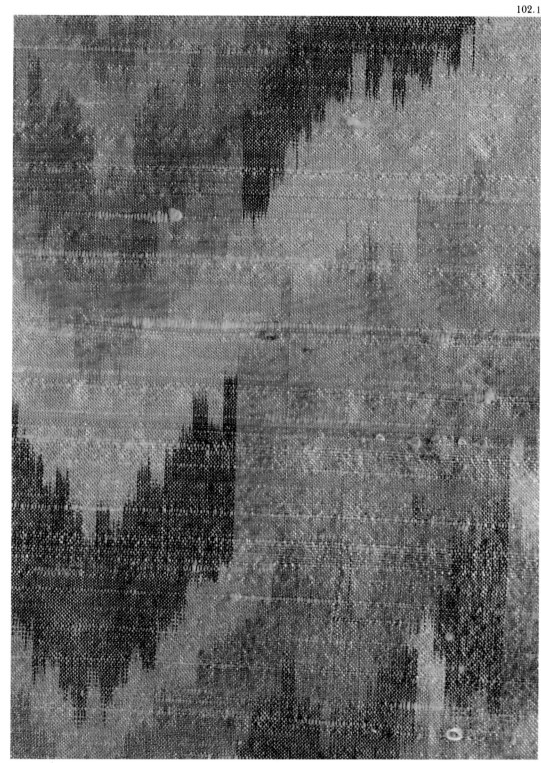

103 to 108
Silk yardage,
Single ikat
From the showroom of
Roopkala Saris, Bombay

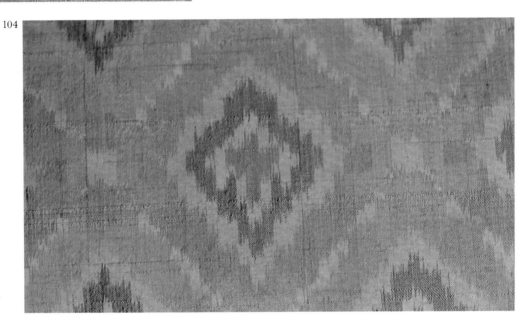

104

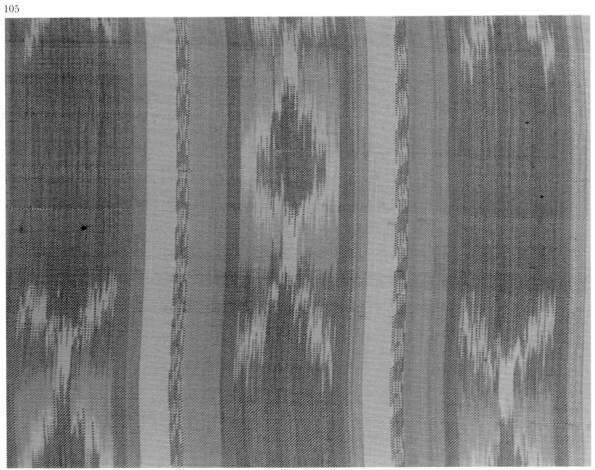

106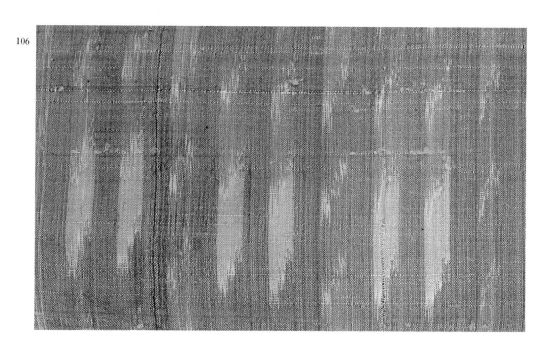

107

108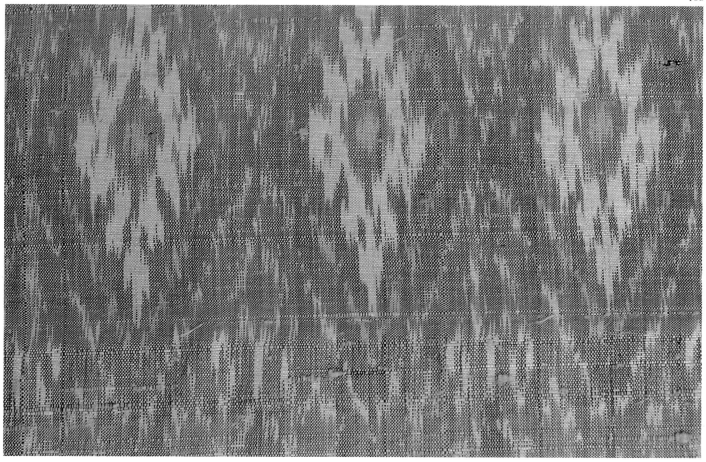

109

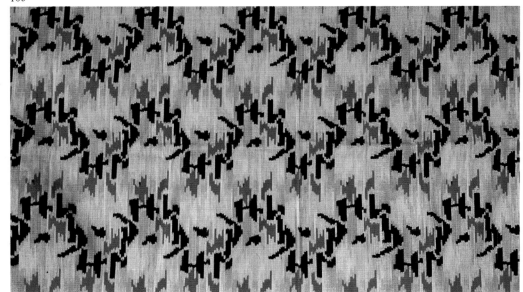

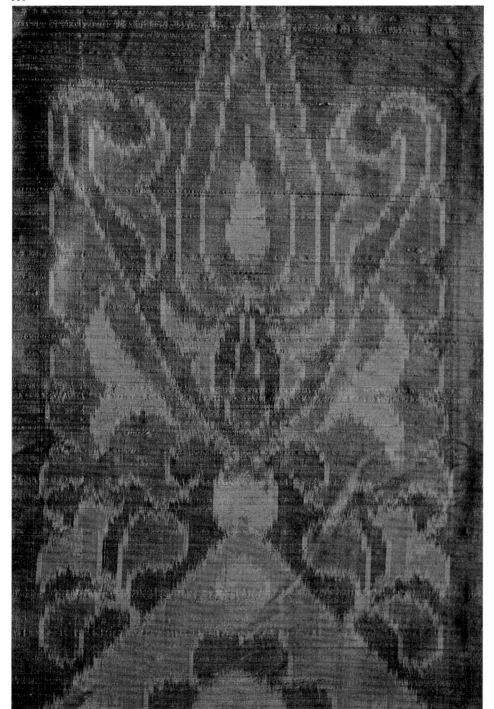

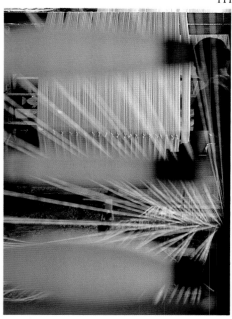

109
Silk yardage,
Screen printed
warp, single ikat
Collection of
Weavers Service Centre,
Hyderabad

110
Silk yardage,
Single ikat,
Collection of
Weaver's Service Centre,
Hyderabad

111
Yarn from bobbins
being wound around a
warping wheel,
Koyalguddam

112
Wall hanging,
Screen printed warp,
single ikat,
Collection of
Weaver's Service Centre,
Hyderabad

111

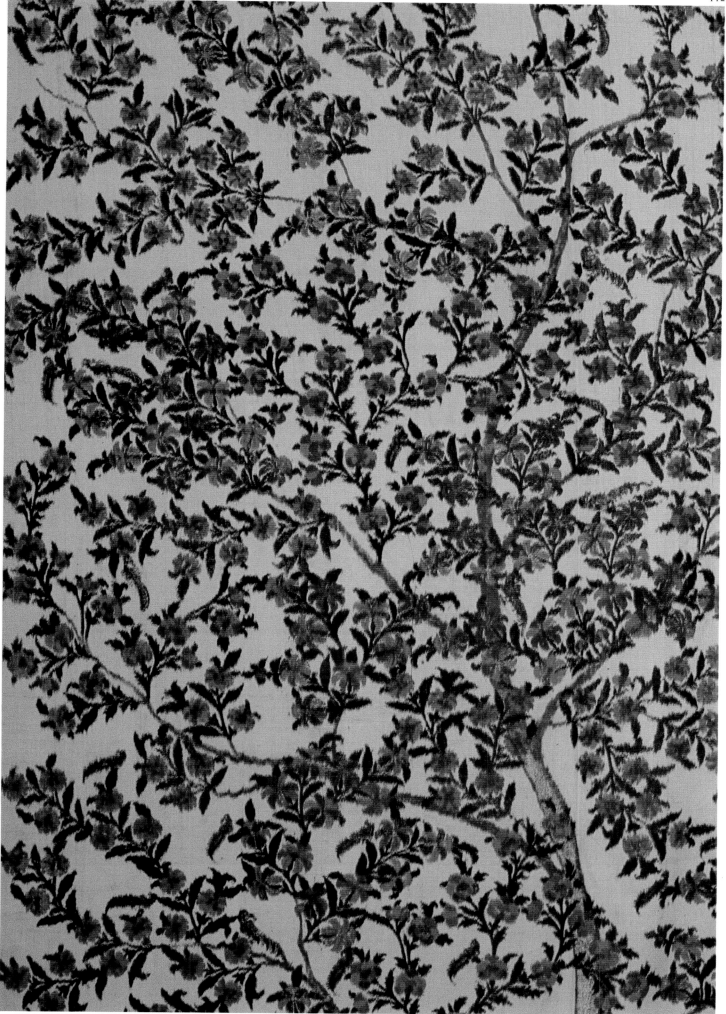

Garments made from Ikat Textiles

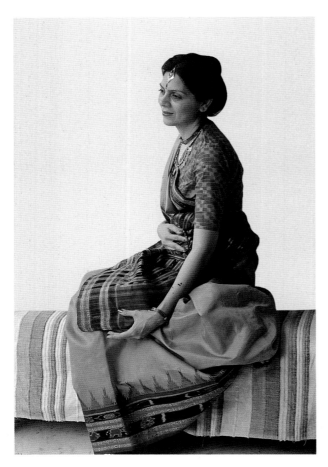

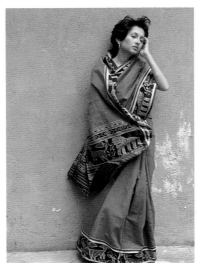

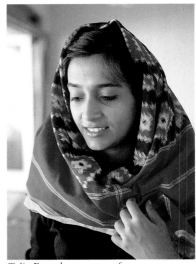

Telia Rumal worn as scarf

Ikat choli or blouse

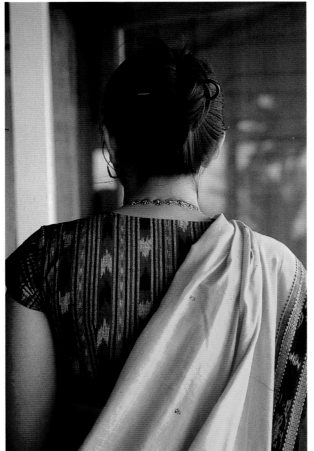

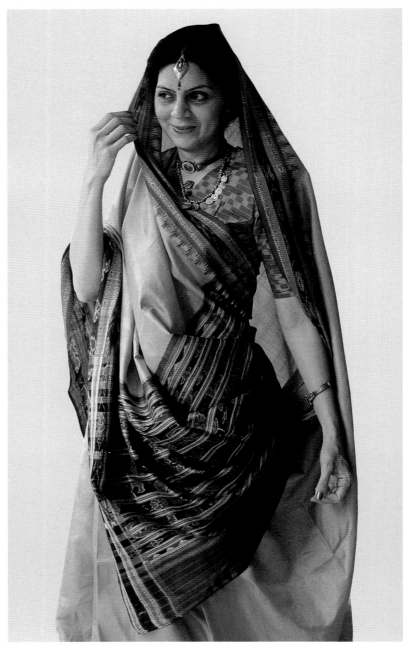

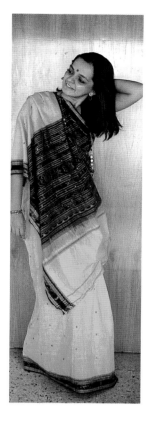
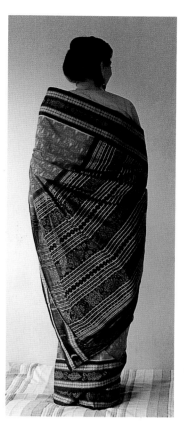

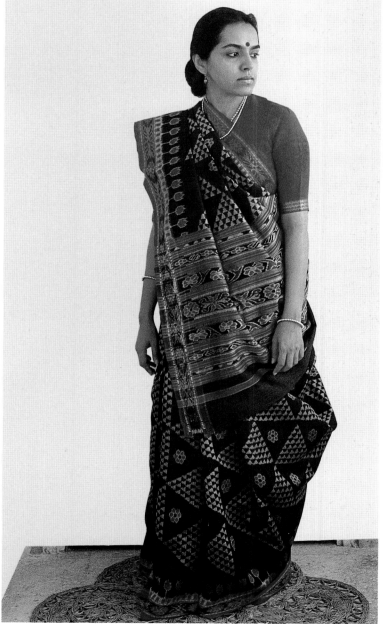

Ikat sari worn in a traditional style

Ikat sari worn in contemporary style

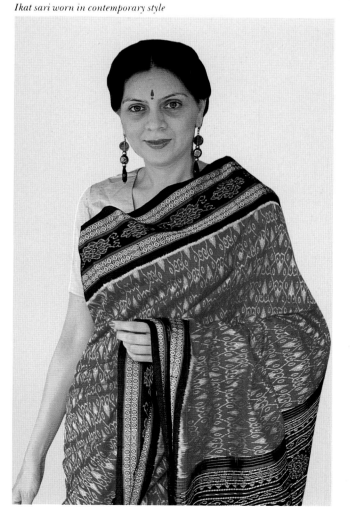

133

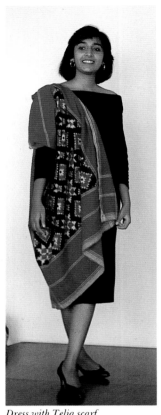

Dress with Telia scarf

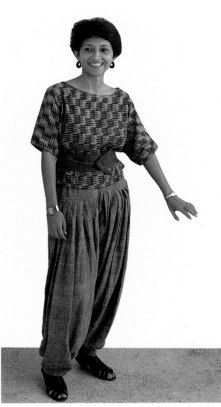

Ikat blouse

Ikat dress

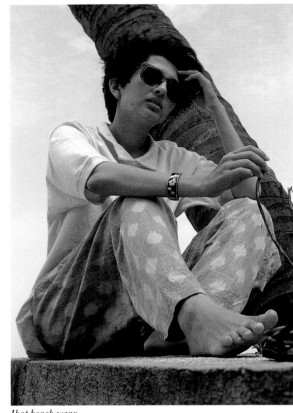

Ikat beach wear

Ikat kurta

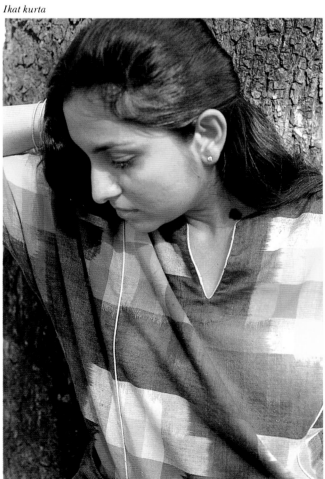

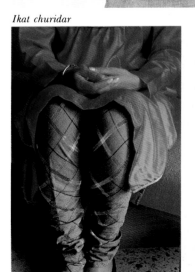

Ikat churidar

Ikat shalwar

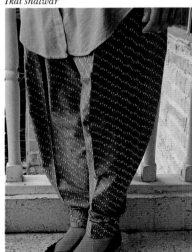

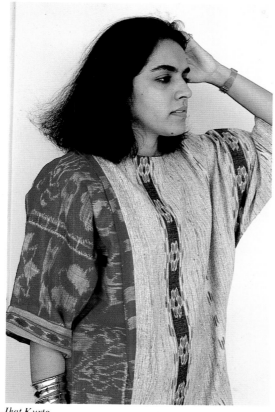

Ikat scarf

Ikat dress　　*Ikat Kurta*

Ikat dupatta worn in 3 ways

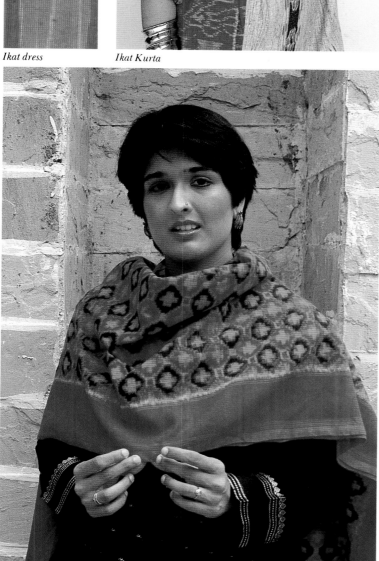

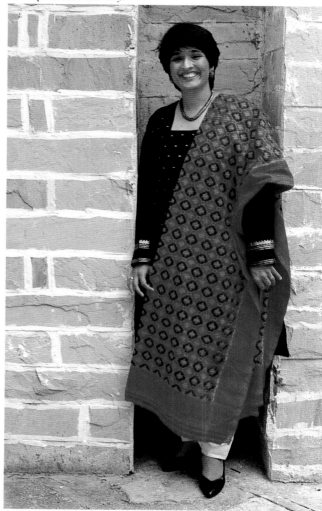

Products crafted from Ikat Textiles

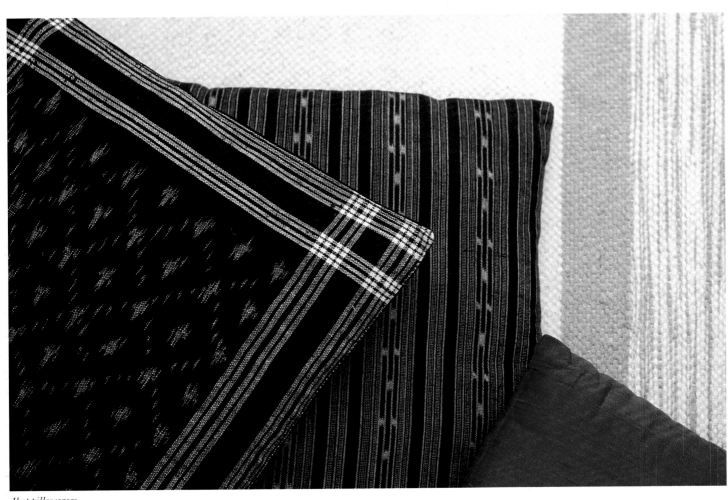

Ikat pillowcases

Ikat

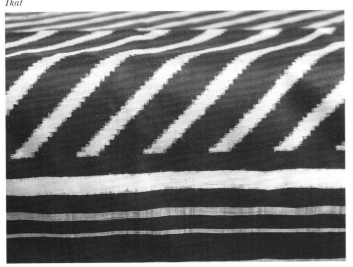

Ikat pillowcases

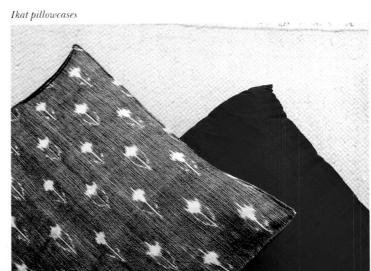

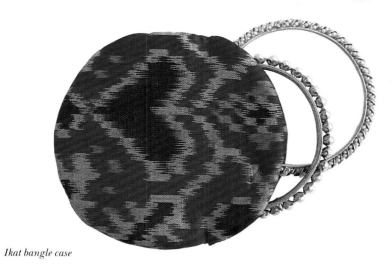

Ikat bangle case

Ikat napkin

Ikat table cloth

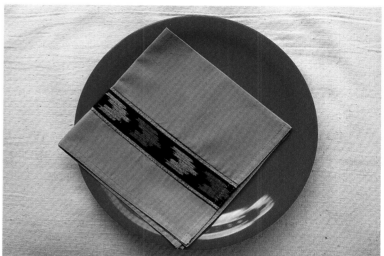

Napkin with ikat border

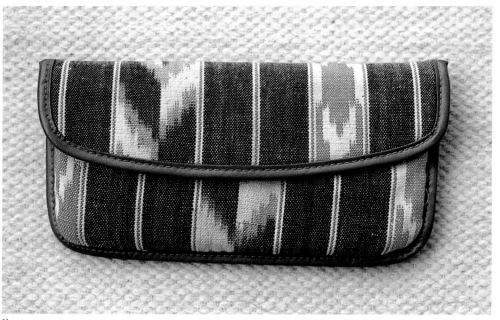

Ikat purse

Ikat bedspread

Quilted ikat pouch

Ikat shopping bag

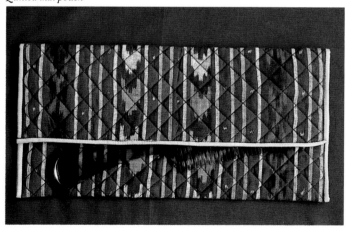

Ikat table mat

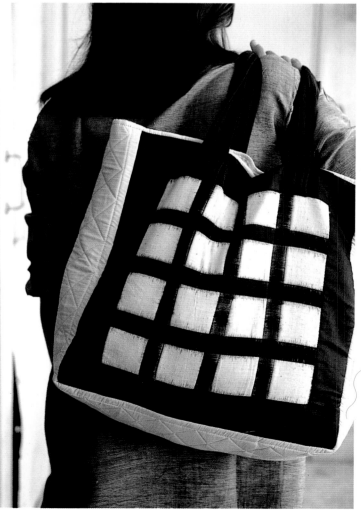

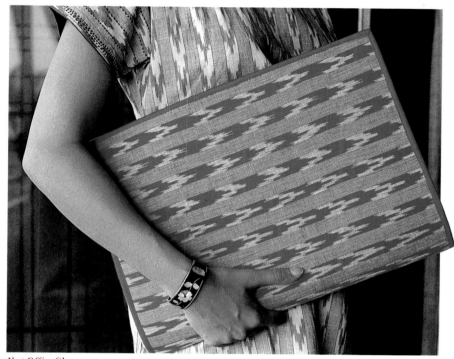

Ikat Office file

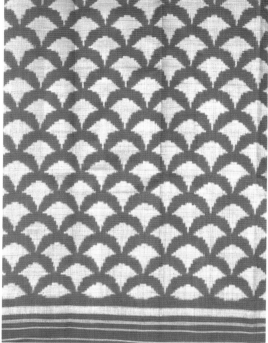

Ikat bedspread

Ikat bedspread

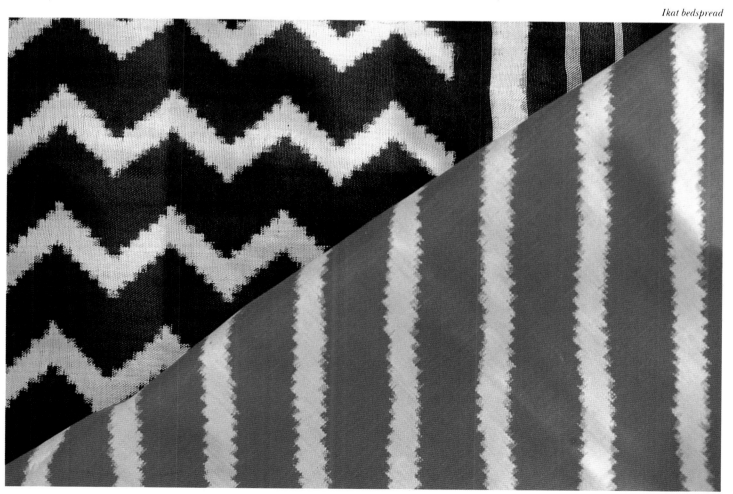

Ikat Imitations

The striking visual character of ikat textiles has been imitated in several mediums, some of them are reproduced here.

Section of a printed curtain

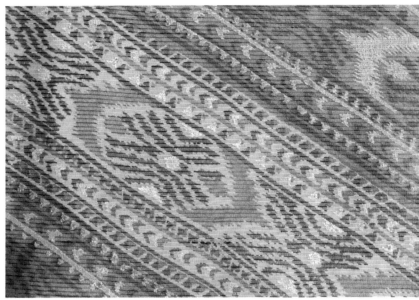

Section of a printed sari

Detail of a printed and patched sleeve

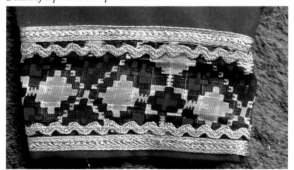

Motif from a printed sari

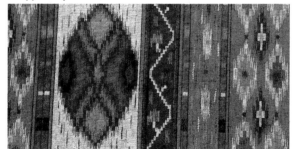

A printed textile pattern

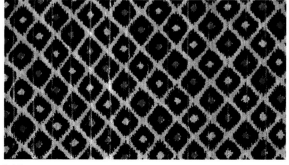

A printed textile pattern

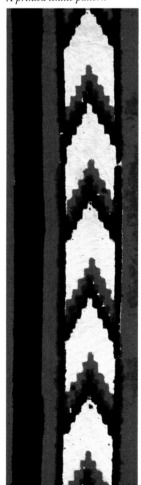

A printed textile motif

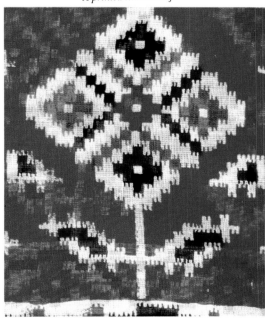

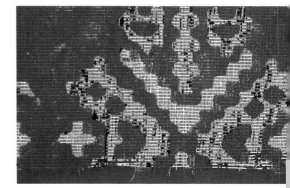

A magazine advertisement

A bead purse

A gift box

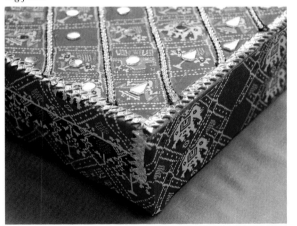

Printed stationery

Section of a printed dupatta

Fragment of a printed sari

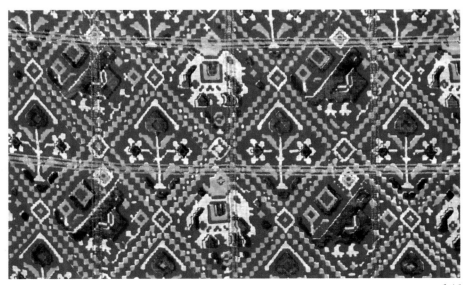

141

Conversely ikat textiles have also been influenced by
other textile techniques and patterns. Some of them are
reproduced in the box below.

Wall hanging of Lord Jaganath. The ikat technique here is used as in painting.

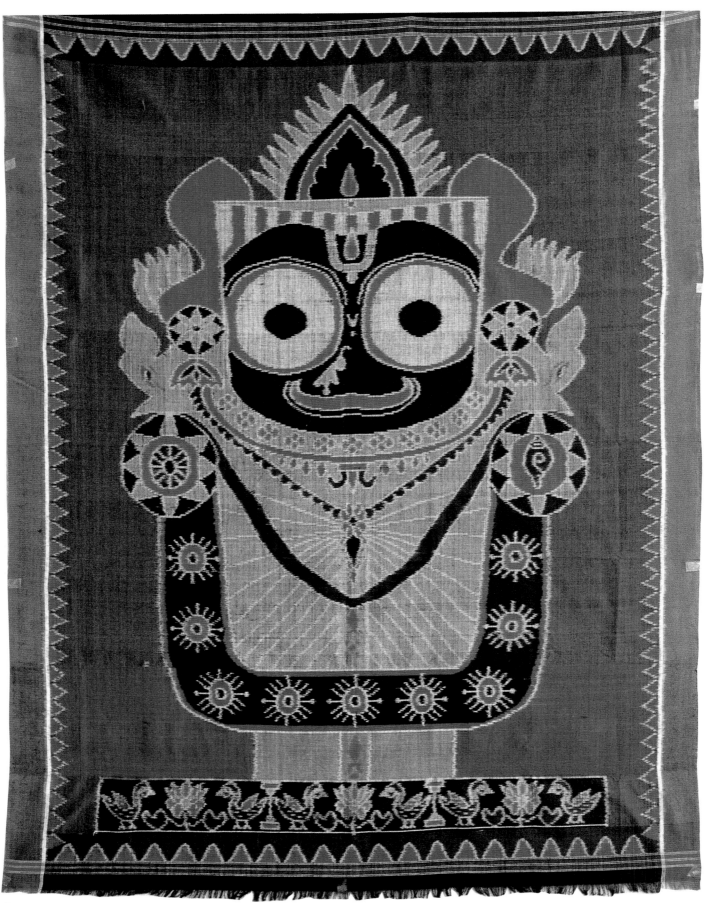

Imitation of a traditional brocade butta or motif

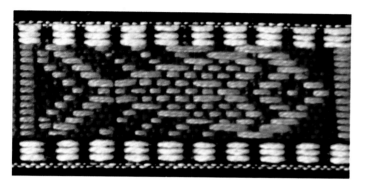
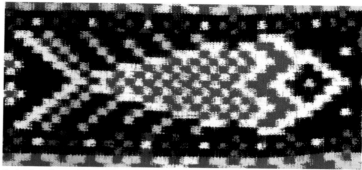

Imitation of a traditional brocade fish motif

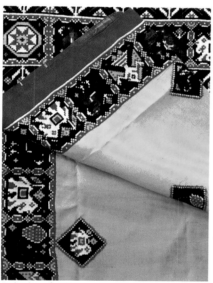
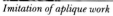

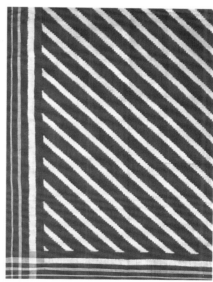

Imitation of aplique work

Imitation 'bandhini' design or cloth resist dye design

Imitation Laheria design, or diagonal cloth resist design

Imitation of a brocade motif

Imitation of a paisley brocade motif

Imitation of a traditional 'Ghar cholu' layout

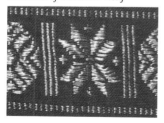

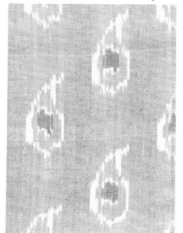
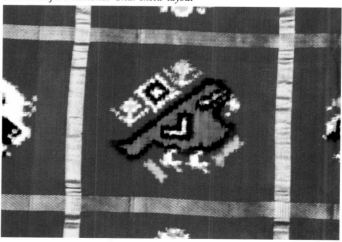

Similarities between Indian & Japanese Ikat Textiles

Some fascinating similarities between Japanese ikat (kasuri) and Indian Ikat textile patterns are reproduced below.

Traditional ikat mashru pattern, India

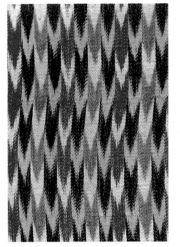

Traditional kasuri pattern, Japan

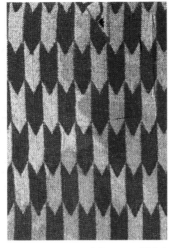

Traditional lotus motif, Japan

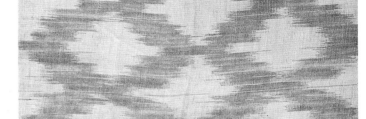

Traditional, enclosed lotus motif, India

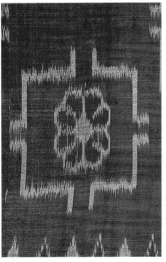

Traditional enclosed flower motif, Japan

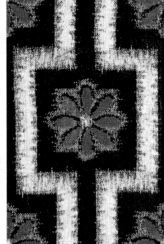

Traditional lotus motif, India

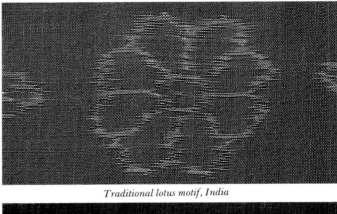

Traditional lotus motif, India

Traditional ikat motif from a Telia Rumal, India

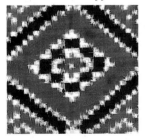

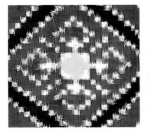

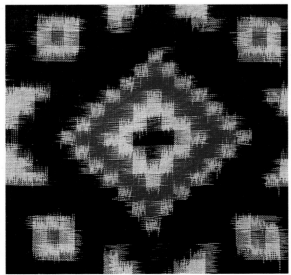

Traditional kasuri motif, Japan

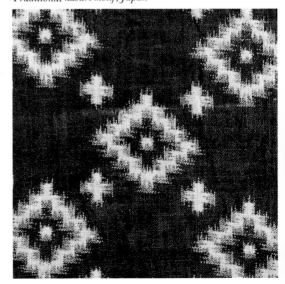

Contemporary ikat motif, India

Contemporary ikat pattern, India

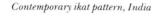

Traditional kasuri motif, Japan

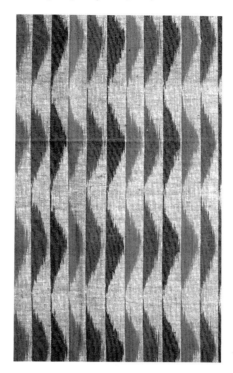

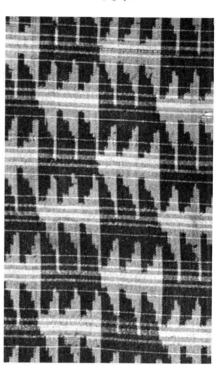

Traditional Kasuri pattern, Japan

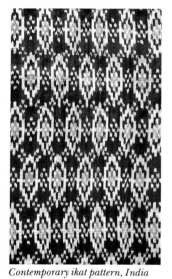

Contemporary ikat pattern, India

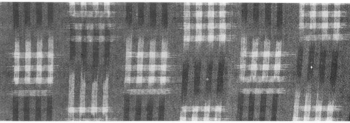

Contemporary ikat pattern, India

Traditional kasuri pattern, Japan

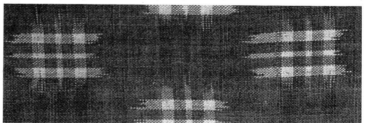

Traditional kasuri pattern, Japan

Contemporary ikat pattern, India

Traditional kasuri pattern, Japan

Symbolic Forms in Ikat Textiles

Some motifs within the rich design vocabulary of ikat textiles are actually symbolic forms rooted in Indian wisdom.

A few of these symbols are represented below with brief interpretations and explorations of their meaning in context to Indian culture.

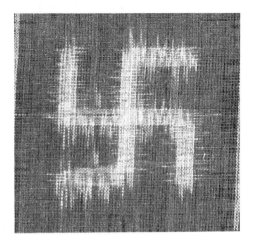

The Swastika

The swastika is a symbol of auspiciousness. In sanskrit 'swastika' means 'it is well'. There are several interpretations of this symbol. It is a symbol of the vedic fire god Agni and has been used to symbolize the Sun or Vishnu. It also represents the world-wheel, the eternally changing world, around a fixed and unchanging centre — God. The Swastika sign is commonly used on threshholds, walls and in ceremonies as a symbol of good augury, good luck and longevity.

The Lotus

According to Professor N.R. Krishnamoorthy, the lotus bud is born in water and unfolds itself into a beautiful flower. Hence it is taken as the symbol of the universe emerging from the sun. It rises from the navel of Vishnu and also forms the seat of Brahma the creator.

Another interpretation is as follows:- the lotus blooms from the underworld into light and is therefore symbolically associated with transcending of man's spirit over worldly matters. It is also seen as the link between earth and the cosmos. According to Dr. S.V. Gorakshkar, the lotus is a solar symbol and also symbolizes the womb.

Psychic centres in the body associated with the rising of kundalini power are pictured as lotuses.

According to Manu Desai, the interpretation of the 8 petalled lotus is as follows:- Each petal represents earth, fire, air, ether, mind, intellect and ego. With the basic elements which represent external factors and the 3 inner elements, one can attain self knowledge (jnana) and with the use of this knowledge one can attain the central point, the 'bindu'. The 5 petalled lotus represents the five elements and the 5 organs of knowledge, namely, touch, taste, smell, sound and vision.

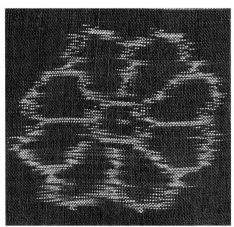

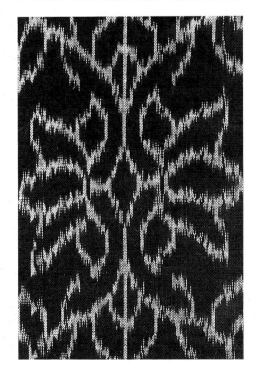

The Shankha or Conch

According to Mr. V.A.K. Aiyar, the Shankha or conch occupies an important place in hindu thought. It is said to symbolize the Pranava or the mystic symbol 'OM'. It is held in the hand of Lord Vishnu, symbolizing Nada Brahma or God in the form of sound.

According to J.C. Cooper, it is one of the 8 symbols of good augury. A white conch depicts temporal power. Among the conches, the 'Dakshinavarta' or right turned conch is said to be rare, most auspicious and of the highest value.

On another plane, conches were used as bugles in war and in ancient India each warrior had his special famous conch.

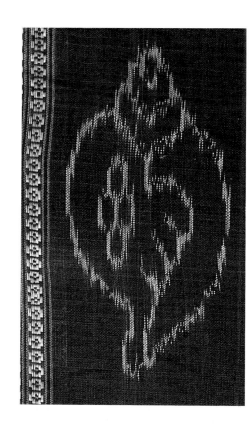

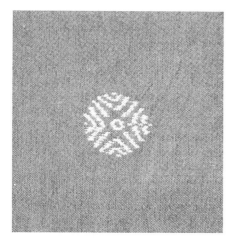

The Rudraksha

The rudraksha is a seed of the Rudraksha tree which grows in the Himalayas. A string of these beads known as 'rudrakshamala' are worn by devotees of Lord Shiva (especially those of the Saiva Sidhanta School) and used as rosaries, for counting and repeating mantras. According to the 'Yoga Sara, spiritual powers abide in these seeds. The name 'Rudraksha is a compound of the two sanskrit words 'Rudra' meaning Shiva and 'Aaksha' meaning eyes. Rudraksha therefore means the eye of Shiva.

The Matsya or Fish

The fish is the first incarnation of Lord Vishnu. It is also one of the 8 symbols of good augury and good luck. The people of coastal Orissa are fish eaters, hence the fish has come to symbolize prosperity.

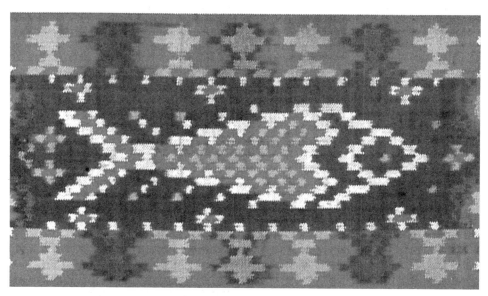

Animals are no more forms but personified ideas and attributes — Dr. S.V. Gorakshkar.

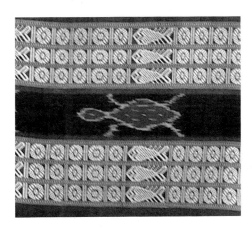

The Tortoise

The tortoise is known to withdraw its limbs within, according to Dr. S.A. Upadhyaya, this act is symbolically interpreted as the need to withdraw one's sense organs within, for internal purification. The tortoise is also represented as the 2nd avtar or ircarnation of Lord Vishnu

The Coiled Serpent

Snake worship or the 'Naga' cult, according to Mr. S. Jagannathan, is very ancient, going back to pre-historic times. The concept of Naga worship has also been absorbed into Hinduism. The snake is believed to be immortal. As one skin is shed to be replaced by another, so the coiled, ever moving serpent has come to symbolize the unending cycle of time and immortality. Cosmic energy is also symbolized as serpent power. According to Manu Desai, life energy – prana is represented as a serpent.

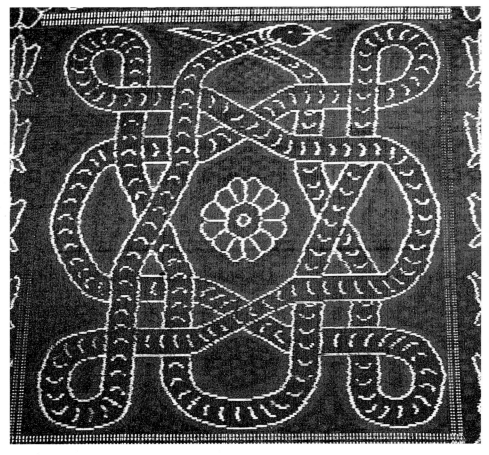

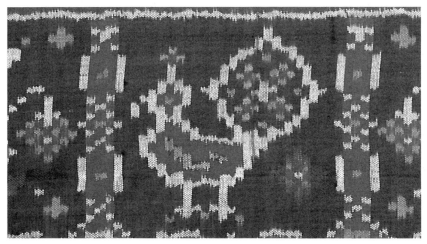

The Peacock

The peacock symbolizes beauty. A dancing peackock symbolizes coming of the rains and is therefore assiciated with prosperity.

The Bichitrapuri Anchal

The 'Bichitrapuri ānchal or end piece, is one of the oldest design features of bandha saris from Orissa. The ornate ānchal has recurring motifs of fish, lotus, elephants, deer and other animate and inanimate forms.

Not many people when asked, seemed to know about the origin or significance of these forms. However, two interesting interpretations did emerge. One explanation, traces the rendering of these motifs to the ornate stone carvings found in temple architecture; the animal or plant being a personification or symbol of a deeper underlying concept.

In another interpretation, it is believed these visual forms were actually drawn from ancient sanskrit literature. In a particular text analogies between animal charecteristics and their relation to how an ideal woman should appear have been found. Some of these lines are reproduced here:- an ideal woman must have eyes of a deer, face like that of the moon, the waist of a lion, the gentle gait of an elephant, the neck of a swan, the grace of a gazel and so on. In all, there are 32 descriptions of a woman, 8 related to flowers, 8 to birds, 8 to animals, and 8 plants. In fact, the central flower in the anchal — the 'Padmatola' originally had 32 petals possibly corresponding to the 32 charecteristics.

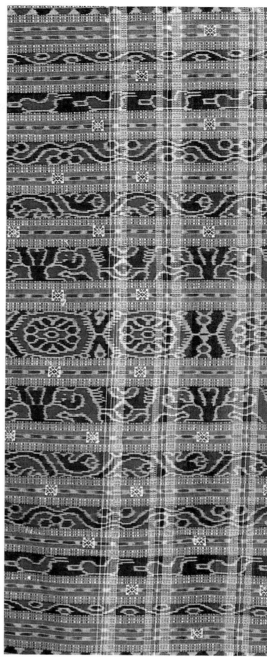

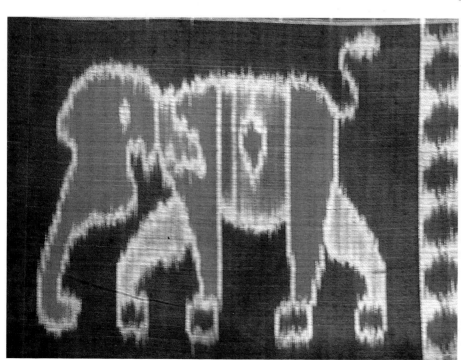

The Elephant

According to Dr. S.V. Gorakshkar, elephants are associated with fertility and cosmic waters. The elephant-headed God of learning, Ganesha, takes precedence to all hindu ceremonies. Ganesha is worshipped as the Lord of knowledge, memory and as the remover of all obstacles.

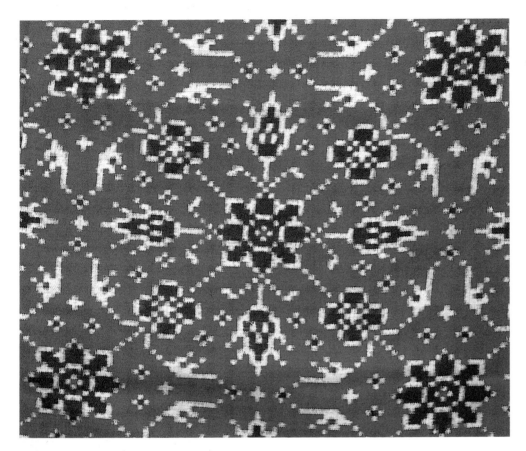

Chaabdi Bhat

This 8 pronged floral ornament was favoured by Anavil Brahmins in India and was very popular amongst the elite in Indonesia, possibly because it symbolized the 8 paths of learning in Budhism.

The Dharma-Chakra

The Dharma-Chakra or 'Wheel of Law' is the most important symbol of Budhism. In an individual's life, 'Dharma' becomes manifest as 'good' or noble conduct. Chakra, means the wheel and Pravartana means 'to set in motion'. The wheel symbolizes a constantly changing universe and the imperminence of everything in the world. The 8 fold path (Arya Ashtangika Marga) corresponds to the 8 spokes of the wheel of Dharma. The wheel, it is believed cannot a survive' without the practise of these 8 virtues nemely: 1) Right view 2) Right resolution 3) Right speech 4) Right conduct 5) Right means of livelihood 6) Right effort 7) Right mindfullness 8) Right concentration.

The Dharma-Chakra presented here is inspired by the famous stone wheels of the Konarak Sun Temple in Orissa.

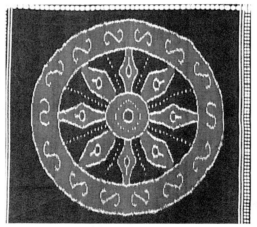

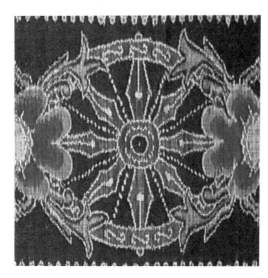

Navratna

The word 'Navratna' or 9 gems is commonly used to describe the 9 planets of our solar system, known as 'Navgraha'. According to Swamini Saradapriyananda, these 9 are said to have the greatest influence on the physical and psychic conditions of living beings. The 9 'grahas' represent the Sun, Moon, Mars, Mercury, Jupiter, Venus, Saturn and Rahu, Ketu which are ascending and descending nodes of the moon. It is believed the futre of an individual is decided by the position of these nine planets at the time of birth. On special occasions 'Navgraha Shanti' a ritual ceremony is performed. The sun is always represented in the centre. The 8 grahas or planets surrounding, the sun represent the 8 fold nature of man, which manifests itself as life, while the Sun represents the higher nature, 'the soul'. When a man knows how to keep the two natures within him separate from one another (detachment) he stands at peace with himself and the world around. 'Navagraha' literally means a 'new grasp'.

①

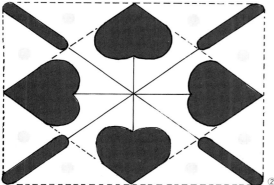

②

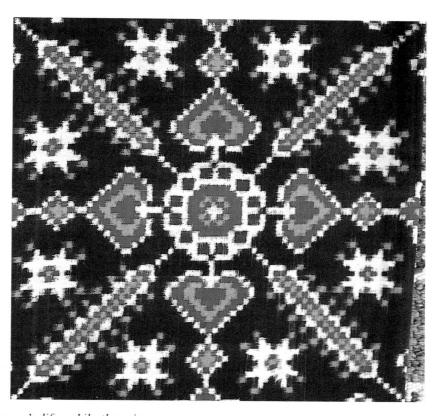

Vohra Gaji Bhāt

Although this motif is known as 'Vohra Gaji', a design patronized by hindus and Vohra muslims hence the name Vohra Gaji, I believe this design is based on the hindu birth chart or horoscope known as 'Janam Kundali'. The horoscope chart is basically a geometrical diagram with 12 divisions. The 4 main sections (diamonds) converge at the centre and are known as Kendras while the 8 triangles known as 'trikons' lie along the periphery of the rectangle. At the time of birth the position of each planet is charted on this diagram. Planets which fall within the 4 diamonds, exert the strongest influence on one's life, while those in the 'trikons' or triangles have a lesser influence. If the Vohra Gaji symbol is superimposed on this chart (diagram 2) one can see that the leaves have been derived from the 4 kendras (diamonds), the stars represent each trikon, while the caterpillar like forms act as dividers between the 4 main kendras

GLOSSARY

ānchal: end piece/end panel of sari from Orissa

bāndha: ikat textile of Orissa

Bichitrapuri ānchal: ornate end piece of traditional sari from Orissa

Bor jāli bhāt: berry and trellis pattern

būtta: a floral motif

Chāābdi bhāt: basket pattern, floral pattern of patola

chaupār: a dice and board game

chevron: arrowhead form

chowka: motif consisting of square or rectangular units.

Dādham bhāt: pomogranate pattern

Dado bhāt: ball pattern

domui: literally 'two mouths', name given to an Orissa sari with 2 end pieces.

dupattā:'double folded cloth', shawl, stole, veil worn by women

ek phuliā: 'of one flower' a floral pattern

Ful dāli: flower and stem

gaja sinha: elephant and lion

Gālo: a type of patolu with a plain centre field

Geet Gobind pheta: Calligraphic textile offered to Lord Jaganath

Ghar bandhi ful: 'flower enclosed within a house, '(name of a patolu pattern)

Golo bhāt: ball/circular pattern

Ikat: Malay-Indonesian word meaning to tye, dye or wind around

jāli: netting, criss-cross pattern

Joth: name of sari from Nagpur, Maharashtra State.

Kalinga sundari: beauty from Kalinga (Orissa)

khanduā: traditional sair from Orissa.

khanjiri: wave like formations found in mashru textiles.

kumbha: literally 'water jar', symbol of auspiciousness

Kunjifulbedi: type of motif from Orissa

Laheria bhāt: diagonal striped pattern

latā: creeper

lungi: lower garment worn by men.

mandalā: a symbolic thought diagram

mantra: a magical formula

māshru: silk and cotton fabric, woven in satin weave

māthamani: name of an ikat pattern from Orissa

Mor patangyu bhāt: peacock and butterfly pattern

Nāri kunjar bhāt: girl/lady and elephant pattern

navagraha: nine planets

Navratna bhāt: 'nine jewels' pattern

ōdhni: a veil, cloth worn by women

padma: lotus

padmatolā: lotus motif/pattern

pāllav: end piece/end panel of a sari

pān bhāt: leaf shaped pattern

Pānch ful bhāt: 'of five flowers' pattern in ikat of Gujarat

Pān chowka: leaf and square pattern

pānch patti: 'of five lines'

pānch phuliā: 'of five flowers' a pattern in ikat of Orissa

Pātan: name of town where patola textiles are woven

Patnayakpar: name of an Orissa sari

patolu: double ikat sari of Patan, Gujarat

Patrarekha: leaf pattern sari of Orissa

Pochmpalli patolu: name of village where double ikat textiles are woven

popat: parrot

Rāss bhāt: a traditional circular dance pattern of Gujarat

Rājkot patolu: name of city where single ikat textiles are woven.

Ratan chowk bhāt: jewel mosaic design or cross of diamonds design

rudrāksha: a sacred seed of the 'rudraksha' tree.

Sacipar: name of an ikat sari of Orissa

Saktapār: name of a traditional ikat sari of Orissa

Saktapriya: name of an Orissa sari

shankha: conch

swāstika: an auspicious symbol of the Hindus

Tājsiai: name of an Orrisa sari

tārabali: star pattern (Orissa)

Tāralia bhāt: star pattern (Gujarat)

tāntric sarpa: esoteric snake motif

tel: oil

Telia Rumal: square, double-ikat textile of Andhra Pradesh

thān: yardage (in Orissa)

Tran ful bhāt: 'of three flowers' a pattern in ikat of Gujarat

tussar: type of silk produced in Orissa

Vohra Gaji bhāt: name of patolu pattern popular amongst vohra muslims of India

ACKNOWLEDGEMENTS

I owe my deepest gratitude to my parents for their enthusiasm and unending support and also to Mr. Kuze and Ms. Samejima for their genuine interest in this project.

I wish to thank all my friends and relatives for their wholehearted support. My sincerest thanks to Ashwin Shah, Shobhna Bhagat, Amit and Nandini Gandhi, Rajesh Vora, Lalana Lakhani and Satish Kamath.

Also, a special thank you to Darius Mistry, Daisy Mistry and Suresh Mehra of Hyderabad, and to Professor B.C. Mohanty of Bhubaneshwar.

One of the most challenging aspects of this project was to acquire as varied a range of ikat textiles as possible. Had it not been for the kind assistance of the Weaver's Service Centres, other Government organizations, master weavers, individual collectors, and sari stores, such a wide collection of textiles may never have been compiled. For this, I am particularly grateful to Mr. B.B. Dutta, Mr. R.N. Mahicha, Mr. P.L. Panda and Mr. J.K. Reddiya of the respective Weaver's Service Centres of Bombay, Ahmedabad, Bhubaneshwar and Hyderabad. I would like to especially thank Mr. S.K. Dash of Sambalpuri Bastralaya, Bargarh and Mr. Arjun Behra of the Directorate of Textiles, Sonepur for their kind cooperation.

154

BIBLIOGRAPHY AND NOTES

Battenfield, Sally, *The Ikat Technique*. Van Nostrand Reinhold Company, 1978

Bühler, Alfred and Eberhard Fischer, *The Patola of Gujarat*, 2 Vols, Basle 1979

Bühler, Alfred; Eberhard Fischer and M. Nabholz, *Indian Tie-dyed Fabrics*. Ahmedabad 1980

Desai, Manu, *Indian Graphic Symbols*. Bombay 1982

————, *The Master Weavers*, Festival of India in Britain, Sponsored by the Development Commissioner of Handlooms, Government of India, Bombay 1982

Gulati, A.N., *The Patolu of Gujarat*, Museums Association of Gujarat, 1951

Jaykar Pupul, *"A Neglected group of Indian Ikat Fabrics."* Journal of Indian Textile History, Vol I, 1-11, pgs 54-56 Ahmedabad 1955

Jaykar Pupul, *"Indian Textiles through the Centuries"*, Marg, Vol XXXIII No.1., Bombay

————, *Indian symbology*, IDC, Powai, Bombay 400 076.

————, *"Patola Influences in SE Asia."* Journal of Indian Textile History, Ahmedabad, Vol 4, pgs 4-46, 1959

Khanna, Madhu, *Yantra*, Thames and Hudson, London, 1979

Larsen, Jack Lenor with Bühler, Alfred and Solyon, Garret and Bronwen, *The Dyer's Art: Ikat, Batik, Plangi*. New York, Van Nostrand Reinhold Company, 1976

Mehta, R.N., *"Bandhas of Orissa."* Journal of Indian Textile History, Volume VI, Ahmedabad 1961

————, *Ikat of India*, Mingei Foundation, Mingei International Museum of World Folk Art. 1981

Mittal, Jagdish, *"Telia Rumals of Pochampalli and Chirala"*. Marg, Vol XV, Part 4, Bombay, 1962.

Mohanty, B.C. and Kalyan Krishna, *Ikat Fabrics of Orissa and Andhra Pradesh*. Ahmedabad 1974

Nathan, R.N. (editor), *Symbolism in Hinduism*. Central Chinmaya Mission Trust, Bombay 1983

Yoshimoto, K., *Traditional Ikat*. Graphic-Sha Publishing Company, Tokyo.

————, *Weaver's Service Centre*, Government of India, Ministry of Commerce and Industry.